Splash 11 | New Directions

THE BEST OF WATERCOLOR

edited by Rachel Rubin Wolf

NORTH LIGHT BOOKS
CINCINNATI, OHIO
www.artistsnetwork.com

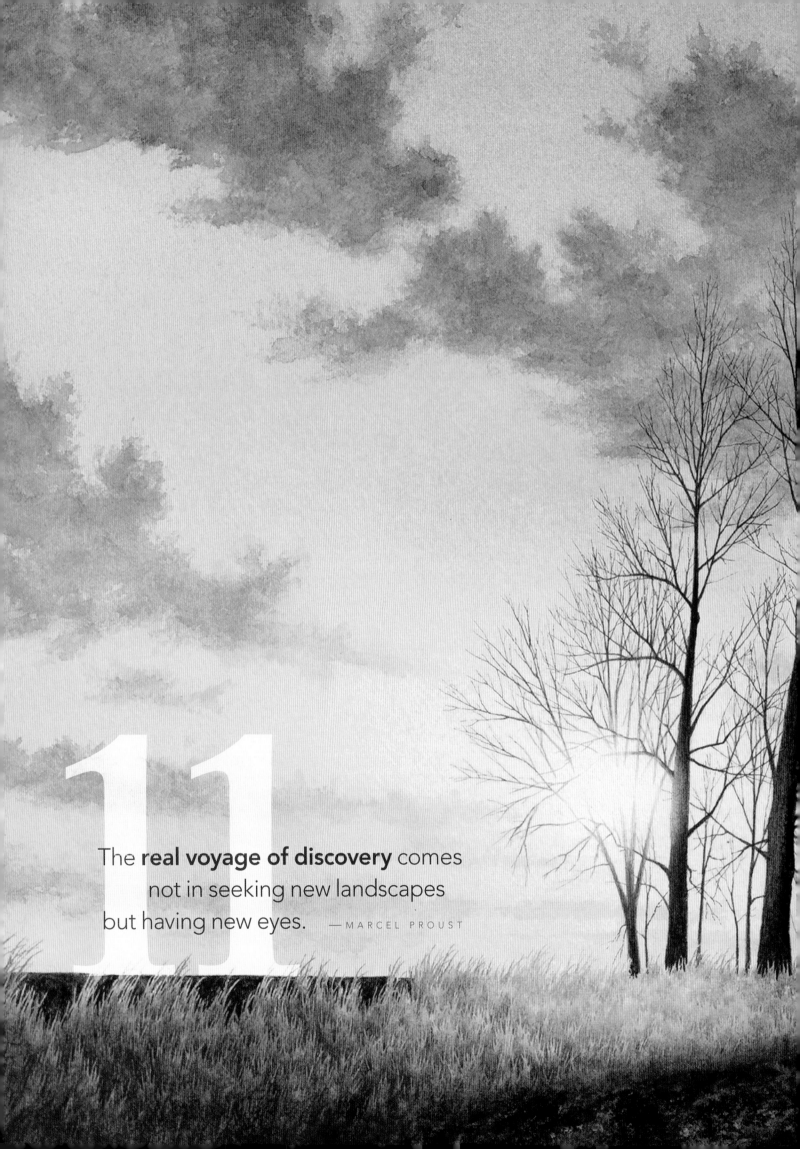

11

The **real voyage of discovery** comes not in seeking new landscapes but having new eyes. —MARCEL PROUST

fw media

Other fine North Light books are avail-
able from your local bookstore, art
supply store or online supplier. Visit
our website at **www.fwmedia.com**.

14 13 12 11 10 5 4 3 2 1

DISTRIBUTED IN CANADA
BY FRASER DIRECT
100 Armstrong Avenue, Georgetown, ON,
Canada L7G 5S4 | Tel: (905) 877-4411

DISTRIBUTED IN THE U.K. AND
EUROPE BY DAVID & CHARLES
Brunel House, Newton Abbot, Devon,
TQ12 4PU, England | Tel: (+44) 1626
323200, Fax: (+44) 1626 323319 | Email:
postmaster@davidandcharles.co.uk

DISTRIBUTED IN AUSTRALIA
BY CAPRICORN LINK
P.O. Box 704, S. Windsor NSW, 2756
Australia | Tel: (02) 4577-3555

Library of Congress Cataloging in
Publication Data is available from the
publisher upon request.

DURAND DUSK | Tom Linden
Transparent watercolor on 140-lb. (300gsm) cold-pressed Arches
14" × 21" (36cm × 53cm)

My paintings had become stagnant and uninspiring. Inspiration came
during a winter sunset as the clouds veiled the sun. I captured the
moment with a quick watercolor study, which led me to more works,
including *Durand Dusk*.

IONIC CROWN | Anne Hudec
Transparent watercolor on 140-lb. (300gsm) cold-pressed paper
18" × 12½" (46cm × 32cm)

TERRACE IN BALI | Ong Kim Seng
Transparent watercolor on Arches | 71" × 50" (180cm × 127cm)

Metric Conversion Chart

TO CONVERT	TO	MULTIPLY BY
Inches	Centimeters	2.54
Centimeters	Inches	0.4
Feet	Centimeters	30.5
Centimeters	Feet	0.03
Yards	Meters	0.9
Meters	Yards	1.1

PRODUCTION EDITED BY **SARAH LAICHAS**
DESIGNED BY **JENNIFER HOFFMAN**
PRODUCTION COORDINATED BY **MARK GRIFFIN**

PHOTO OF RACHEL RUBIN WOLF BY DON LAMBERT

acknowledgments

Much gratitude and credit go to the editors, designers and staff at North Light Books who have done the detail work needed to make this into a beautiful finished book, including Jamie Markle, Pam Wissman, Mark Griffin and Marylyn Alexander. Special thanks to production editor Sarah Laichas and designer Jennifer Hoffman.

Big thanks also to all of you contributing artists! I was very impressed with how so many of you rose to the challenge of producing excellent digital art for us—even if it took a few tries! This is no small feat. But I am even more grateful for your sharing such intimate moments of your lives with us. It is always a pleasure to speak with so many of you. Watercolor painters are a special group of people with an unusual generosity of heart.

SOUL | Al Zerries
Transparent watercolor
28" × 42" (71cm × 107cm)

about the editor

Rachel Rubin Wolf is a freelance editor and artist. She had edited and written many fine art books for North Light Books, including *Watercolor Secrets*; the *Splash: The Best of Watercolor* series; the *Strokes of Genius: Best of Drawing* series; *The Best of Wildlife Art* (editions 1 and 2); *The Best of Portrait Painting*; *Best of Flower Painting 2*; *The Acrylic Painter's Book of Styles and Techniques*; *Painting Ships, Shores and the Sea*; and *Painting the Many Moods of Light*. She also has acquired numerous fine art book projects for North Light Books and has contributed to magazines such as *Fine Art Connoisseur* and *Wildlife Art*.

A **new direction** opens the door,
but you must enter yourself.

— JUDY MORRIS

table of contents

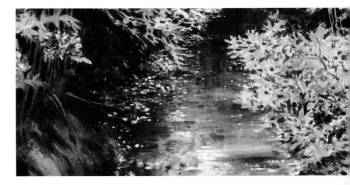
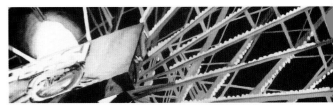
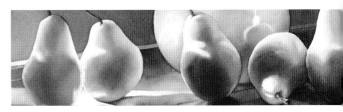

DAY OFF | Sandrine Pelissier
Watercolor, acrylic and watercolor pencil on watercolor paper
29" × 21" (74cm × 53cm)

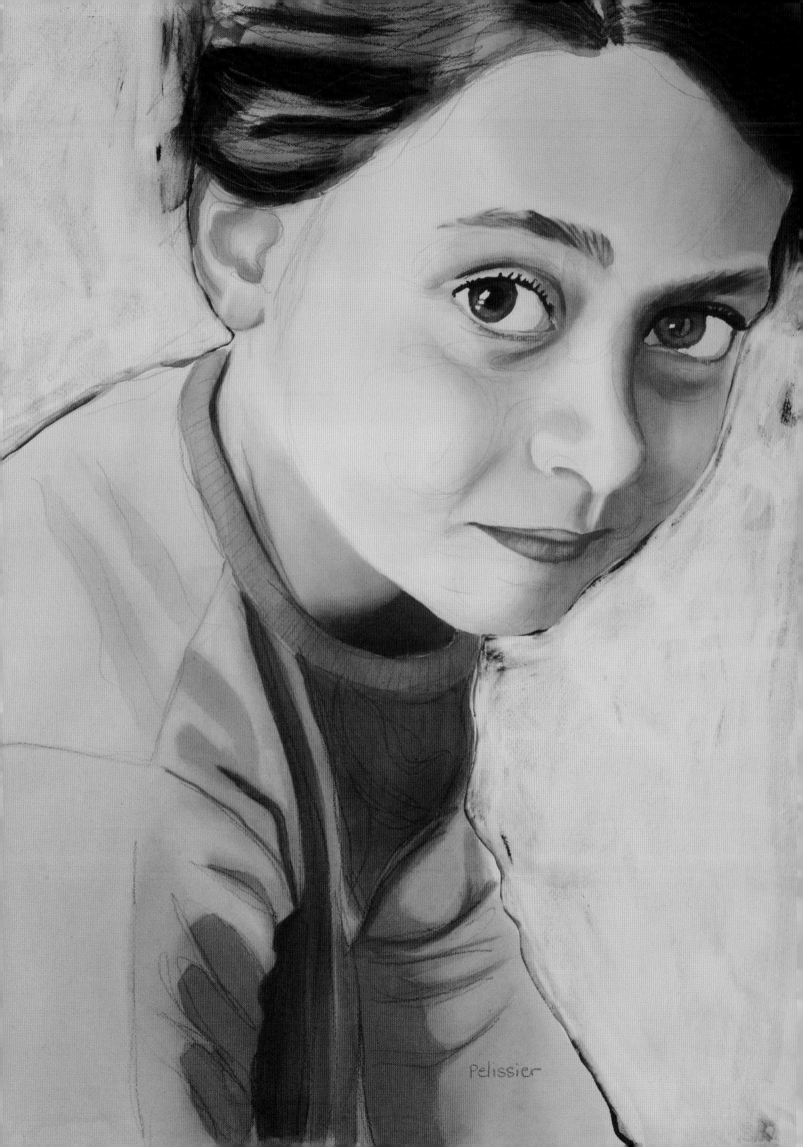

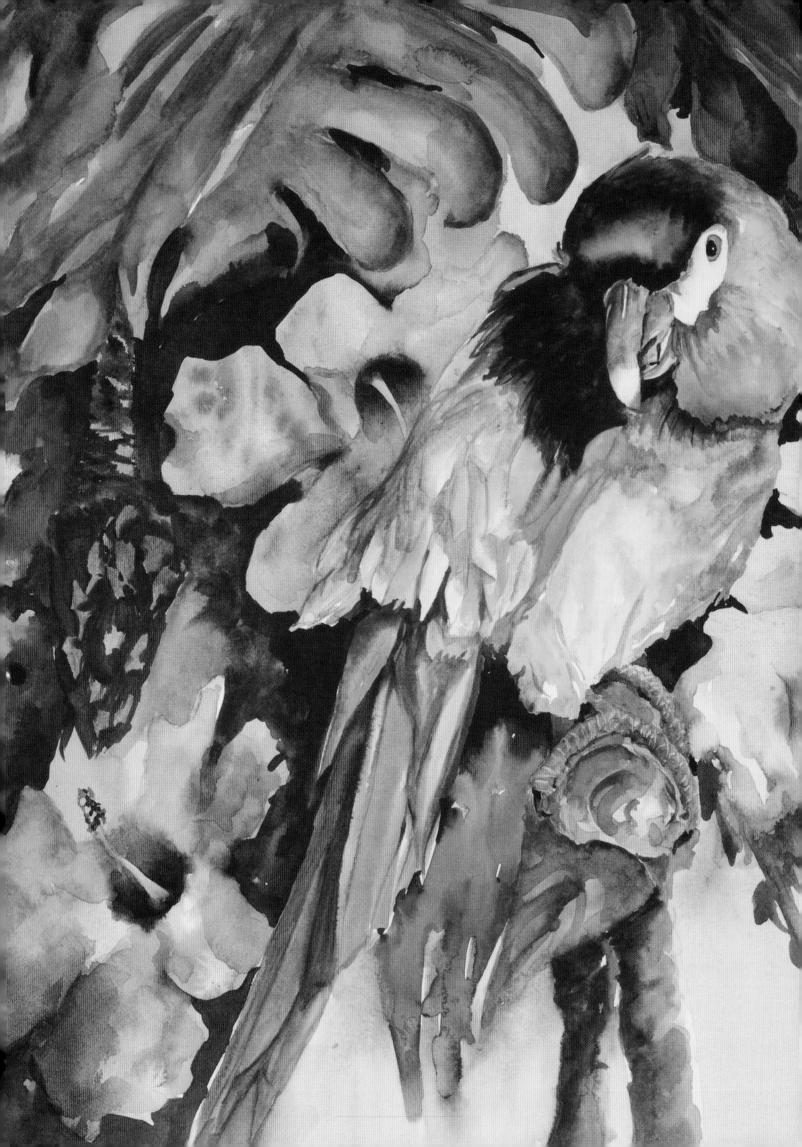

introduction

In the twenty years since the publication of *Splash 1* in January of 1991, *Splash* has become a central watercolor gathering place. Here we can share the never-ending wonder and delight of watercolor together. Here we can inspire and challenge one another to press on, not just in watercolor painting but in life—finding the joy, beauty and love present in our lives, no matter what unexpected or difficult twists and turns we find ourselves navigating.

And as with our lives, *Splash 11* is celebrating *new directions*. We recognize that we are in a new millennium, with new technology and new ideas coming at us from all corners of the globe. It is hard to keep up. Yet our new directions are solidly rooted in old, tried-and-true traditions of art and excellence. Many of the new directions the contributing artists generously share with us on these pages grow directly out of real events and stages in their lives.

Pamela Patton writes of painting geraniums from a photo taken in her father's garden, not knowing that this would be the last time she would see him. Paula Fiebich tells us how her first trip to Italy affected her life and her art in so many ways. David Stickel shares that his still life of Chinese tea cups includes symbolism revolving around his precious adopted Chinese daughter. Every one of us has many stories to tell, and watercolor painting helps us share these parts of ourselves, reminding us all that we are not alone, and we are always growing.

Splash 11 brings you some of our longtime favorite watercolorists along with quite a few new faces, never before seen in print. We have selected a few more artists from Asia, and we hope you agree with us that watercolor is a terrific medium for exploring new places, new painting techniques and new aspects of yourself!

Rachel

When in doubt, **add water**.
— VICKIE NELSON

TROPICAL TROUBLE | Vickie Nelson
Transparent watercolor on hot-pressed watercolor board | 18" × 18" (46cm × 46cm)

Living in gray, rainy Washington state, I vacation in Hawaii as often as possible. Having saturated my world with color for the last 25 years, my new direction is capturing light, regardless of the subject matter. Here I concentrate on the warm glow of tropical light on the bird. Painted directly and with glazing, the intense black shadow on the back of the bird was mixed by using the same reds and greens already in the painting, but with less water.

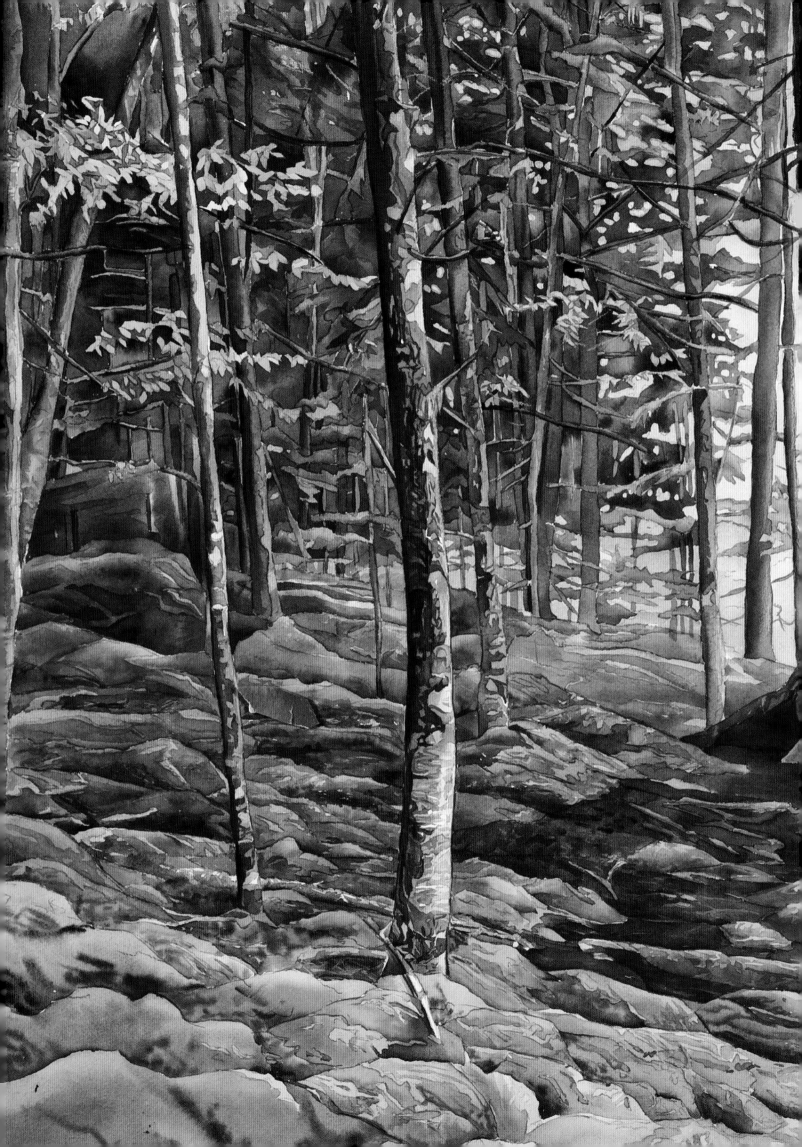

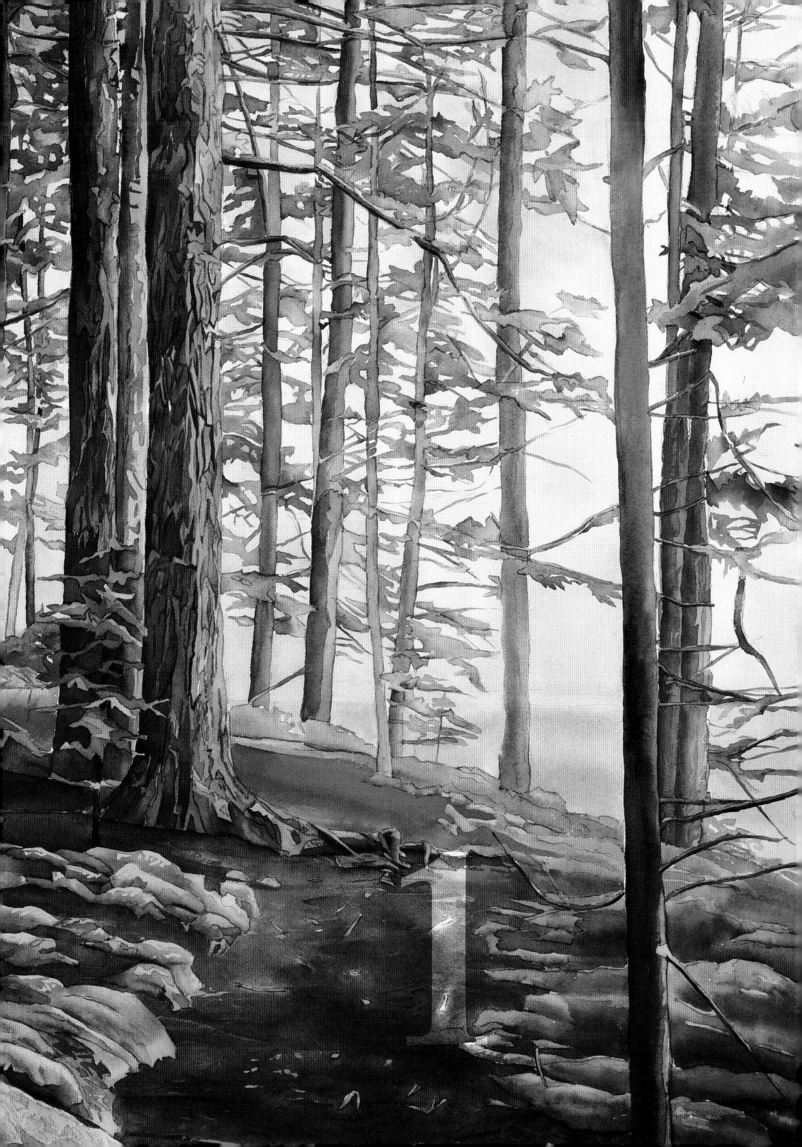

COASTAL FOREST IN SUN AND FOG | Marjorie Glick

Watercolor on 300-lb. (640gsm) Arches | 30" × 40" (76cm × 102cm)

1

While on a painting trip to coastal Maine, I found the forest enveloped in thick fog. Suddenly the fog began to lift to reveal the forest. This experience inspired me to focus my work on moments of transition that transform a scene into something completely new. It is at this edge where I now find what I want to paint. To create the contrast between the fog and the sunny foreground, I used semiopaque watercolors for the fog and transparent staining ones for the foreground.

Natural World

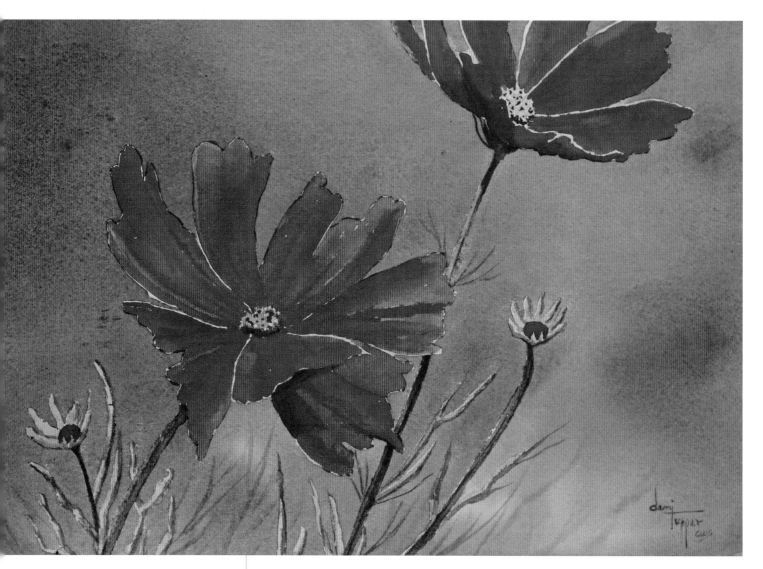

RED COSMOS | Dani Tupper

Transparent watercolor on 140-lb. (300gsm) cold-pressed Arches | 10" × 14" (25cm × 36cm)

In a workshop with Jean Grastorf, I fell in love with the transparency and beautiful blending you get when you pour on the paint. While I still paint and teach many different watercolor techniques, pouring has become one of my favorites. I started *Red Cosmos* by masking the flowers and stems. Then I poured the background using only the three primary colors. After removing the masking fluid, I painted the cosmos.

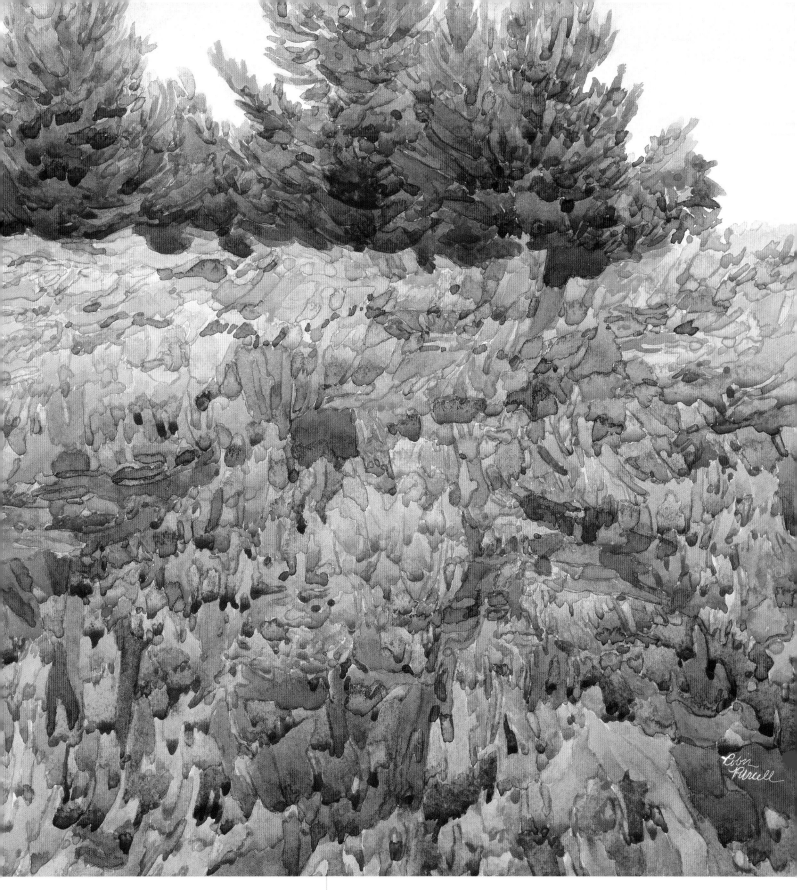

To grow as an artist,
you must get out of
your comfort zone.
Be adventurous.

— DANI TUPPER

A TANGLED PLACE | Robin Purcell

Watercolor on Arches | 14" × 14" (36cm × 36cm)

I like to find a balance between realism and abstraction. Usually I paint panoramas and avoid foregrounds because I find them difficult to simplify. I decided to challenge myself and compose a series of paintings with the foreground as the main part of the painting. My goal with *A Tangled Place* was to have one's eye meander up the tightly controlled values of the stylized meadow to the mass of three trees dancing at the top.

13

Watercolor on 140-lb. (300gsm) cold-pressed Arches | 13" × 30" (33cm × 76cm)

Old photos of two different views of the Grand Canyon's North Rim inspired this painting. I mostly paint flowers and previously felt that the Grand Canyon was too difficult to paint. But there were certain competitions I wanted to enter, so I needed to take on more challenging subjects like this. After finishing this painting, I now take on different subjects and ideas with a new attitude. What is holding you back from completing the painting you think you can't paint?

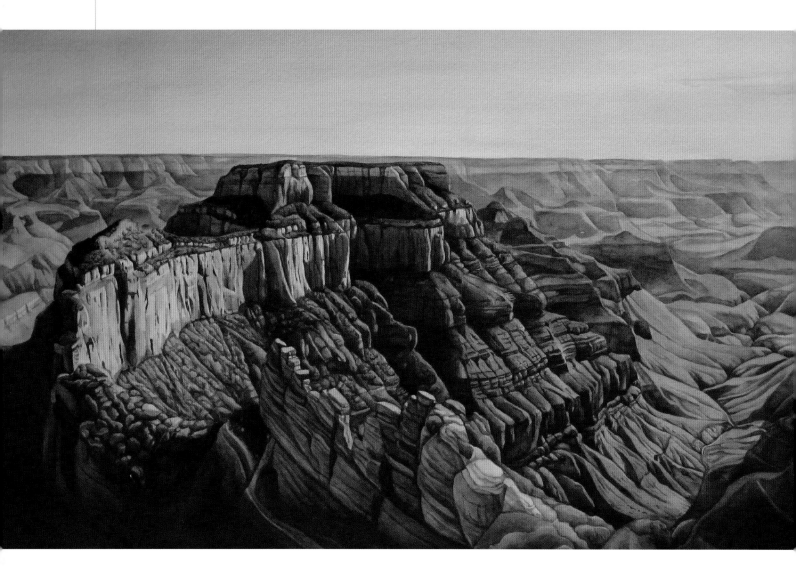

WALK TO THE WHITE HOUSE | Robert Highsmith
Transparent watercolor on 300-lb. (640gsm) Arches | 30" × 22" (76cm × 56cm)

The inspiration for this painting came from a visit to one of my favorite national parks, Canyon de Chelly National Monument in Arizona. The new directions theme is very fitting because I recently moved back to New Mexico, where I grew up. For more than thirty-five years I had been painting on the East Coast in the U.S.—Connecticut, Maine, South Carolina and Florida. The regions are all so different, but I believe a painter brings his entire life with him in all he paints. I've had lots of struggles in the transition from countryside to canyons, but I am enjoying the challenge.

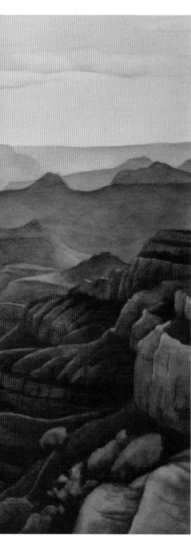

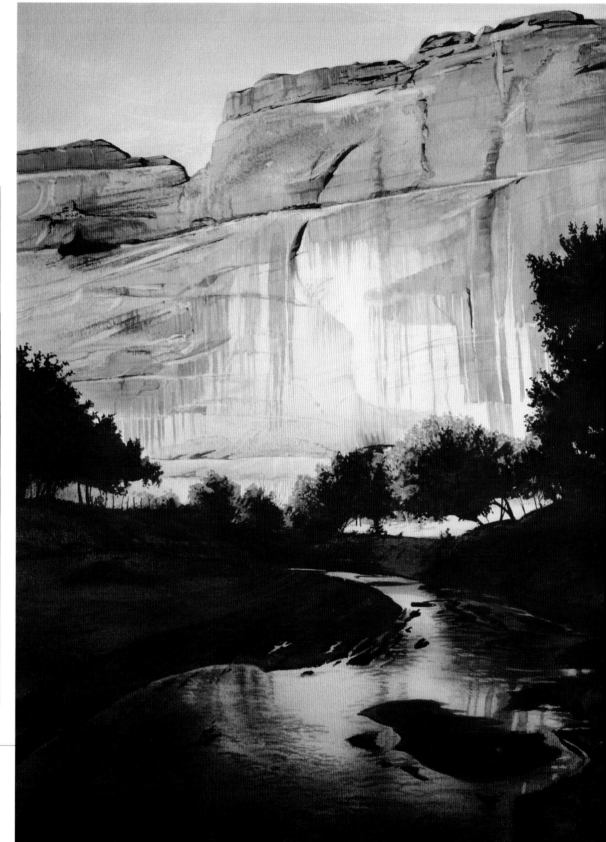

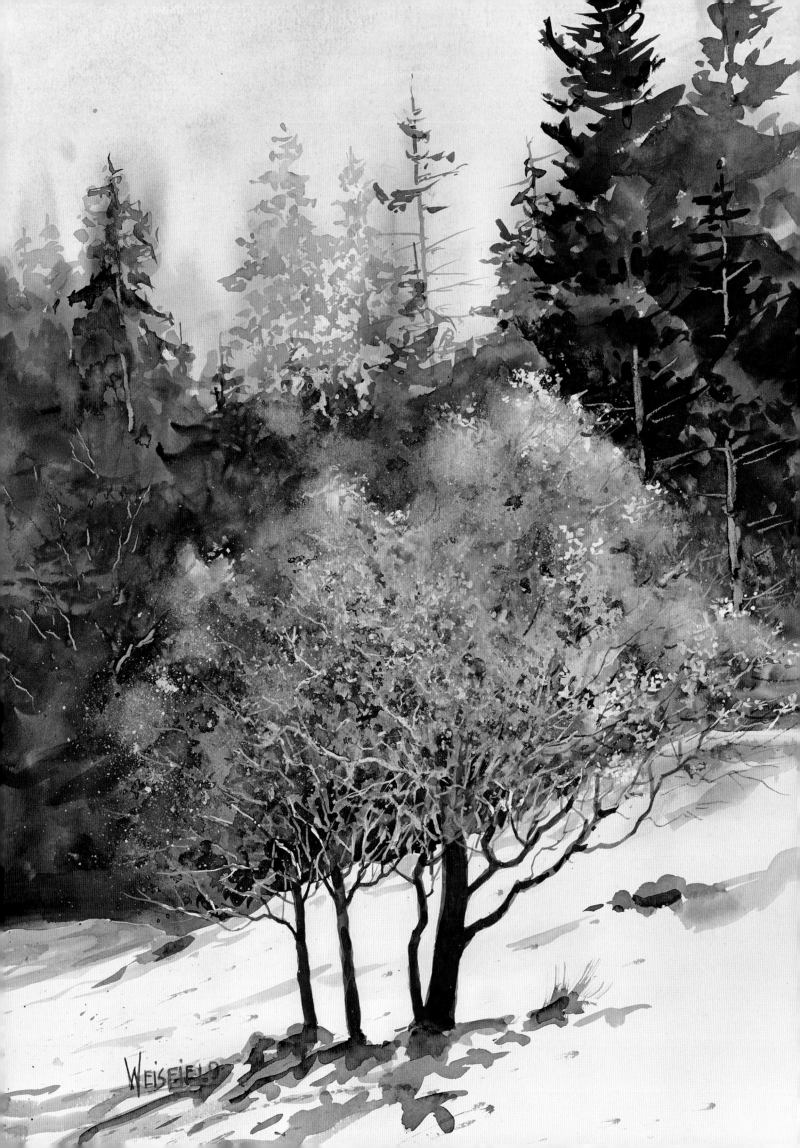

LUMINOSITY | Kathy Gagnon

Transparent watercolor on cold-pressed Arches | 22" × 30" (56cm × 76cm)

I take digital photos to capture the drama created by backlighting on flower petals. My artwork took a new direction when I began filling the entire paper with my drawing, touching the edges at a different point on each side. I make the negative space different at each corner. The more variety I can create in this way, the stronger the design, and as a bonus, I have less background to deal with! I paint the flowers with transparent pigments, leaving as much white paper as possible. When the subject is white, I enhance any reflected colors (or invent a few!).

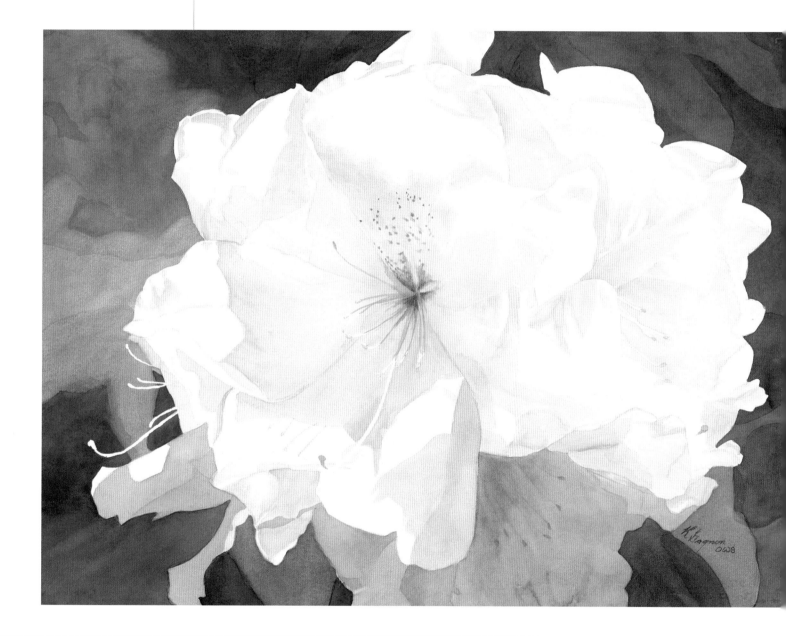

OAK STAND | Gayle Weisfield

Transparent watercolor on 140-lb. (300gsm) watercolor paper | 29" × 21" (74cm × 53cm)

Oak Stand, painted from my studio window, uses stark contrasts with rich darks and textures. A transparent wash of a primary triad is poured and splashed onto a saturated stretched paper. I tilt and rock the paper, letting the color mix to a luminous atmospheric glow. This becomes the *ha* of my painting. A kahuna taught me this Hawaiian word, which means "the breath of life." Discovering this new direction lets me see beyond my subject to find the emotional connection. My *ha* is the magical moment when time stops and skill, inspiration and emotion come together as art.

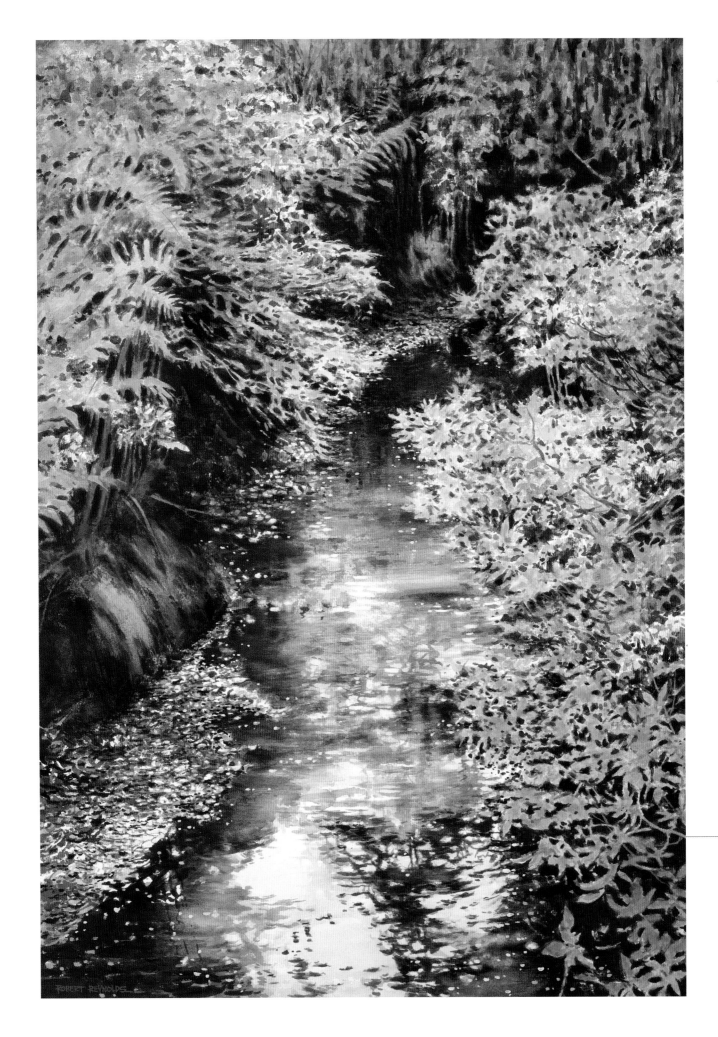

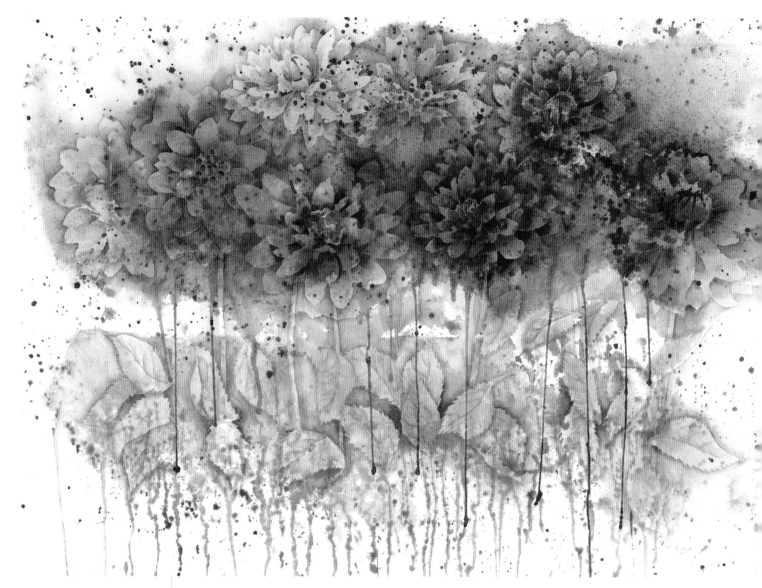

DAHLIA STEMS | Suzanne Hetzel
Transparent watercolor on 140-lb. (300gsm) paper | 22" × 30" (56cm × 76cm)

For me, everything that happens with transparent watercolor is a little miracle. After completing the realistic dahlia flowers, I held this painting up for examination. The Permanent Rose dripped! I decided to create lemonade from lemons by adding more drips. This approach complemented the stems, connected the flowers to the leaves, and gave the painting a more vertical composition. The freeness of the drips and splatters softened the intensity of the realism and allowed me to bring myself into the painting. There are only two colors in this painting: reds and greens straight out of the tube. I continue to use this approach in all my floral paintings; the drips and splatters feel like a relief after completing the realistic detail.

SECLUDED STREAM | Robert Reynolds
Transparent watercolor on rag paper | 38½" × 28" (98cm × 71cm)

It all started with wet-into-wet; loose and fast. That was the California School of Watercolor that ruled the way California watercolorists expressed themselves. As a young man, I was influenced by a number of the wet-into-wet master painters at the time, such as Rex Brandt. Over time, I realized what was missing for me was the use of substantial drawing skills, which suited me better than portraying the stylized characterizations of forms. I found myself moving away from the abbreviated look to a more in-depth vision.

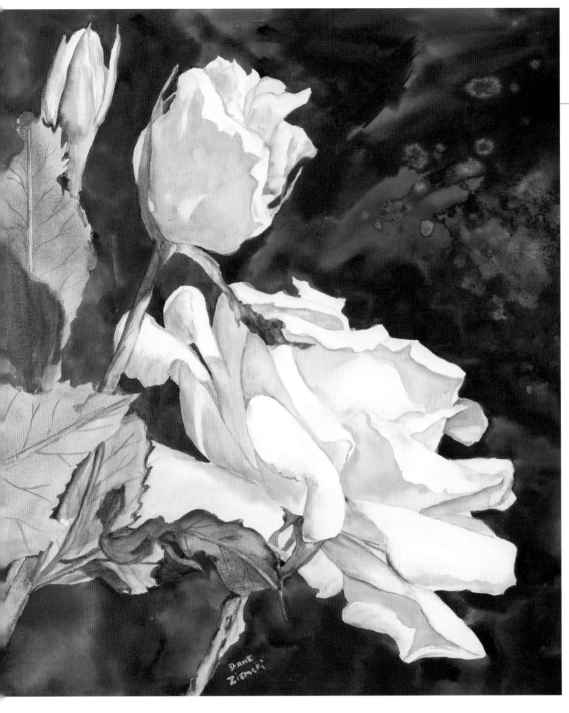

YELLOW ROSE AFTER TEXAS
Diane Williams Ziemski
Transparent watercolor on 140-lb. (300gsm) cold-pressed paper
18" × 18" (46cm × 46cm)

All of my paintings reflect the new direction my life has taken over the past ten years: a new city, new career, new marriage, then retirement in 2002 with my new hobby of watercolor painting leading to becoming an artist! This rose was blooming in my yard when I returned home after attending a reception for my first major exhibition. I felt that this flower was representative of me: the sun sparkling on the glorious warm yellows of the petals, the dark purples and turquoises depicting the past. This is the first painting in which I integrated a dark background and used complementary colors to strengthen the contrasts. I included all three stages of the bloom's life, not yet realizing that this is a biographical painting of my life. I painted with a traditional wet-on-dry application, which allowed colors to mingle on the paper.

OCTOBER GERANIUMS | Pamela K. Patton
Transparent watercolor on Aquabord | 12" × 16" (30cm × 41cm)

One beautiful fall morning, after taking pictures in our woods, I came upon my father watering his geraniums. We chatted, and I took pictures of him and his flowers. I watched the guarded pride of my rugged father as he was watering flowers instead of sitting in his usual position atop a tractor. This was the last time I would see him. He passed away in his sleep a few days later. I was left with a wonderful image of my father, content and still enjoying the pleasure of growing the things he planted. To portray the beauty of my father's garden, I used one of the photos and painted on Aquabord instead of the hot-pressed paper I normally use. I achieved rich deep colors on this new surface.

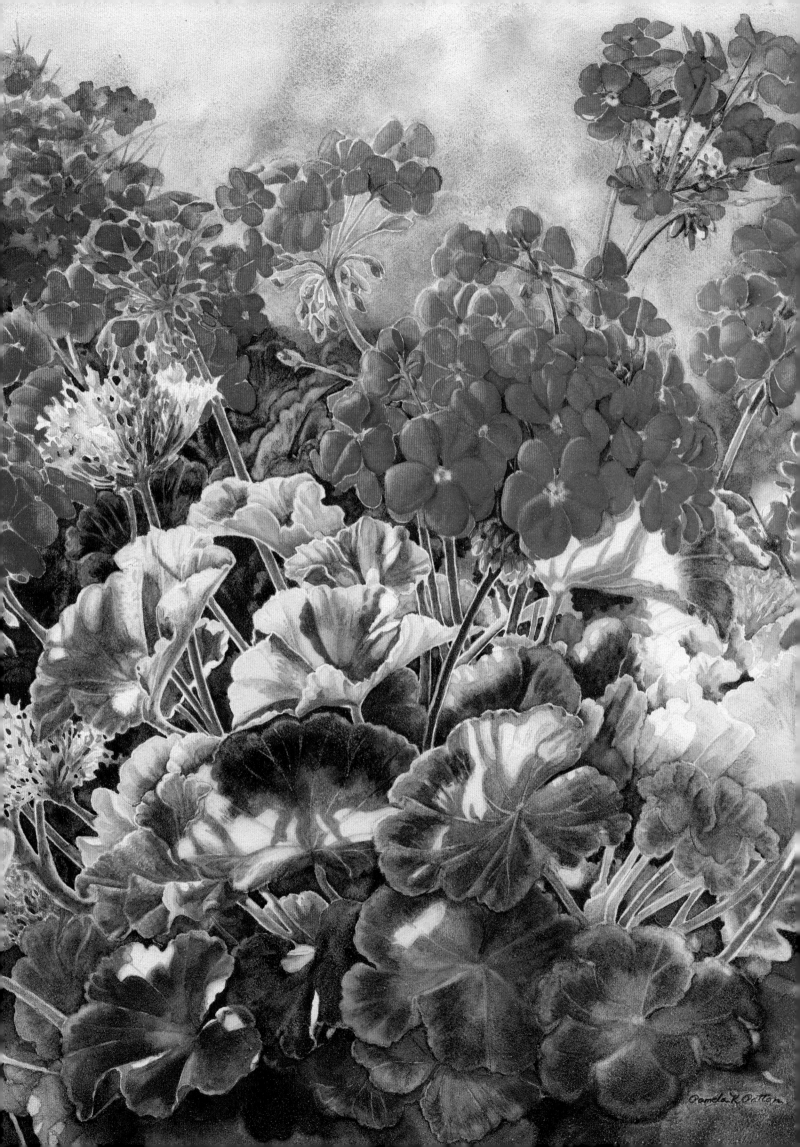

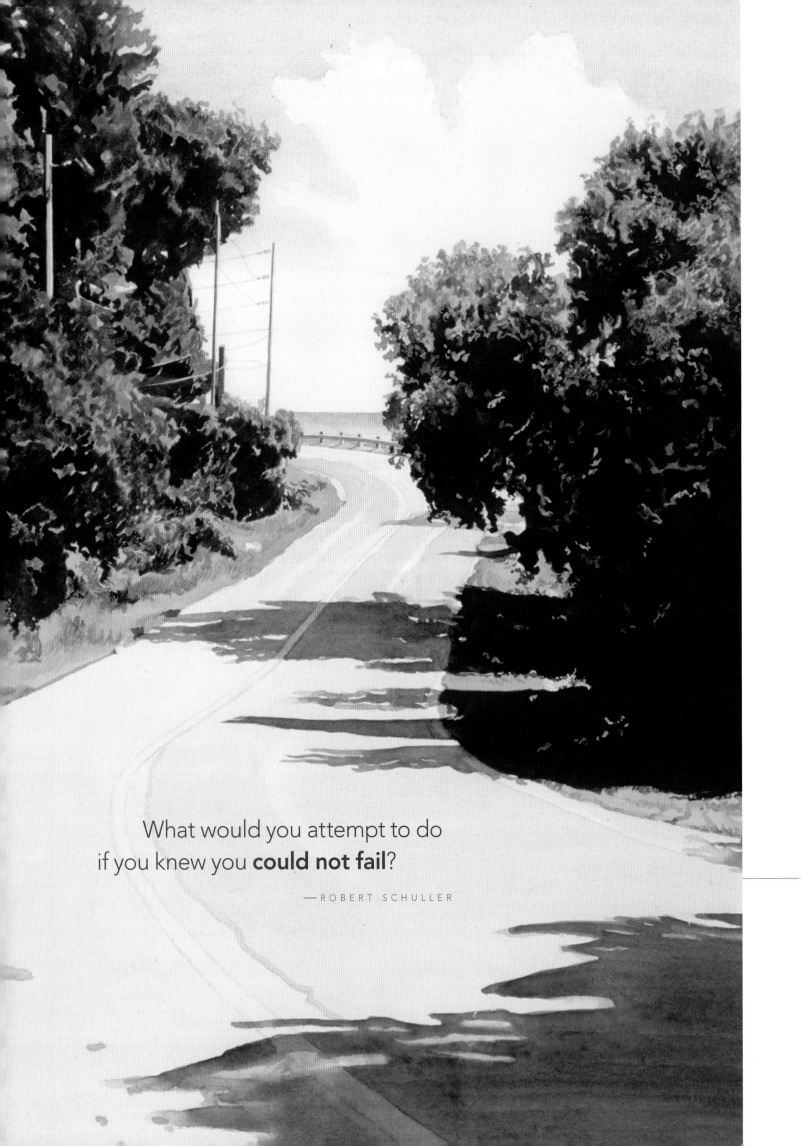

What would you attempt to do
if you knew you **could not fail**?

— ROBERT SCHULLER

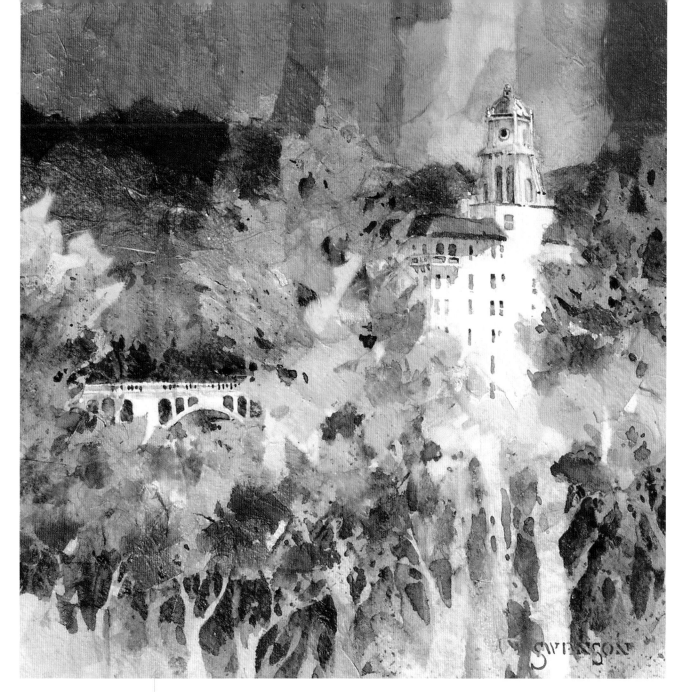

VISTA DEL ARROYO | Brenda Swenson
Watercolor on 300-lb. (640gsm) Japanese watercolor paper | 12" × 11" (30cm × 28cm)

I enjoy the energy of painting en plein air but have found it challenging to bring the same enthusiasm back into the studio. Discovering a new technique changed that. I stain Japanese papers with transparent watercolor, and then I use the papers to roughly block in the painting. Once the watercolor paper is completely covered with these colorful pieces of paper, I begin to paint. This approach has helped me to simplify the subject matter and focus more on design. The most exciting part is that it has brought energy and enthusiasm back into the studio!

BOND HEAD, NEWCASTLE | Linda Kooluris Dobbs
Watercolor | 28" × 18¾" (71cm × 48cm)

This is a departure for me. Unlike most of my works, which come from my travels to other countries, this is from my personal world. On our way to visit friends at their weekend home, just after we leave the highway, we climb a hill, and this glimpse of Lake Ontario appears. It reminds me of summers of my youth in Martha's Vineyard. I allow the viewer to imagine what is just beyond the turn in the road rather than filling in all the answers. I started with a technically-exact photograph as that is my other passion and profession. Color, composition and light matter to me. With good references, one can invent freely in the painting process. Without, one is handicapped.

POPPIES ON SILVERBELL ROAD | Ellen A. Fountain
Transparent watercolor on paper | 16" × 12" (41cm × 30cm)

A series of events starting in 2001 caused me to nearly stop painting altogether and then to re-examine my life. I felt I needed to reinvent myself for the years ahead, and that meant reinventing my art practice as well. I'd been a studio painter most of my professional life, focusing on still life and semi-abstracted Southwestern imagery. So in 2004, I stepped outside, figuratively and literally. Plein air painting was a totally new experience and a real challenge in our desert environment. I had to change the way I applied paint, my color palette, the size of my work—in short, everything. *Poppies on Silverbell Road* is a scene on a street I travel nearly every time I leave my house. In the spring the wildflower displays can be breathtaking.

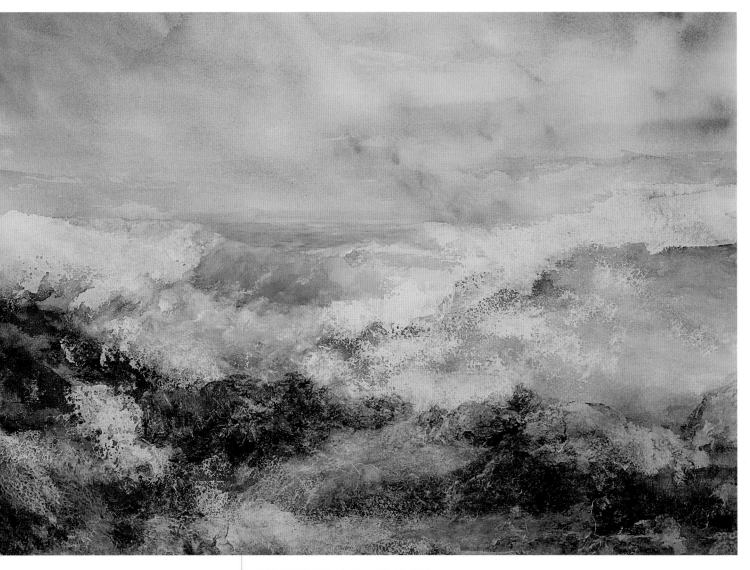

SURGING SEA | Mary "Mariska" Folks
Transparent watercolor with collage on 300-lb. (640gsm) Arches | 21" × 29½" (53cm × 75cm)

Pounding surf, thunderous waves and jewellike colors of the mighty Pacific! How can the primal forces of the sea and all this texture be created in a different way, without using salt or a palette knife or opaque white? What will not look contrived? Ah! Gerald Brommer's workshop on the use of Oriental rice paper—the perfect solution! My rice paper contained a variety of lines, which created textures in rock and water surfaces. The cascading water was created using a different paper, which caused a foam effect in the crashing waves. I like to let things happen on their own, but I am always adjusting shapes, colors and textures.

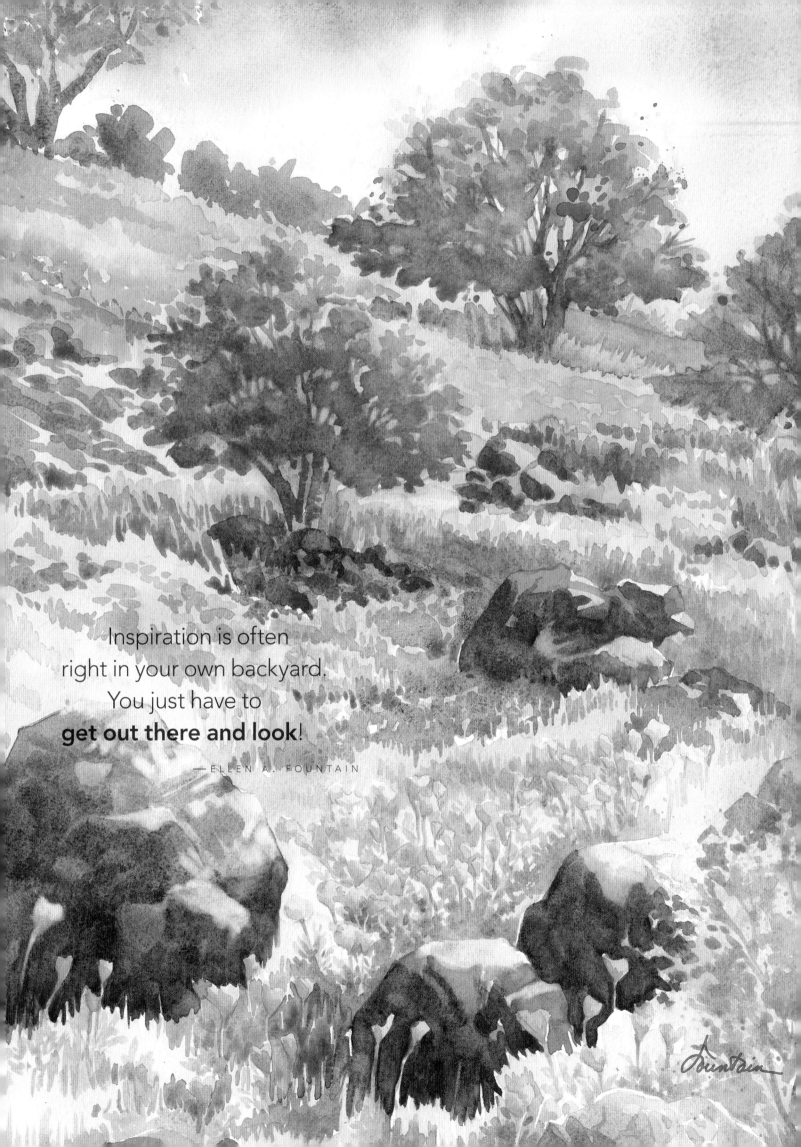

Inspiration is often
right in your own backyard.
You just have to
get out there and look!
—ELLEN A. FOUNTAIN

HAMPTON PALM LIGHTS | Jaimie Cordero
Watercolor on paper | 24" × 24" (61cm × 61cm)

A breathtaking glance at a palmetto leaf struck by the late afternoon sun inspired me to take a photograph. I later played with the photo to capture the essence of my experience. I then made a large drawing and transferred the image onto double elephant paper. This painting was the second one created from the same drawing. I masked out the white areas of the paper and freely poured and splashed colors, using transparent staining pigments. I then saved lighter painted areas with more masking fluid and generously glazed bright transparent pigments over the previous layer. Finally I added deep darks to express the breathless emotion I felt when I beheld this sight. By painting the same drawing several times in different ways, I free myself to experiment with different limited color palettes. *Hampton Palm Lights* took me on an exuberant new path completely around the color wheel—certainly a change in direction for me! As scary as such an experiment seems, I find the more I paint with abandon, the more wonderful the results!

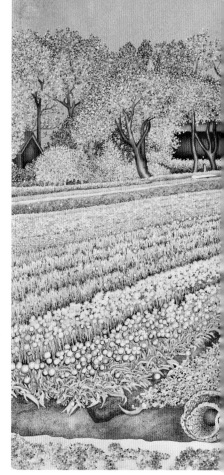

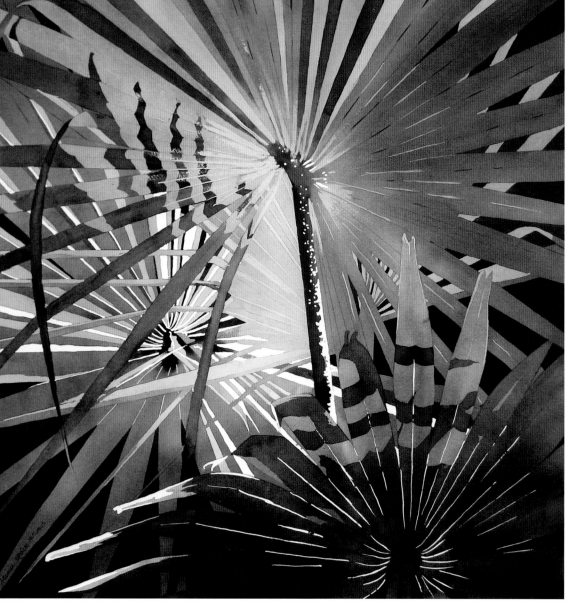

I give you
permission to
make a mess!

— JAIMIE CORDERO
ADVICE TO HER STUDENTS

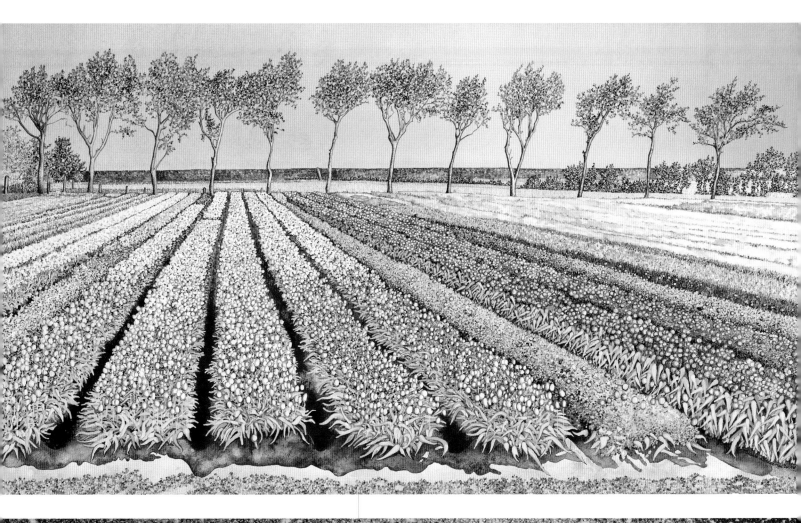

It doesn't matter how you get to the end of your painting, so long as you get there.

—WALDO E. JOHNSON
DICKENS'S HIGH SCHOOL ART TEACHER

TULIPS AT DAWN WITH BEADS | Missie Dickens
Transparent watercolor with gouache, acrylic and water-soluble oil on Arches accented with silk, lace and multicolored glass beads | 30" × 48" (76cm × 122cm)

My dream was to paint the tulip fields of Holland. After taking photographs in Amsterdam, I fulfilled that dream and completed my painting—or so I thought. The painting called for "still more." Hanging in my home was an intricate quilt full of colors, textures and laces made by my great-grandmother. That inspired me to experiment with something new. Mounting lace to silk, I excitedly sewed colored beads graded from pinks to dark purples to echo the dawn sky of my painting. Honoring other artistic ancestors, I have created many more watercolor paintings embellished with little treasures. *Tulips at Dawn with Beads* was the first in my new direction.

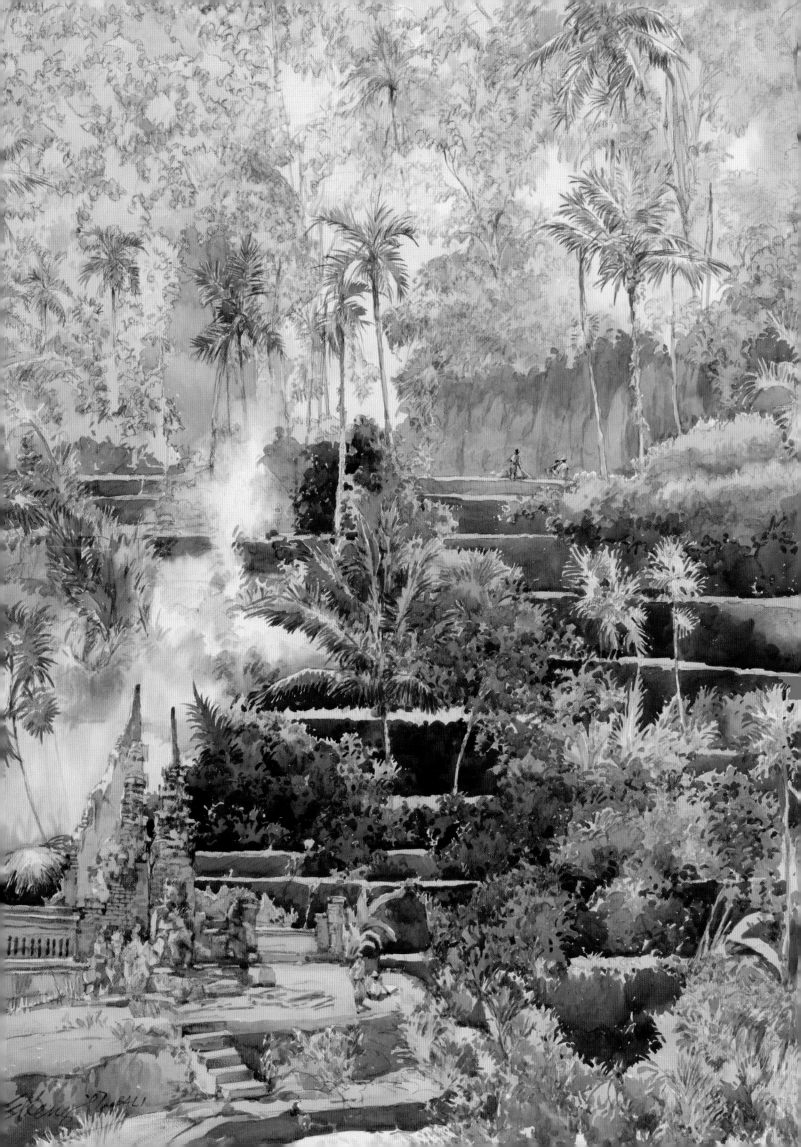

Some say you need to really know a subject in order to paint it. But I am also eager to experience a new place and note my first impressions. Recently we traveled to the Netherlands, the place of my wife's ancestry. I expected to see windmills, of course, but I never imagined they would have the visual impact that ultimately captivated me. Holland's broad countryside is very flat with only trees and farm buildings to break the horizon. This makes the windmills stand out majestically against the big skies. The images of their towering wings stretching wide against the magnificent sunsets, coupled with wide-angle foregrounds of flowing fields and winding waterways were etched deeply into my memory.

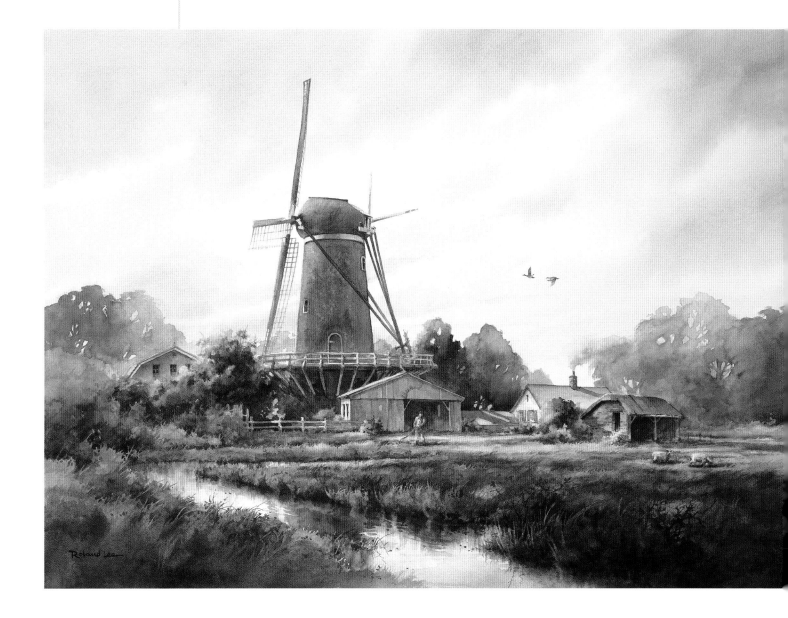

TERRACE IN BALI | Ong Kim Seng
Transparent watercolor on Arches | 71" × 50" (180cm × 127cm)

Bali's enchanting scenery is incomplete without the soul's connection to the landscape. In Bali a village is incomplete without a temple. A film crew was shooting my art practice for a televised art program, and I was scouting for a huge terraced landscape with a temple. I could not find one, so I "moved" one into this scene from a distance. This huge painting was a challenge, as there was the risk of creating a bland expanse of green. To differentiate the greenery, I varied tonal values to the rice terraces and worked at a fast speed, intermixing different shades of green with translucent orange, siennas and blues.

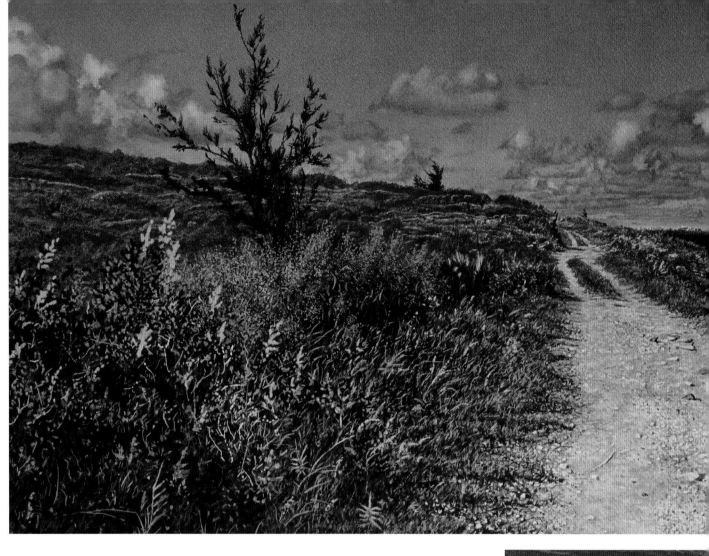

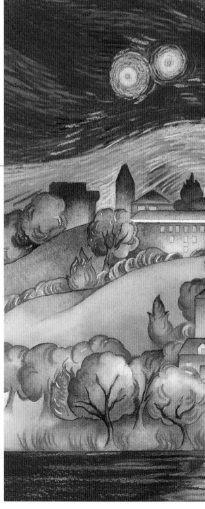

FAR ABOVE CAYUGA'S WATERS | Cheryl Chalmers
Watercolor with pastel on cold-pressed Arches | 15" × 30" (38cm × 76cm)

By painting this homage to Vincent van Gogh, I explored a new mixed-media technique, combining abstraction with realism. This new direction grew well beyond my initial idea. I first constructed tight sketches from photographs, highlighting the elements of the city—the university on the hill and the boathouse along the canal. I discovered a new color palette, with washes of Ultramarine Blue and Burnt Sienna, while simplifying the details. I was striving for a whimsical, creative interpretation, having fun with the broad strokes of pastel, which gave a textural, more color-saturated look.

FERRY REACH, BERMUDA | James Toogood
Watercolor on 140-lb. (300gsm) cold-pressed paper | 12" × 21¾" (30cm × 55cm)

This was done in the studio from a series of sketches and photographs. This North Shore scene is one of the few remaining unspoiled locations on the island; it's a quiet, lonely kind of place. I used the cloud formations to create a sense of deep space and connect the foreground to the Royal Naval Dock Yard in the distance. After developing and masking the clouds, I applied several washes of Cerulean Blue and Cobalt Blue to the sky. Cerulean Blue varies little in its appearance from its undertone to its mass tone and is easily scrubbed. Therefore, I could both lift and fuse color along the cloud edges to soften them. I used pure Cerulean to paint the breaks in the clouds.

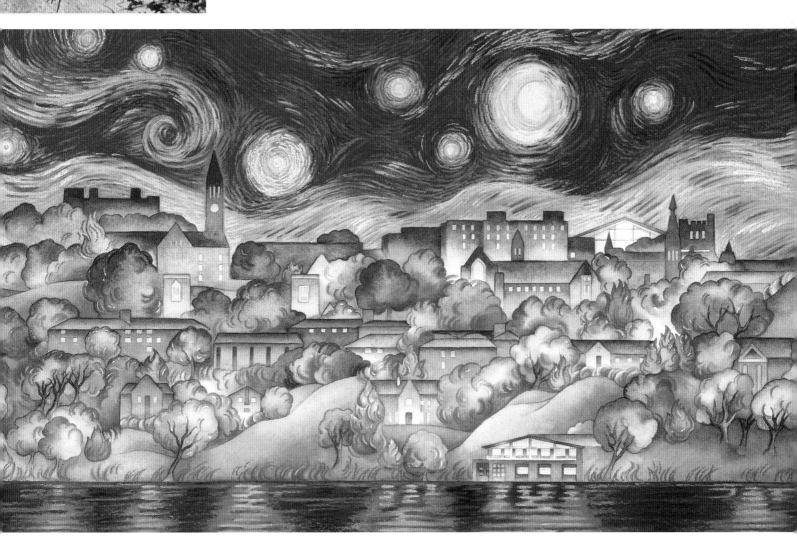

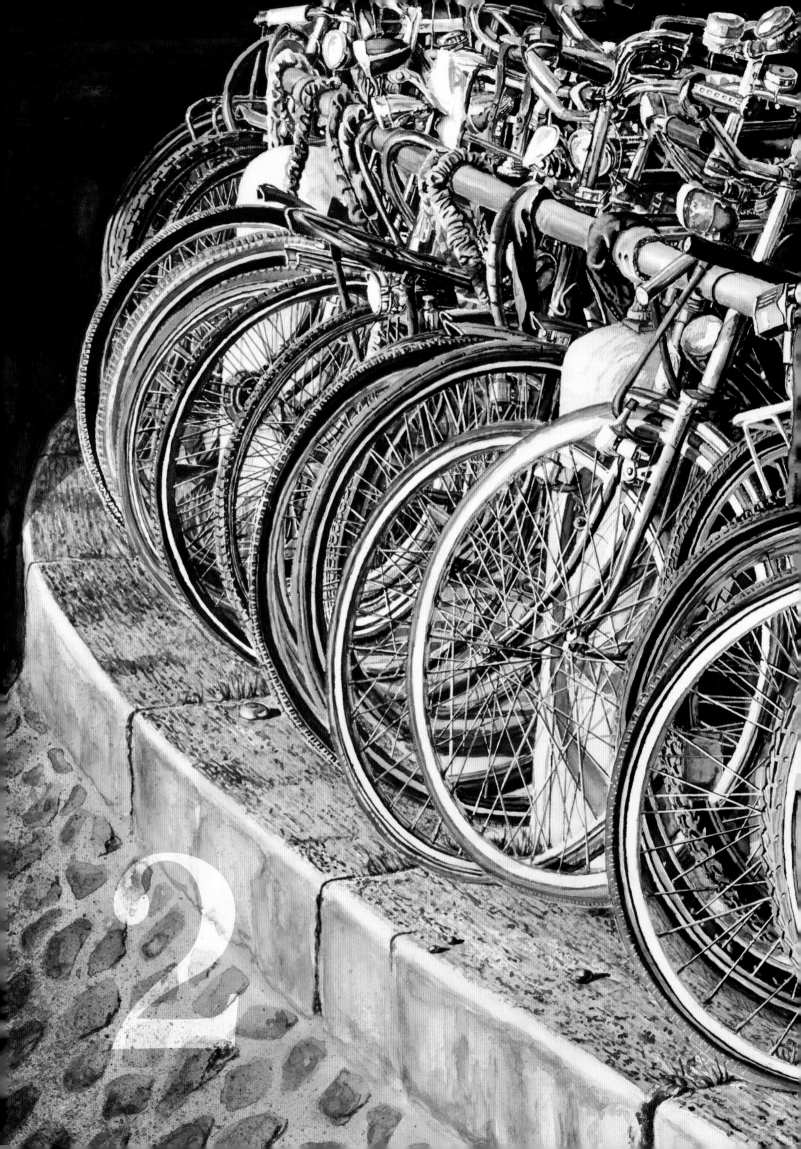

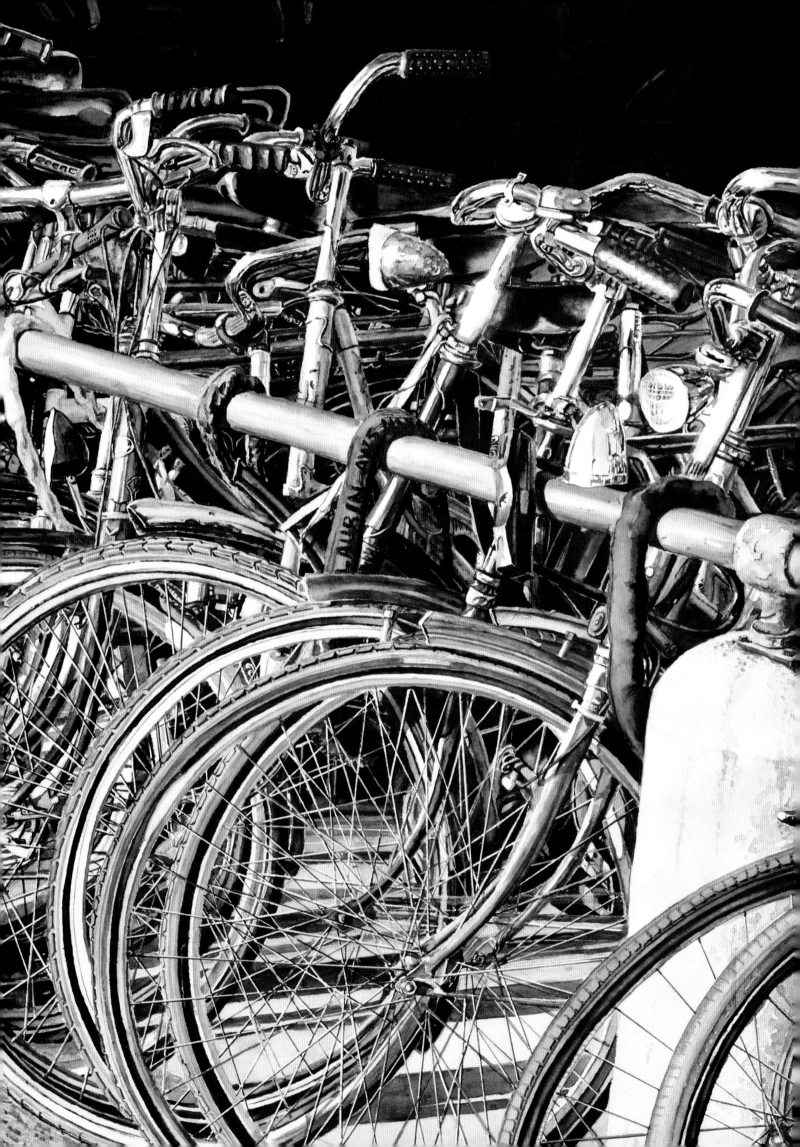

BICYCLES—AMSTERDAM | Laurin McCracken

Transparent watercolor | 20" × 27" (51cm × 69cm)

2

I have been referred to as a photo-realist, which I had not strived to be until this painting. The reference photo was taken one afternoon as I was returning from a day trip to Aachen, Germany, to view a fabulous collection of paintings by the Dutch painter Willem Kalf, one of my heroes. I thought there might be an opportunity for an extreme realist painting, full of complex lines and curves—like life, taking us in so many directions. The execution of the spokes was crucial because if they were not exact, the whole impact of photo-realism would be lost. I finally figured out that I could mask the spokes using an old ruling pen with diluted masking fluid. This allowed me to paint the background behind the spokes. I then used the ruling pen to make the shadows under the individual spokes.

Things We Make

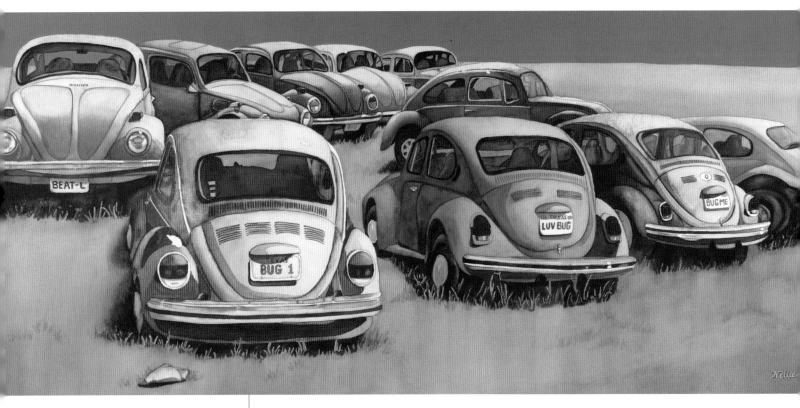

DEAD BUGS | Nellie Kieke Kress

Watercolor with acrylic on 140-lb. (300gsm) cold-pressed Arches | 15" × 34" (38cm × 86cm)

Dead Bugs was painted using three different photos from one site, a field of old Volkswagens. The photos were enlarged and reduced on a copy machine and cut out with scissors and rearranged until I had an interesting composition. I simplified the field and sky to focus attention on the cars. I chose to paint all of the cars in cool colors except the hot pink one, so it could act as a focal point. I made up the words on the license plates for added humor.

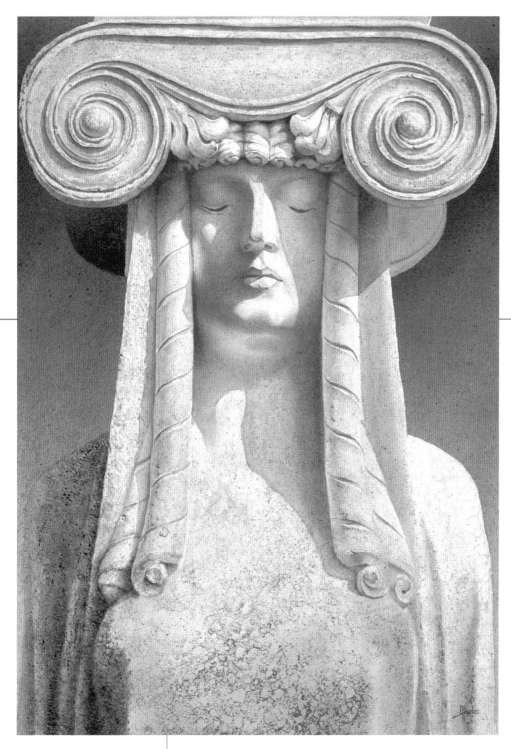

Never confine yourself to preconceived limitations. Be willing to break your own rules and chart new directions… to **trust your instincts**.

— ANNE HUDEC

IONIC CROWN | Anne Hudec
Transparent watercolor on 140-lb. (300gsm) cold-pressed paper | 18" × 12½" (46cm × 32cm)

Ionic Crown led me in two new directions. Unlike my previous work, in which I followed my photographic references closely all the way through, this time I abandoned that approach once I had established my foundation. Following my instincts permitted me the freedom to rely on my experience and to enhance or modify elements to support my vision. The second change in direction was the departure from relying solely on my brush. While the first half of the painting was laid down with brushes to develop the form, the remainder was executed by other methods such as spattering and stamping—even in the deepest shadows. The entire process was incredibly exciting, inspiring and liberating!

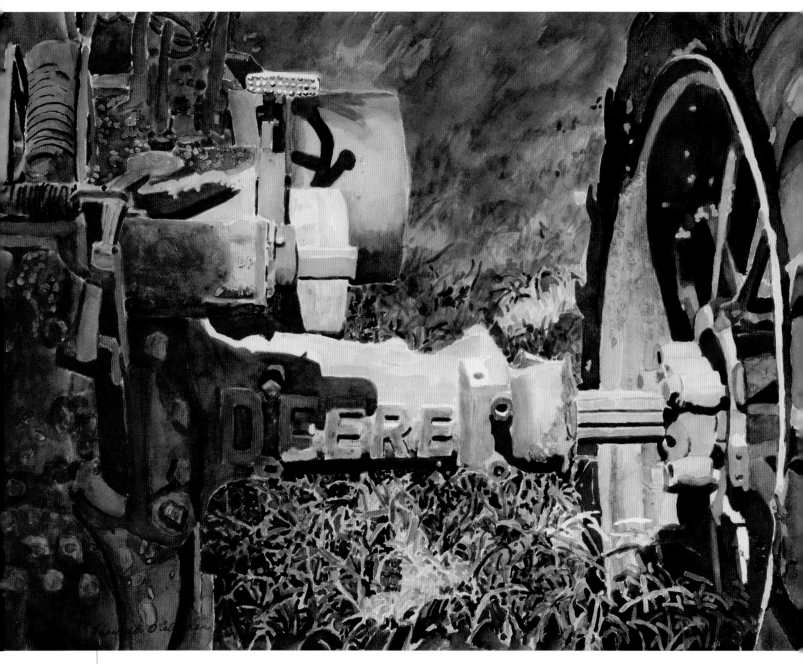

THERE'S A DEER(E) IN THE PASTURE | Frances Briscoe O'Callaghan
Transparent watercolor with gouache and Aquapasto on cold-pressed Arches | 21½" × 28½" (55cm × 72cm)

Light and Shadows and *There's a Deer(e) in the Pasture* use industrial and agricultural artifacts to reveal the beauty in the interstices found among the tools of life. Light and nature expand and change to fill the space left to them. Working from photographs of machines, with their intricate geometric patterns and their omnipresence in our world, allows me to explore these fluid contrasts and confront new design options for my art. Both paintings called for extensive glazing for the darks. Frisket was employed to protect the light patterns. Fluorescent gouache enhanced some of the highlights, and Aquapasto helped produce the look of grease and rust on metal.

LIGHT AND SHADOWS | Frances Briscoe O'Callaghan
Transparent watercolor with gouache on 140-lb. (300gsm) cold-pressed Arches | 28" × 19" (71cm × 48cm)

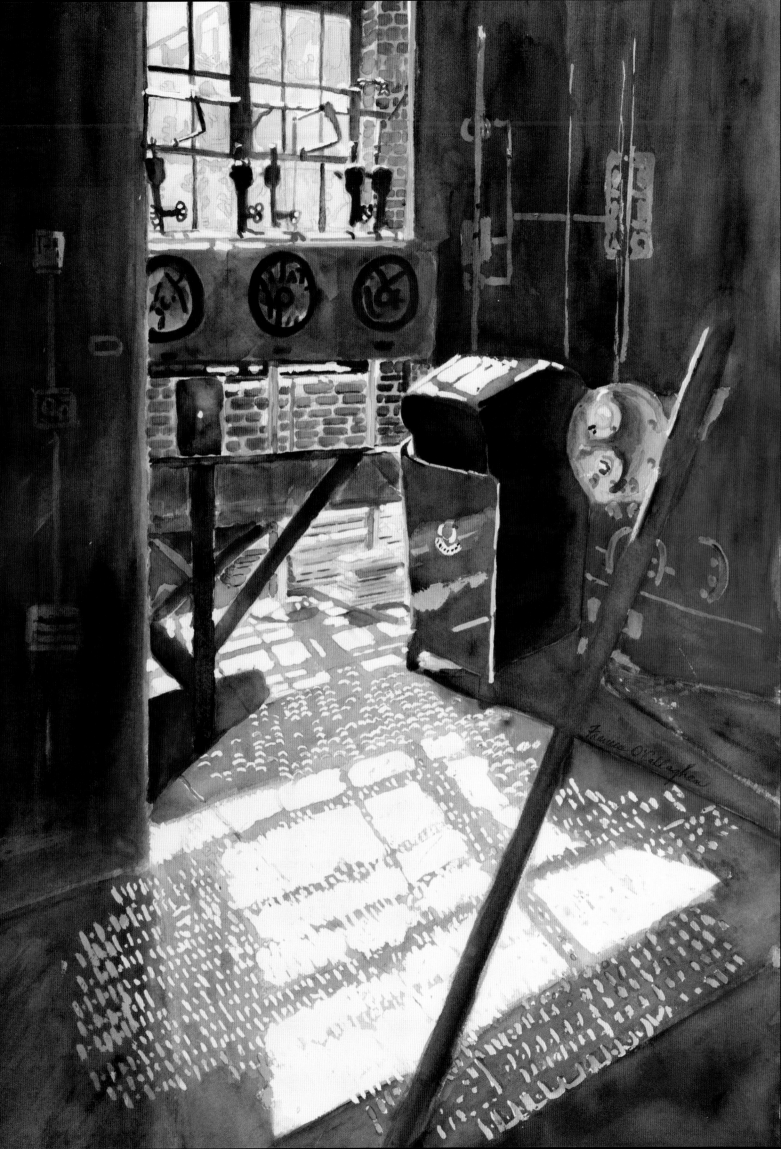

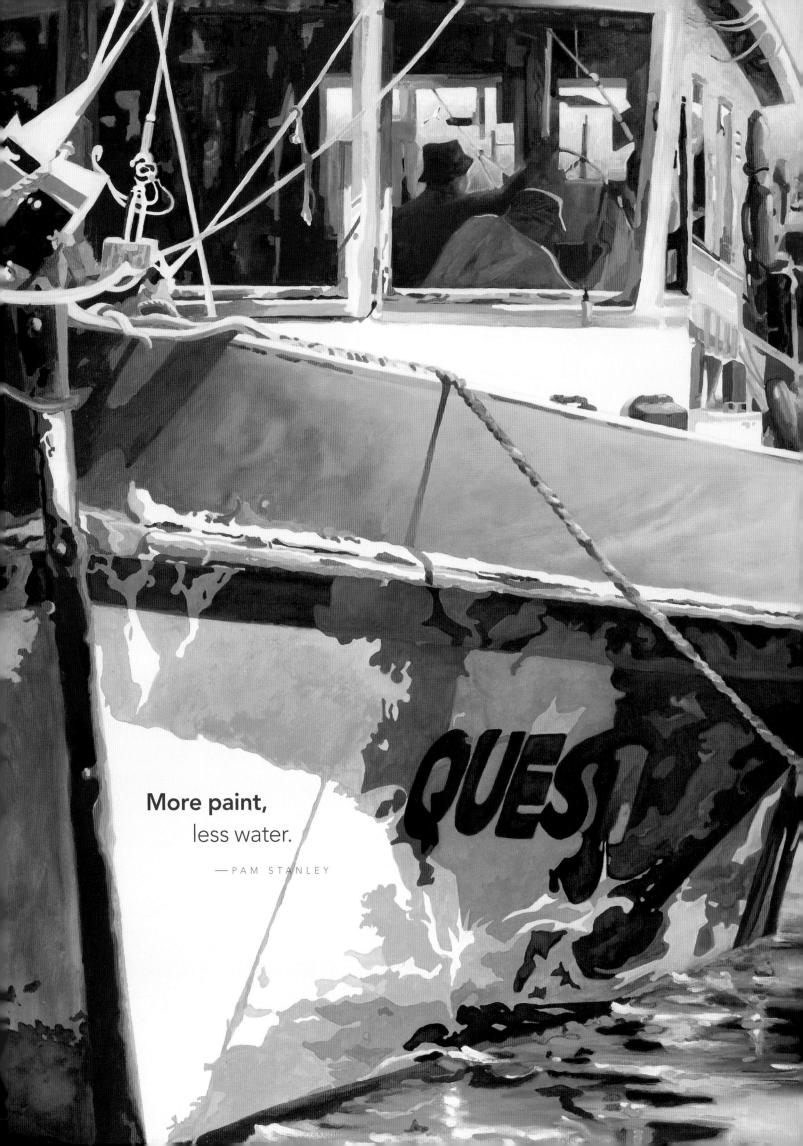

More paint, less water.

—PAM STANLEY

BLACK & WHITE & RODE ALL OVER | Terri Hill

Transparent watercolor on 140-lb. (300gsm) Arches | 26" × 40" (66cm × 102cm)

As part of a group exhibit called *Black and White and Red All Over*, I had to come up with a painting that spoke to the theme and was also based on a recent article from our local newspaper. This forced me to contemplate a lot more than just subject matter and design. I attended the local Tour of California bicycle race and found my image: black, white and red—and also rode! I was excited to paint all the circles, angles, reflections and shadows. My challenge was to create easy pathways for the eye without oversimplifying the complexity of the image. I wanted to keep as much information and rhythm as possible without creating a chaotic painting.

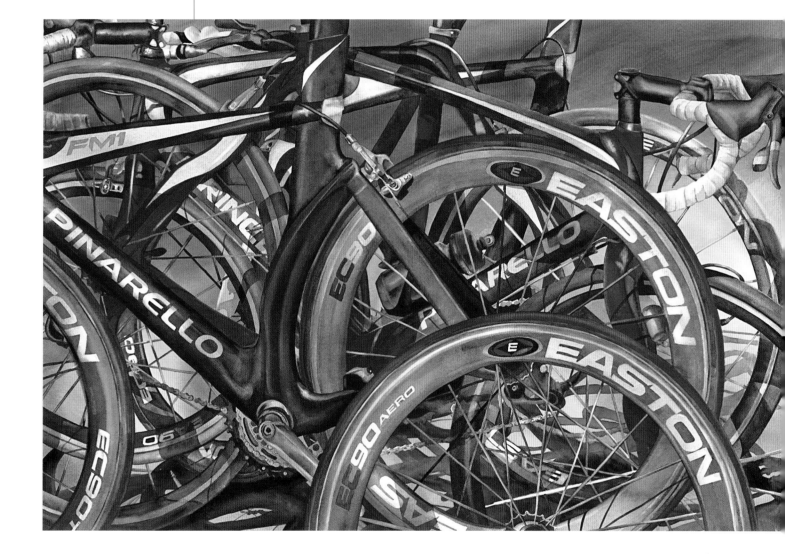

ALL ABOARD | Pam Stanley

Watercolor on 140-lb. (300gsm) cold-pressed paper | 21" × 29" (53cm × 74cm)

This coastal region is home to the bay shrimp boat. The marina is my favorite spot to visit with lunch, camera and hopes of discovering a crew gearing up to leave. Or perhaps a boat arriving with a successful day's catch and seagulls flying above. The majority of my paintings are quick, intuitive land or coastal scenes, done from memory using a limited palette. In contrast, the process for *All Aboard* required extensive planning. My objective was to design dramatic shapes of brilliant analogous colors, emphasize the water's reflecting light on the hull of the boat, and transform the gray window panes by adding life and activity to the interior.

Art is the truest reflection of its creator, and this is abundantly evident in my studio painting *Gdansk*. On a recent trip to Europe, I was entranced by the sights, sounds and ideas that filled the streets. I was able to see the world as a visitor with a fresh and imaginative perspective. This visitor point of view allowed me to take ordinary subjects and infuse them with the fascination I felt in their presence. Through color manipulation, a modification of atmosphere and a majestic point of view, I was able to express the inspiration I felt in the presence of history older than my own heritage. *Gdansk* is a step in a new and rewarding direction.

The **best artists** make the most mistakes. — ANDREW M. KISH III

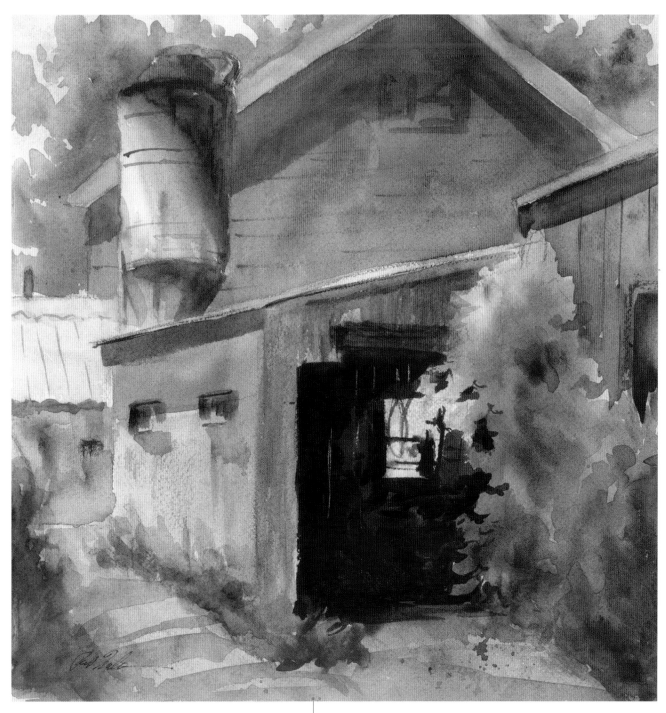

HUDSON VALLEY BARN | Pat Fiorello
Watercolor on paper | 12" × 12" (30cm × 30cm)

This plein air painting was outside my comfort zone in several ways. Rather than rushing to paint as soon as I got to the location, I took some time to really consider the subject and design more abstractly. I selected a square format, which was new for me. If I hadn't thought about it, I probably would have done a more predictable barn scene in a horizontal format. Based on a quick value sketch, I decided to exaggerate the dark interior of the barn with a bit of light shining through. As I painted, I pushed the color beyond what was actually there to capture the feeling of the hot summer afternoon. It was fun mixing the colors directly on the paper and allowing watercolor to do its magic.

I am **still learning**.

— M I C H E L A N G E L O
AT AGE 87

THE BIG TOP | Charles Sluga
Watercolor on 140-lb. (300gsm) rough Arches | 24" × 32" (61cm × 81cm)

The circus came to town and presented an opportunity to paint a real subject that would satisfy an abstract concept—the desire to paint yellow stripes. This concept had been simmering in my mind for at least a year. The challenge was to marry the abstract image with the real scene before me. My excitement as I photographed and sketched the circus was intense. I could not wait to get back to the studio to get started. Since yellow stripes were the inspiration for the painting, I filled much of the paper with the striped tent. It was crucial to give the stripes variety in color, value, edge and texture to make them visually interesting and avoid the "cut out and stuck on" look. I flicked and spattered paint onto the wet yellow stripes to create bleeds, runs and watermarks (blooms), all to achieve variety. The careful use of violet shadows enhanced the feel of light and the lovely wavelike form of the tent.

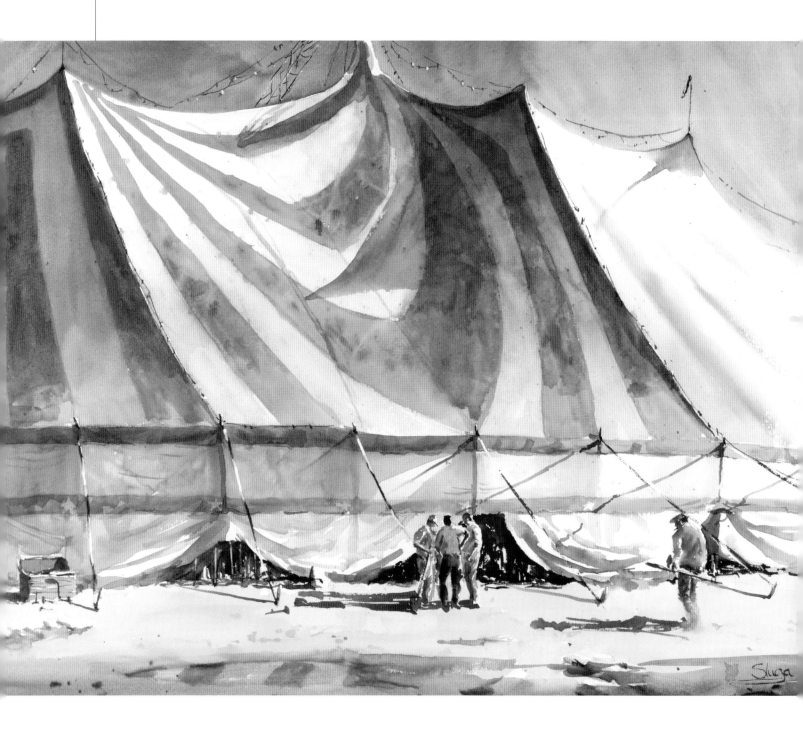

Forget about rules; take the risk to do anything that makes the painting work. —CHARLES SLUGA

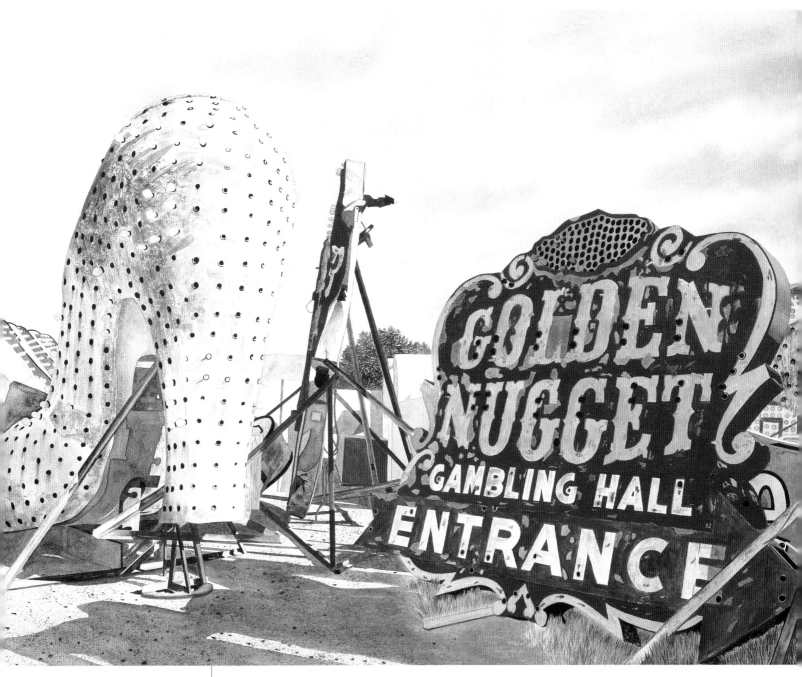

THE NEON BONEYARD | David Milton
Transparent watercolor on 300-lb. (640gsm) Arches | 22" × 30" (56cm × 76cm)

For decades I had sought an untapped, unique subject I could make my own. Imagine my excitement upon discovering this treasure trove of Las Vegas's past. My new direction in subject material was at hand, but this three-acre site was not open to the public. Research revealed that if I wrote a proposal to the board of directors stating my objective of doing watercolor paintings from my photography, I might be granted entry. The fee for taking photographs was $250 an hour by appointment only, rain or shine, no exceptions for artists, and no photographs can be sold ever, or they will sue for your firstborn. After agreeing to the terms, I was let into my version of heaven. I made the best of my time and have so far completed about a dozen paintings.

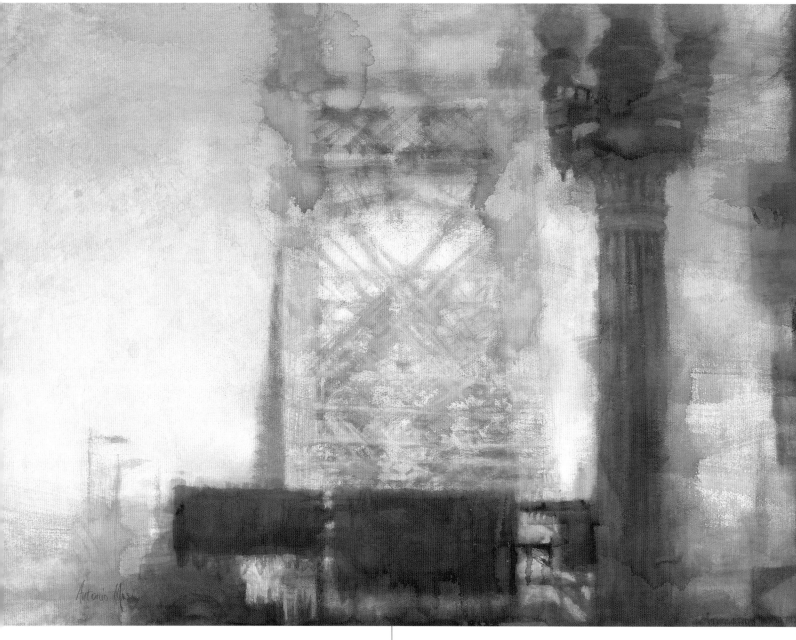

Without light,
there can be no art.

— ANTONIO MASI

59TH ST. MELODY | Antonio Masi
Transparent watercolor with body color on rough paper | 30" × 40" (76cm × 102cm)

This painting was done from on-site sketches, photographs and memory. My approach is direct and quick. I lay down thick brushstrokes followed by glazing. I am constantly striving for that elusive emotionality that captures a mood, an attitude or a distinct personal vision. In this painting I was struck by the flow of light into every form, from the simplicity of silhouettes to the intricate lacework of the steel girders. A golden, diffused light embraced all things. It was a magical moment: the paradox of delicacy and mass united into an extraordinary theme.

Transparent watercolor on 300-lb. (640gsm) Arches | 21" × 29" (53cm × 74cm)

With *Stuck at the Top*, I wanted to take my knowledge of still-life painting and apply it in a new direction and to a new subject matter. I tend to be a rather busy painter, so the goal here was to keep the glow and the light while eliminating anything else that I did not need. I did this with multiple glazes and then proceeded to lift out lights and soften edges that I felt were too distracting. At the end, I went back in with liquid watercolors to strengthen the colors and glow of light.

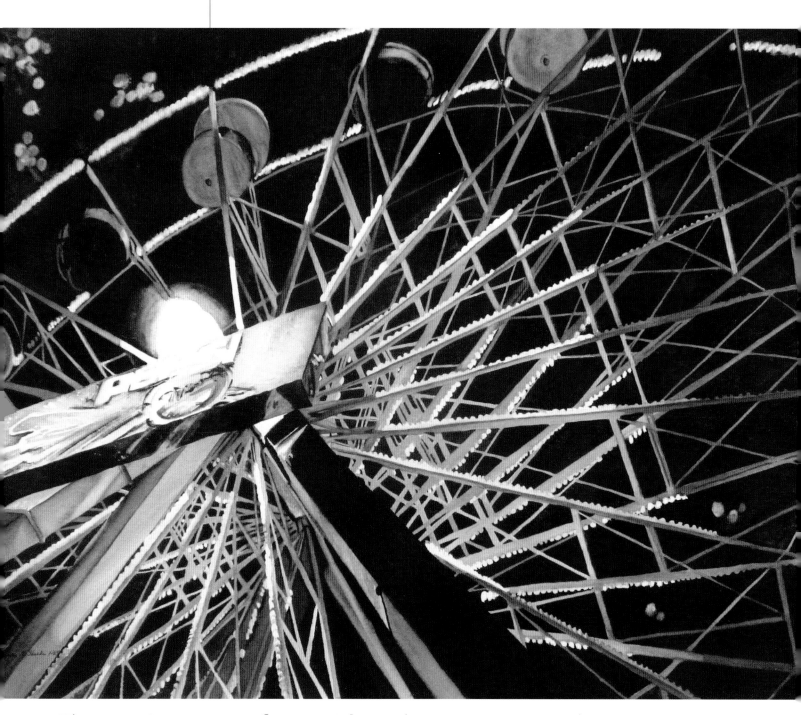

The **passion comes from within**. The source material
is just the starting point for the brain to begin the painting.

— SUSAN M. STULLER

45

VENETIAN GOLD | Paula Fiebich

Transparent watercolor on 300-lb. (640gsm) hot-pressed Arches | 22" × 30" (56cm × 76cm)

My first trip to Italy affected me in many ways. I fell in love with the country, art, food and culture—and let's not forget the wine. As a result of that trip, this painting was a turning point. *Venetian Gold* was created from a mask purchased in Venice, a scarf bought in Florence and a background pattern in my home. I assembled these together in my studio and shot several photos with a 35mm camera. I added richness to the colors by building up layers of washes. After winning the American Watercolor Society Gold Medal of Honor, I was approached by several people who inquired about the kind of metallic paint I used for the mask. I have never incorporated metallic paints into my paintings; I work strictly with transparent watercolor. I just use the power of observation.

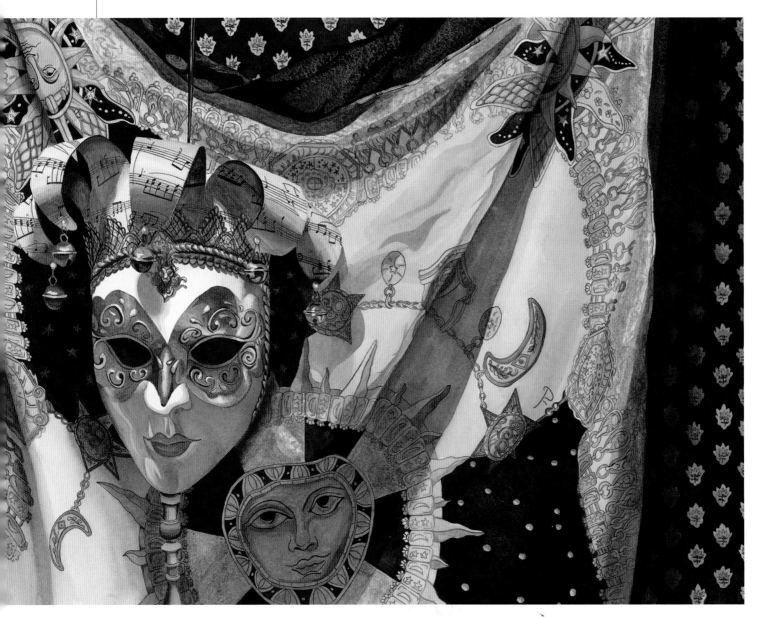

And the day came when the risk it took to remain all tight in the bud became more painful than **the risk it took to blossom.** —ANAIS NIN

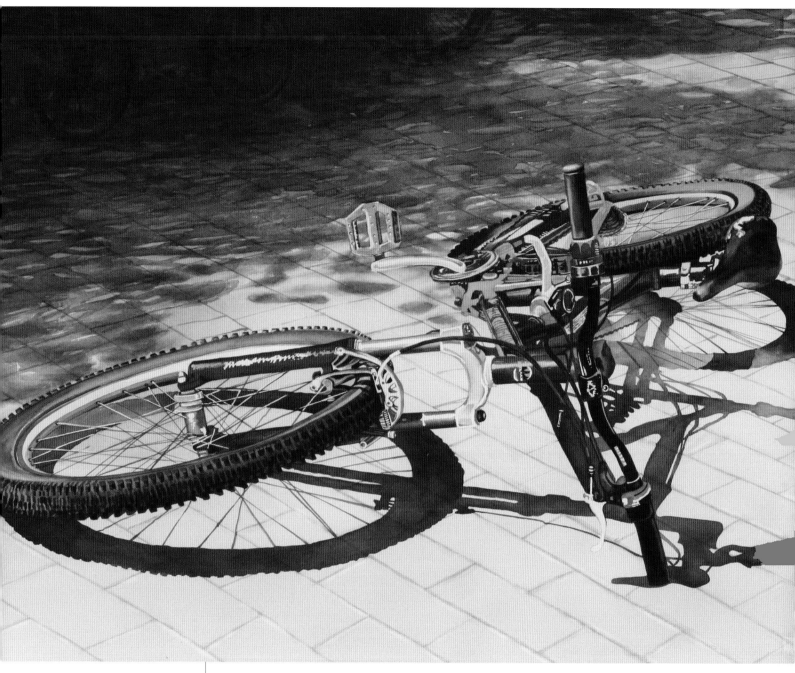

LEFT IT ALONE | Soon Y. Warren

Transparent watercolor on 300-lb. (640gsm) cold-pressed paper | 22" × 30" (56cm × 76cm)

When traveling locally or out of town, I always look for interesting subject matter for a painting. I take snapshots of interesting subjects with a potential composition in my mind. I discovered the source for *Left It Alone* carelessly abandoned next to a bicycle rack. Instead of the usual approach, painting the subject first and then the background, I reversed the process both here and in *Feeding Time* (see page 137). Using diluted Prussian Blue, I started to paint a dark background, the negative space, to create the outline of the subjects first. Then I developed layers of glazing to finalize the main subject. This technique made it easier to gauge the color intensity of the subjects necessary to balance the foreground and background.

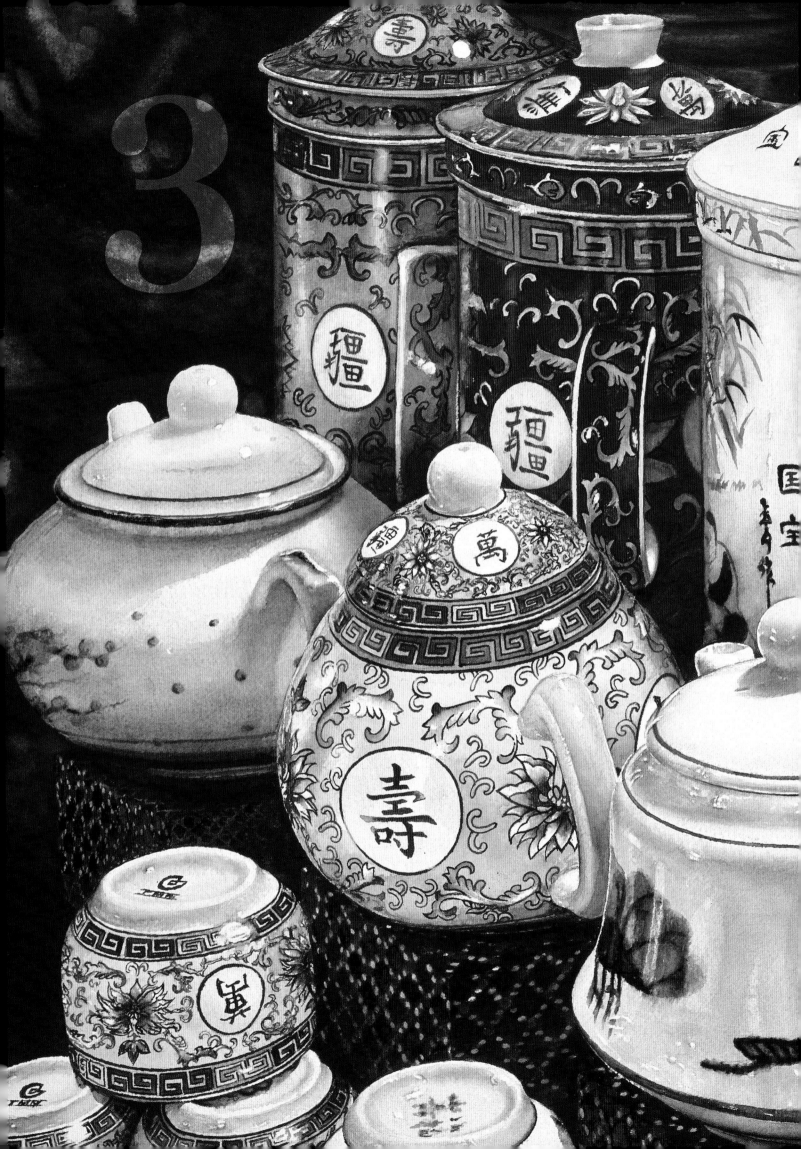

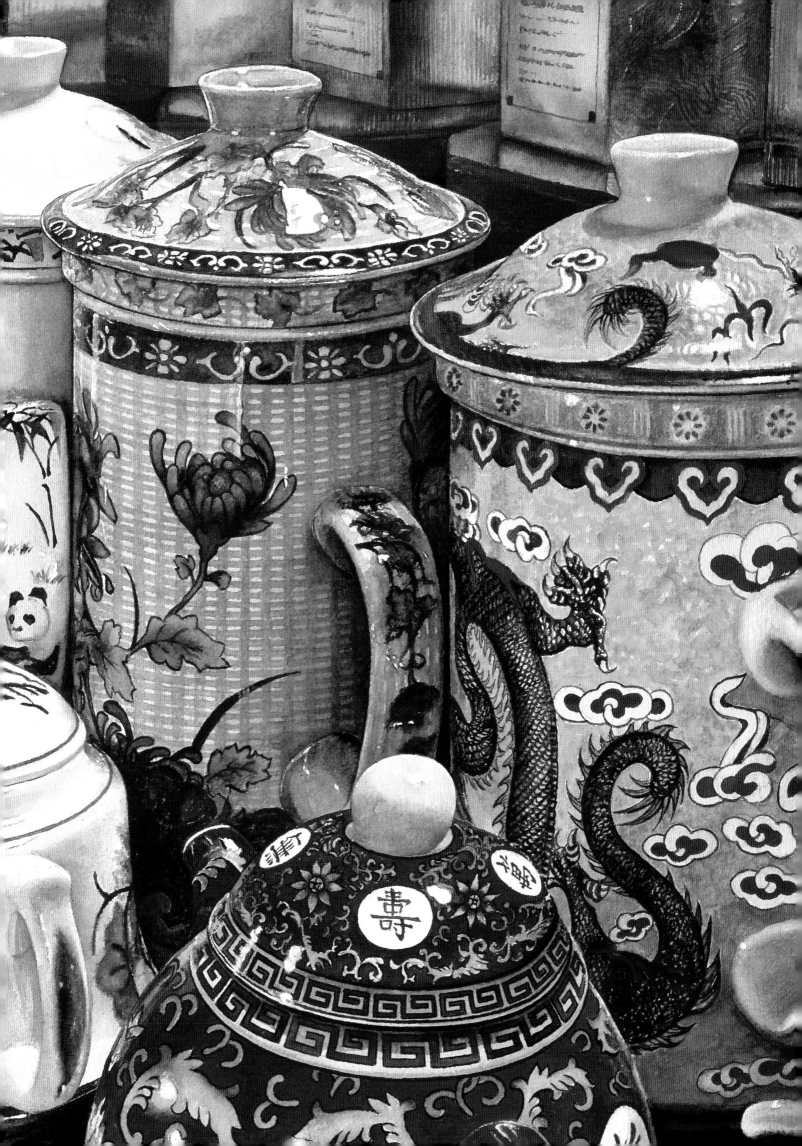

CHINA, TEA AND ME | David L. Stickel

Watercolor on 300-lb. (640gsm) cold-pressed Arches | 22" × 30" (56cm × 76cm)

3

This strong image represents a new direction to intertwine my passions for art and family. The Guangzhou store display intrigued me when we were in China adopting our precious daughter Jubilee. I captured it in photographs and then created this painting in my studio. I carefully drew each cup's design, enhancing repeating patterns. My goal was to portray beauty while emphasizing symbolism in the composition. The five cups, each brilliant and uniquely handcrafted, represent my five children. Jubilee's teacup (in the center with the panda) communicates that our lives revolved around her that trip. Symbolic patterns include Chinese characters for long life and well-being, which we hope fills her cup.

World of Still Life

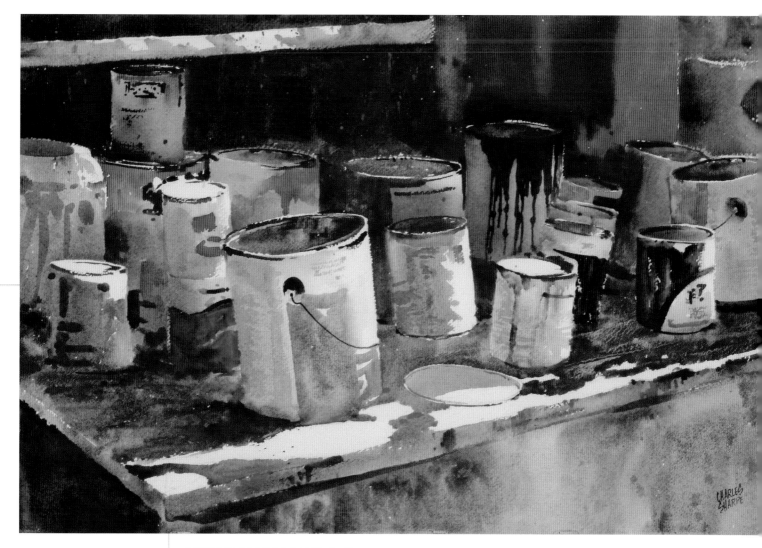

CUSTOM COLORS | F. Charles Sharpe
Transparent watercolor on 140-lb. (300gsm) rough watercolor paper | 12" × 15" (30cm × 38cm)

This watercolor painting is the result of searching for and finding a new and different subject to paint. One day I was looking around my favorite boatyard at the usual marine scenes I could photograph and paint. I noticed an old shed used for storing odds and ends of the boatyard business. By the window was a workbench filled with old and recently used paint cans with paint running down the sides. Voilà! A new subject and a new direction for my work. I created this composition from several photographs of the paint cans. I was inspired to take liberties with color, light and texture—to loosen up and capture the "mess" left by the painter.

TOMATILLAS | Frances Ashley
Transparent watercolor on 300-lb. (640gsm) Arches | 9" × 10¾" (23cm × 27cm)

For some time, my favorite genre of painting has been the still life. I typically begin a painting by carefully choosing the subject, which often includes antique linens. The gathered objects are arranged in my studio for the most pleasing effect and then photographed. I begin painting with direct observation of the objects. In the past, I'd create the background with washes of color taken from the still-life objects themselves. A breakthrough for me came when I began incorporating somewhat complex patterns on top of the washes. The added visual element gave me the finished look I desired, and I continue to incorporate this practice in my work today.

FOUR CUPS, ONE SCABIOSA | Renate Martin
Transparent watercolor on paper | 22" × 30" (56cm × 76cm)

With the deadline of a juried show upon me, I put ten outstanding 8" × 10" (20cm × 25cm) photographs in front of my husband and said, "Pick one!" Each subject had been sketched and the color combination carefully planned. He picked two: one that had enough subject matter to keep me busy for a month and this one. It was the first time I painted "mouse colors" first in order to make the "crown jewels" shine in the end. The shadows were laid down by floating a mixture of granulating paints into a light yellow wash and then resisting the temptation to fix it. By God's grace they turned out.

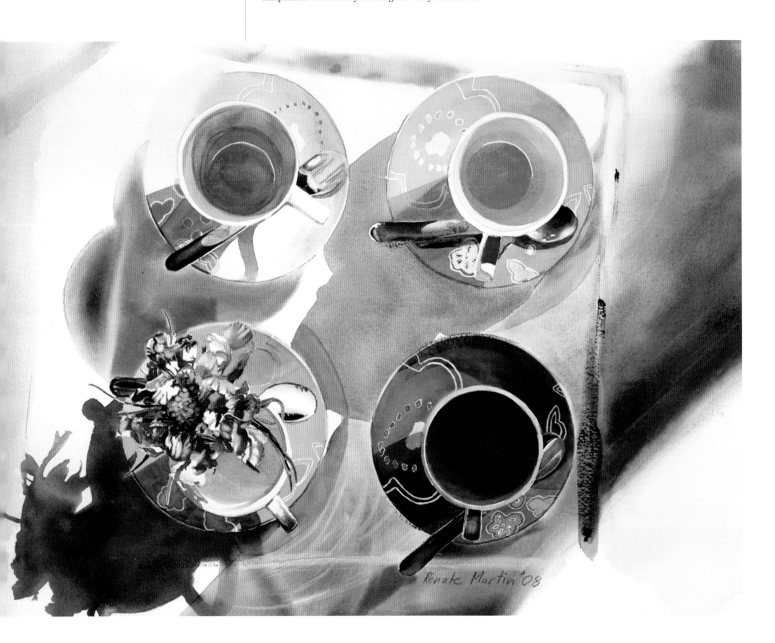

PORK AND BEANS | Nellie Kieke Kress
Watercolor with acrylic black background on 140-lb. (300gsm) cold-pressed Arches | 22" × 16" (56cm × 41cm)

Pork and Beans was painted from a photo I set up outdoors in morning sun so I would get strong shadows. I had always wanted to paint the large cast-aluminum pig, an engagement present to me from my husband, who knew I collected pigs. I felt the pig needed something else with it to make a good composition, and I experimented with an apple and a watermelon slice. But when I saw how the can created wonderful red reflections on the snout, I knew I had the right photo to use for a warm focal point.

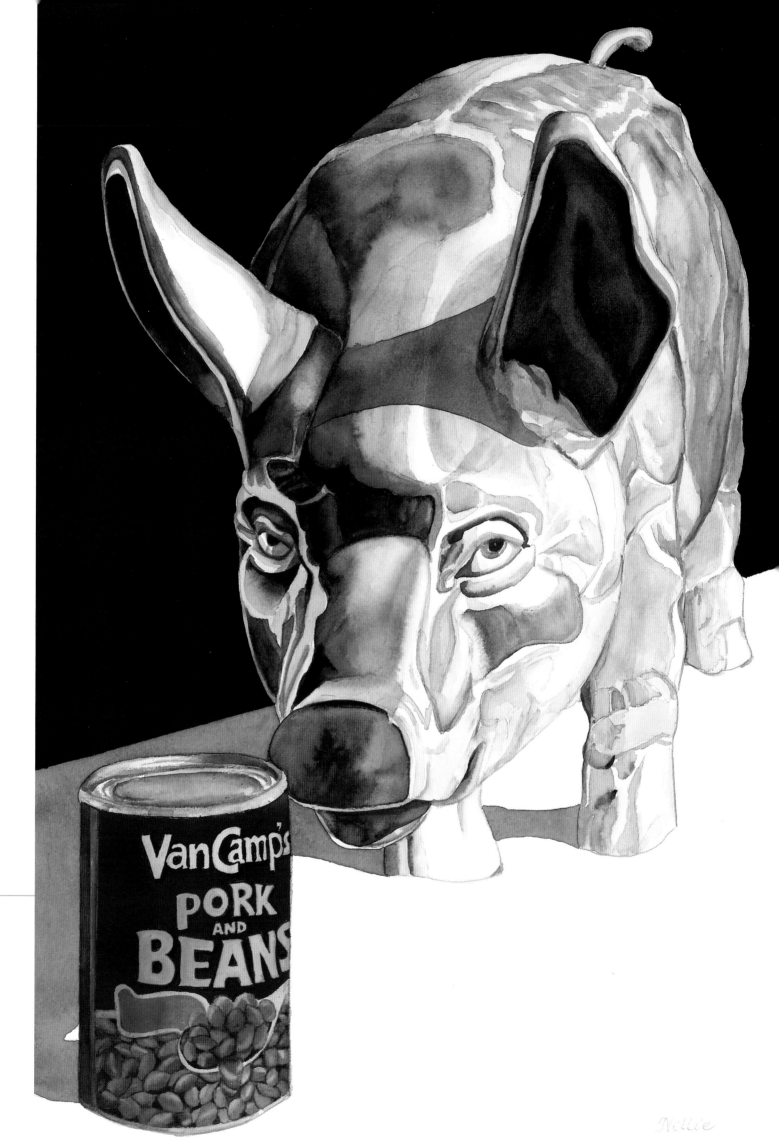

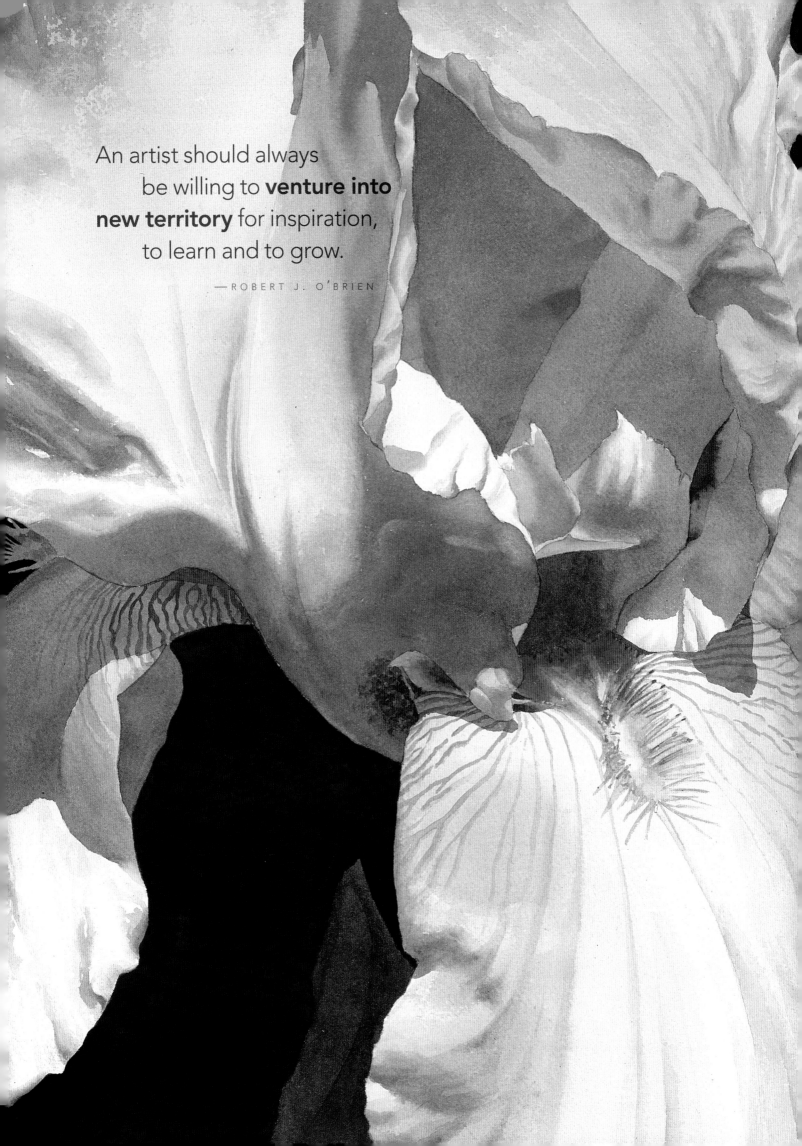

An artist should always
be willing to **venture into
new territory** for inspiration,
to learn and to grow.

—ROBERT J. O'BRIEN

PEACH IRIS | Robert J. O'Brien
Transparent watercolor on 300-lb. (640gsm) cold-pressed Arches | 22" × 15" (56cm × 38cm)

Peach Iris was painted in my studio using transparent watercolors and photo references. I began the piece with broad washes and a wet-into-wet technique. I applied color and shadows, and then added the details and darkened the background to complete the painting. I have recently taken up painting floral subjects and enjoy close-focus studies of them. In this motif, the flower takes on a wonderful abstract shape, and its colors and intricacies transcend the ordinary. There is an endless variety of subject matter out there; all one has to do is look in a flower garden.

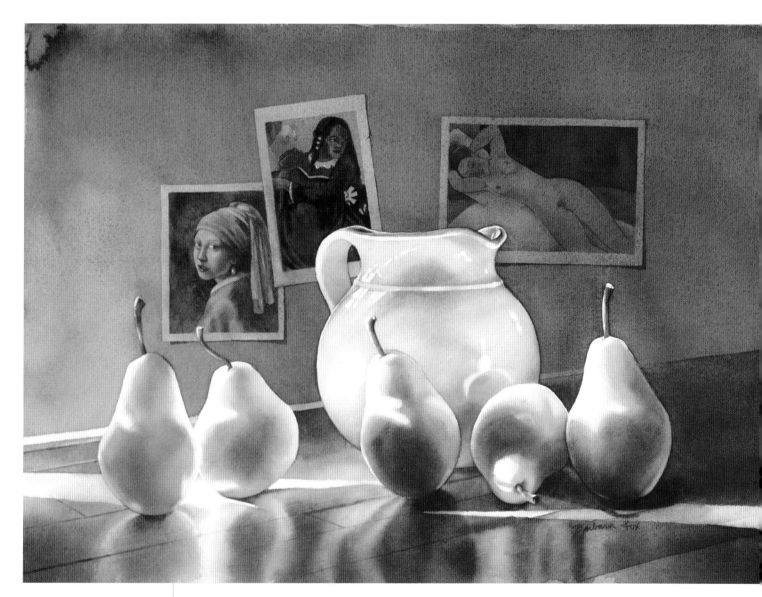

BLESSINGS | Barbara Fox
Watercolor and gouache on paper | 13" × 19" (33cm × 48cm)

I took a new direction to make my still-life paintings more personal. Changing subject matter has helped me add mystery or drama, and has made me want to have deeper, moodier colors, which I build with many layers. *Blessings* came about when I noticed the late evening sunshine spilling across the hardwood floor in my dining room. It was so beautiful I just had to capture it. I grabbed some pears and the little jug, and set up the still life. After I began painting, I realized the pears and the jug had womanly shapes. I added postcards of some favorite paintings of women, and the word "blessings" just felt like the right title.

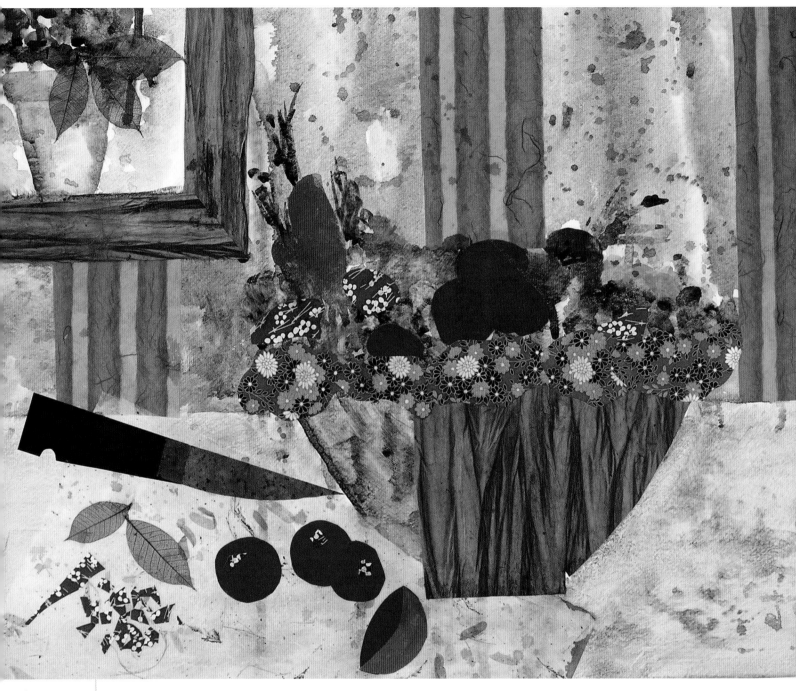

CHOP CHOP | Nancy M. Grigsby

Watercolor and collage papers on gessoed 300-lb. (640gsm) watercolor paper | 20" × 22" (51cm × 56cm)

There are many creative ways to approach a painting. *Chop Chop*, the first of what has become a series for me, began as a title. A group of fellow artists and I meet every couple of months for lunch and a critique of our work. The group agrees on a title and each member renders her own interpretation for our next meeting. We all use different media and paint very differently. For *Chop Chop*, deciding on the subject was easy: what does one chop? I began with a value sketch of a salad bowl with vegetables, a knife, cutting board, etc. The idea of cut papers brought texture and pizzazz and added a secondary interpretation to the title. When I applied the collage pieces over the watercolor, the acrylic medium I used as adhesive slightly blurred the paint, creating a sense of air movement. The end result for *Chop Chop* and all subsequent work in this series—each with different subjects set on the same counter with the same background—is a slice-of-life painting with the feeling that someone has just stepped away.

If you can't **wash the mistake out** of the paper in the bathtub, you've got permission to run over it with your automobile.

— JANET MACH DUTTON

CRACKER PLAY | Janet Mach Dutton
Transparent watercolor on Arches | 22" × 30" (56cm × 76cm)

I bought a box of animal crackers, played with them and photographed them until they fell apart. I ate the ones I couldn't save and kept the others for reference. My new direction was to create a composition investigating play. I wanted to see how play could relate to form and shape; animate and inanimate objects; space, time and imagination. As I played with the crackers, they started to assume animate postures. *Life was possible when they stepped out of the box.* The gorilla waits to take the new arrivals to a world far beyond the checkered table top. You can smile at your whimsical childhood memory of eating the hump of the camel first, or you can examine the meaning of *Cracker Play* more closely.

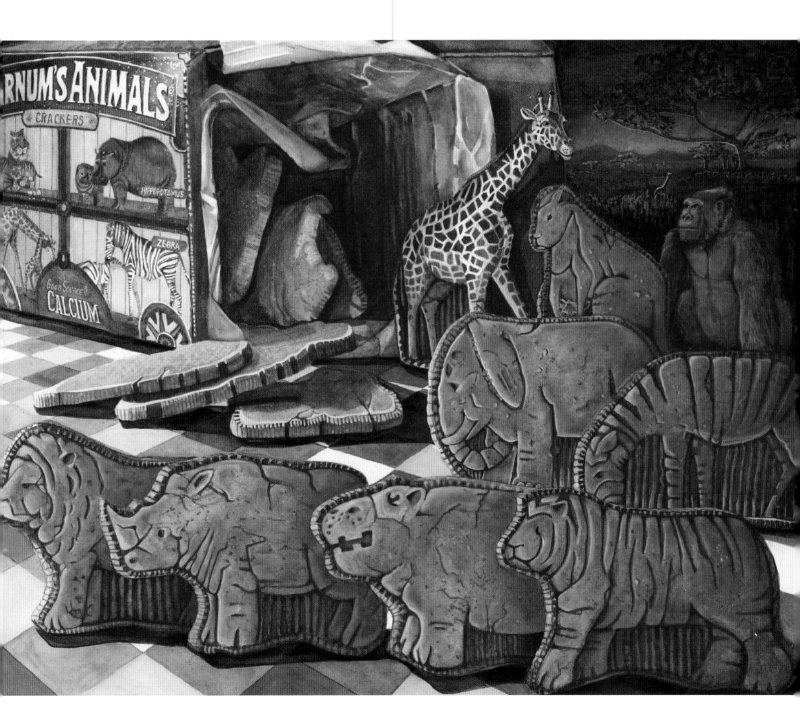

ENCASED | Judy Metcalfe

Transparent watercolor on 300-lb. (640gsm) soft-pressed paper | 29" × 22" (74cm × 56cm)

In a new series of paintings, I combine unrelated objects selected for their color, shape or texture. By pairing opposites, I give equal importance to each element in the composition. In *Encased* the yellow is an immediate contrast against the black-and-white composition, but the subtext is the contrast in the character of the objects: the stately vase paired with a sinuous ribbon. To keep the clean lines of the painting, I use masking fluid. When I mask large areas, I lay down wax paper and seal the edges with masking fluid to avoid overuse.

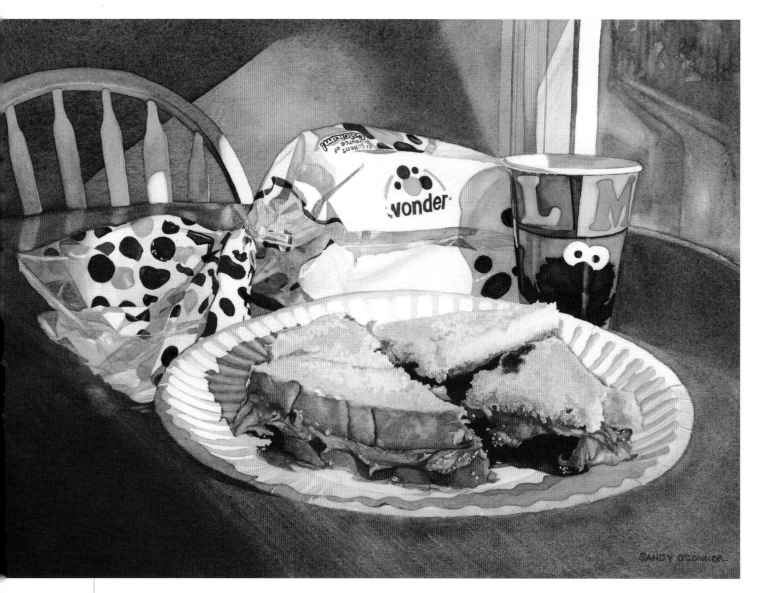

THE WONDER YEARS | Sandy O'Connor

Transparent watercolor on 140-lb. (300gsm) cold-pressed Arches | 11¼" × 14½" (29cm × 37cm)

Living in the quaint seaside village of Cotuit on Cape Cod, I typically paint landscapes and seascapes. So *The Wonder Years*, a still life, was a new direction for me. I painted it in response to the exhibition titled *Of Children and Childhood*, which benefited the Big Brothers and Big Sisters of Cape Cod and the Islands. Anticipating many submissions that would feature children at the beach, I found my inspiration one day while I was making lunch for my daughter. As I placed the gooey sandwich on our kitchen table, I was immediately struck by the obvious. Is there a more iconic, enduring or delicious symbol of childhood than a peanut butter and jelly sandwich?

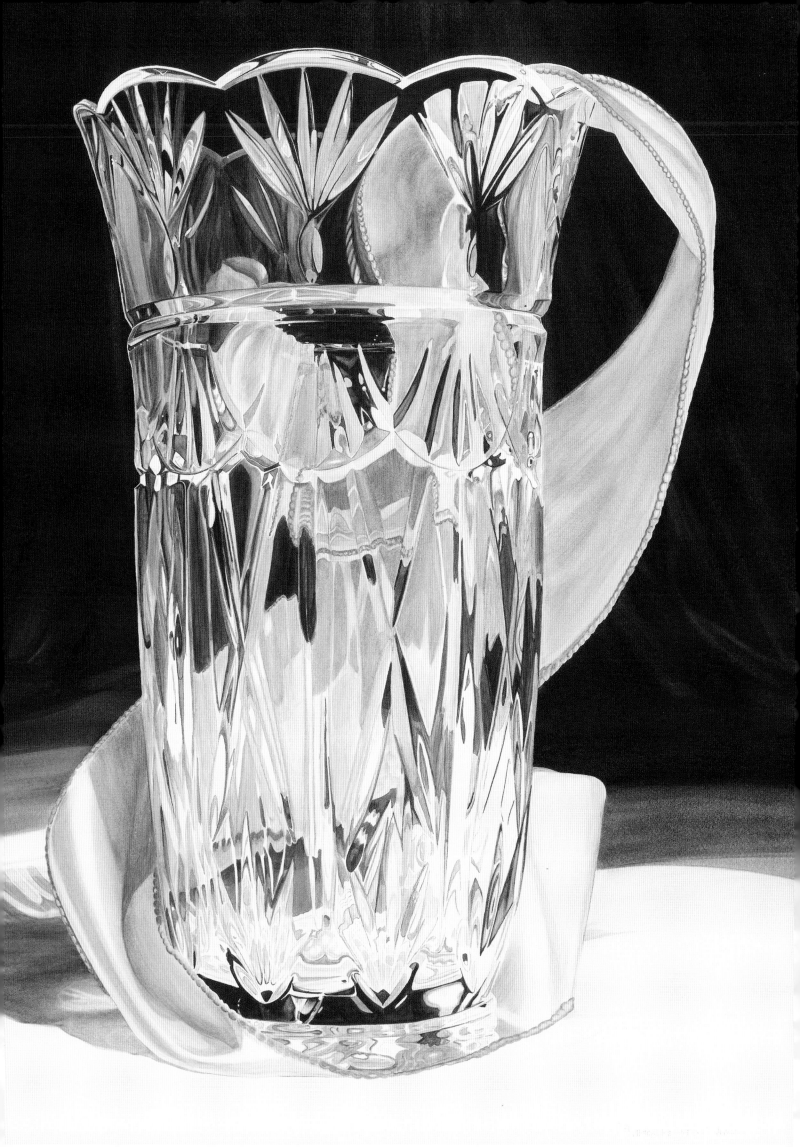

APPLES, IRIS, ALSTROEMERIA | Susan Biros-Dawes

Transparent watercolor on 140-lb. (300gsm) cold-pressed Arches | 12½" × 19¾" (32cm × 50cm)

I probably walked by this dish of apples a hundred times before I decided to paint it. What an incredible color combination: the intense green against the black dish. The apples seem to pop from the frame. My new direction was to paint from an aerial view. I have only recently started to explore this new perspective. The highlight on the apples is the white of the paper. Layers of color were built around the highlight, starting with Cadmium Yellow for a warm glow. I used a mix of Ultramarine Blue and Cadmium Yellow for the green. Lastly, a touch of Cadmium Red was used to create some warm spots on the apples.

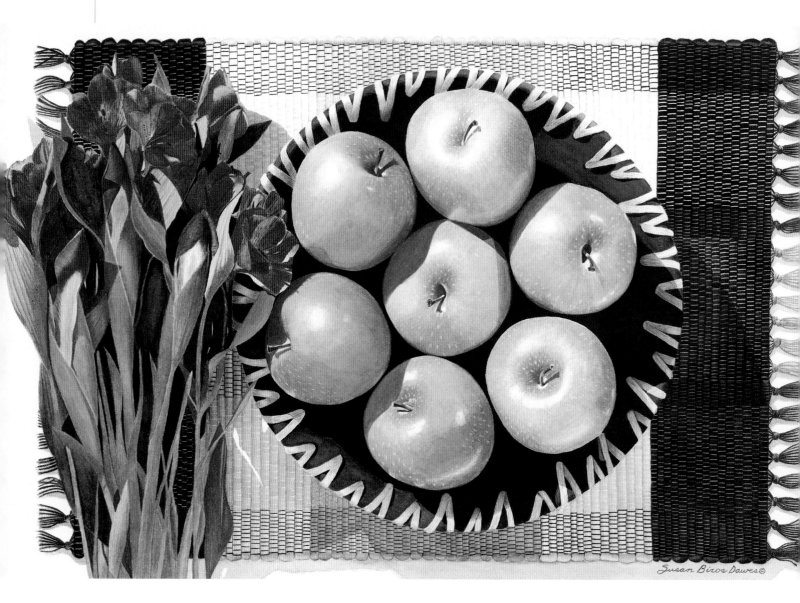

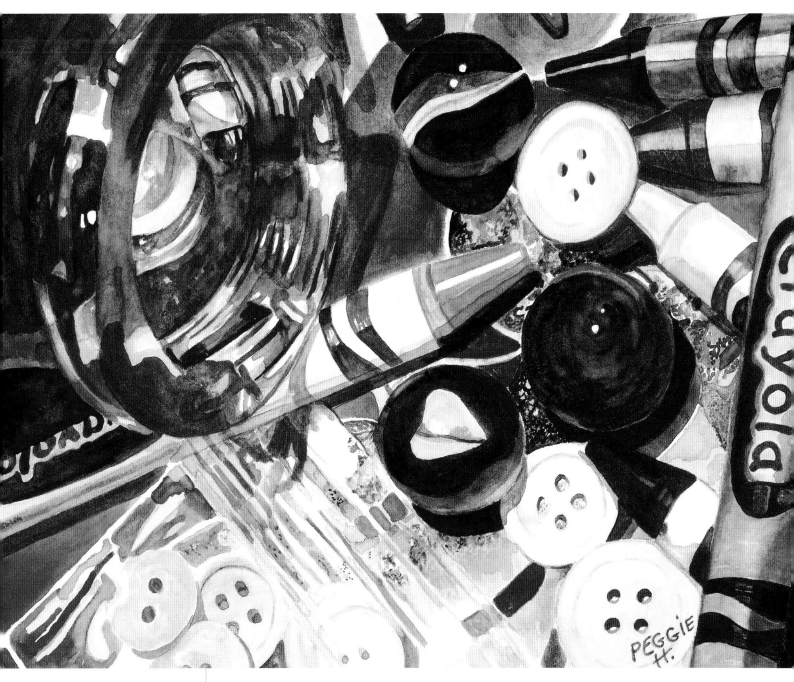

HUE DID IT | Peggie Hunnicutt
Transparent watercolor on 140-lb. (300gsm) cold-pressed watercolor paper | 11" × 14" (28cm × 36cm)

As an art teacher, I've learned to teach all techniques. I tell my students the most important thing is to find their own voice. Recently, I found it was time for my own self-examination. Year after year, I've painted people, places and things, producing a scattered variety of paintings. The design of *Hue Did It* grabs the viewer's eye around in a C shape and centers on a focal point completing the elements and principles of design. That device now shows up in my strongest work. Another new direction I incorporated is I began charging portions of my paintings with Dr. Ph. Martin's watercolors for a little punch. I decided to combine these techniques and focus on a new series of paintings. To test this new direction, I've started entering national shows—and receiving validation!

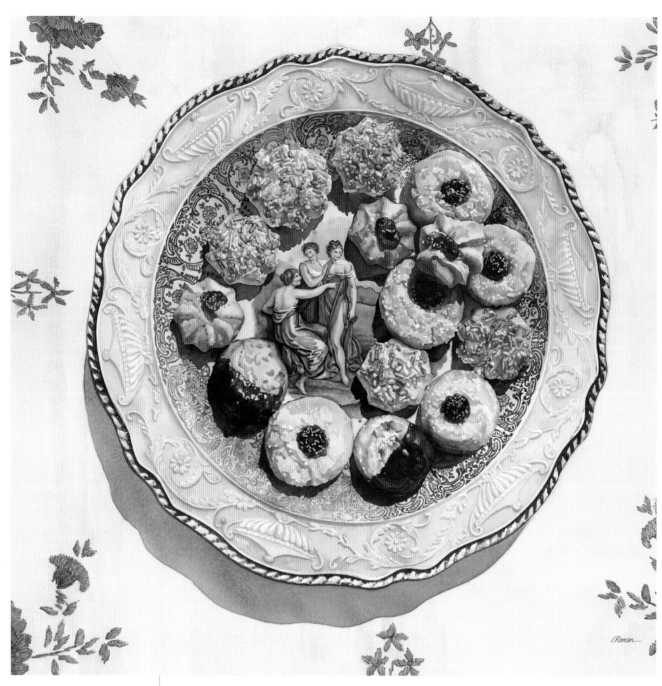

SUGAR COOKIES | Irena Roman
Transparent watercolor on 140-lb. (300gsm) cold-pressed Arches | 19½" × 19½" (50cm × 50cm)

Careful preliminary work is crucial to my process, as I never add white. After creating a contour drawing using a 2H pencil, I ensure a full range of values by masking out highlights before painting. For many years, my preferred subject matter was landscape. Then I inherited many humble household objects from my mother and decided to try a still-life series. Recently, while setting up props, I noticed an unexpected narrative developing that seemed to transcend the objects' surface qualities and hint at a deeper story. I was captivated. Now I look to create those relationships deliberately. Whether humorous or mysterious, my attempt to unlock this communicative potential of inanimate objects has brought a new direction to my painting.

JORDAN ALMONDS | Irena Roman
Transparent watercolor on 140-lb. (300gsm) cold-pressed Arches | 24" × 16" (61cm × 41cm)

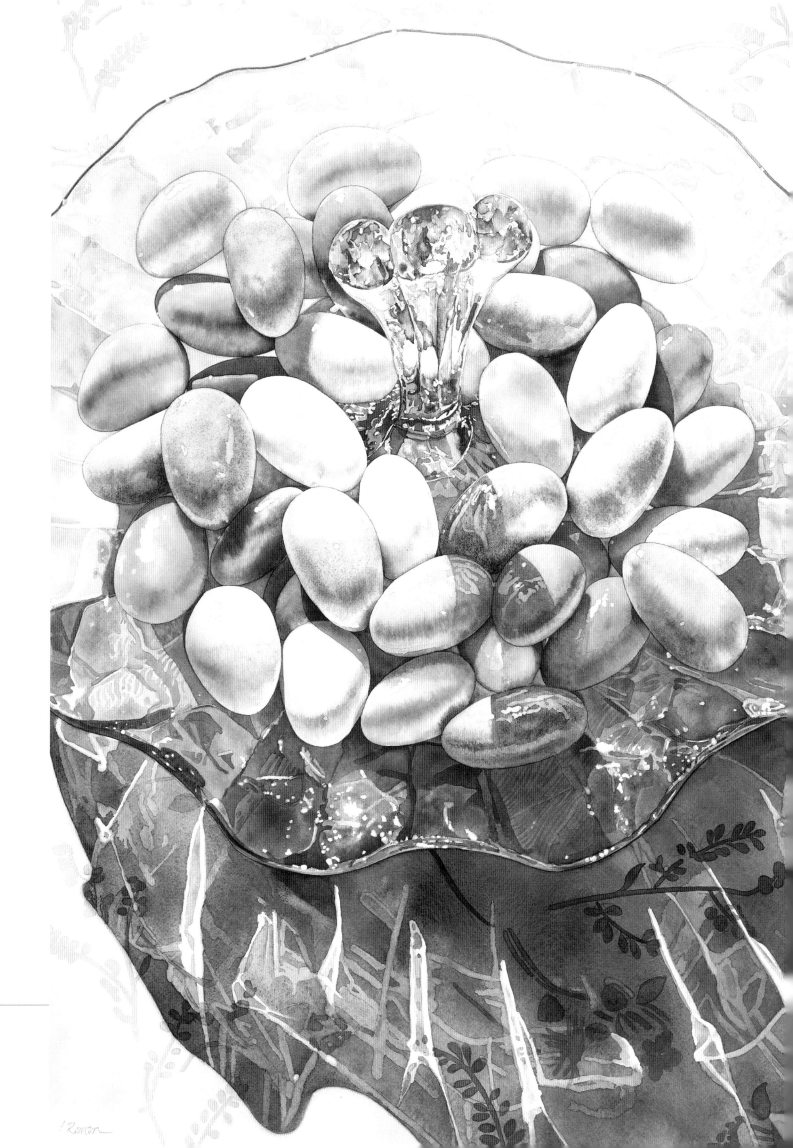

TRADEMARK HANDSHAKE | Heidi Lang Parrinello

Transparent watercolor on paper | 16" × 23" (41cm × 58cm)

This painting of glass bottles represents a departure from my usual subject matter. I was interested in the way that the bottles were solid, yet translucent. They were also reflective and took on neighboring color and light. To render a translucent, reflective surface was a challenge. I've always avoided using masking fluid because I feel that it leaves harsh edges; however, in this piece, I couldn't have done the bottles without first masking out the lettering on them. I mostly paint in my studio from a photograph. Typically I test some paints to get a rough idea of my color palette before I start. Using as few paints as possible helps unify the painting, and with mixing, I can get whatever color I need.

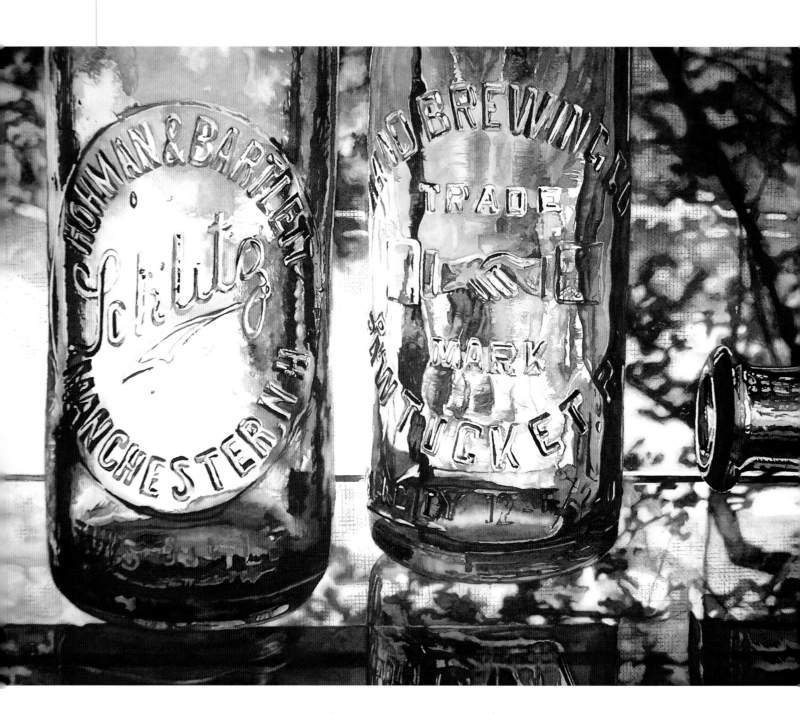

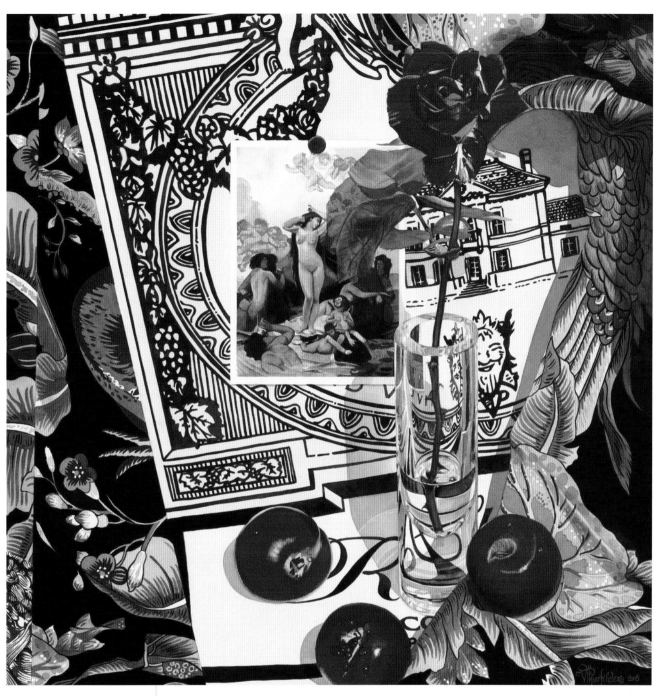

RED LOVE ROSE | Vivian Thierfelder

Transparent watercolor on 140-lb. (300gsm) cold-pressed Arches | 22" × 22" (56cm × 56cm)

A casual toss of my cardboard viewer launched me into a new take on composition, employing what I have come to call "imposed borders." Photos form the basis of my working process; I take many rolls for each proposed work. I review the shots, using the viewer window to select the arrangement I want to develop. My eureka moment came as I was called away and haphazardly tossed the viewer onto a loose array of photos I was considering. Captured in the formatted space was one central composition, but jutting in at various angles on all sides were edges of several similar photos. I was struck by the energy of this overlapping. These irregular edges introduced an element of tension or mystery. I knew this was something I needed to explore further. In *Red Love Rose* I chose to have two subtle, imposed edges to the left dovetail with the patterned fabric on the right, moving the eye up into the center of the painting.

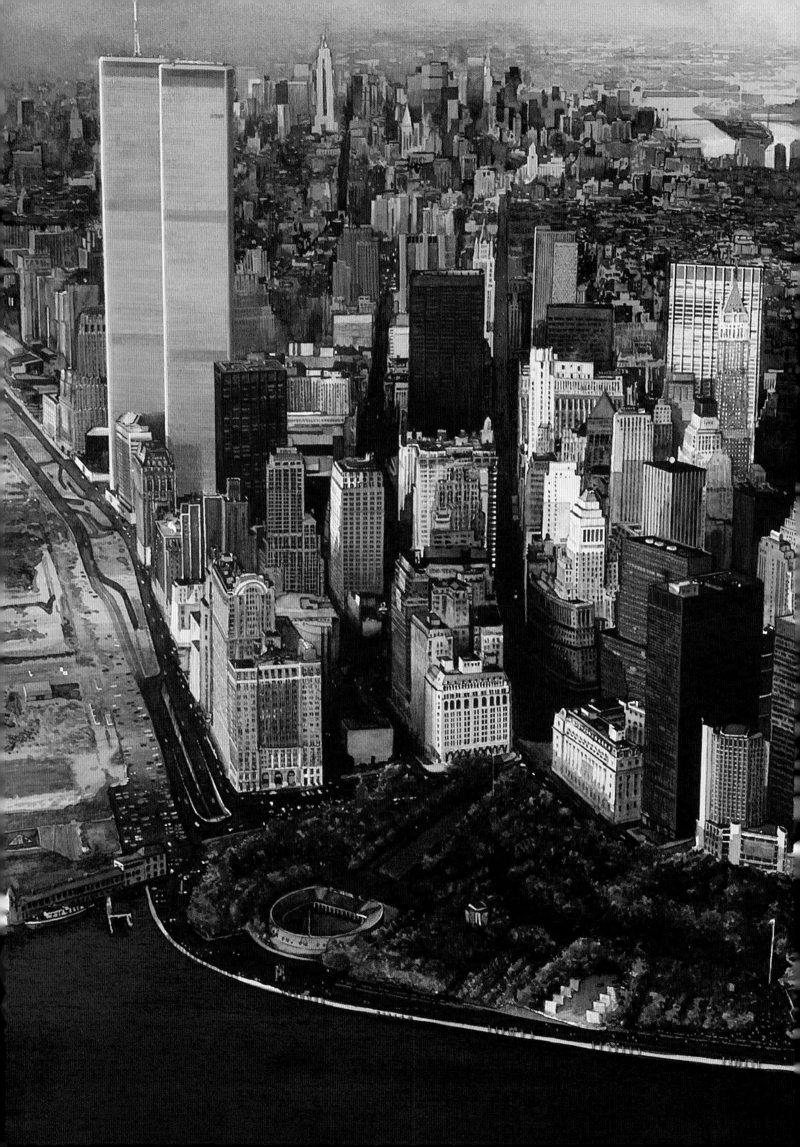

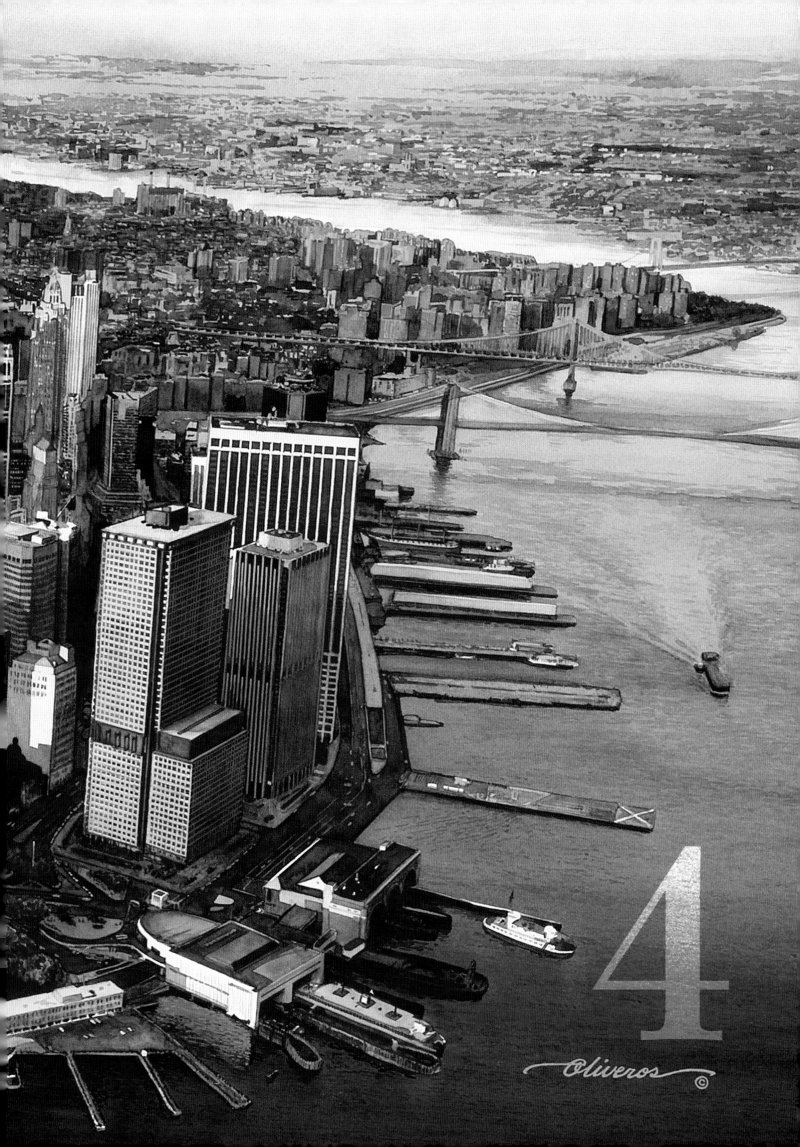

4

Oliveros ©

MANHATTAN ISLAND | Edmond S. Oliveros
Transparent watercolor and Chinese White on illustration board | 19" × 22¾" (48cm × 58cm)

4

This painting was based on a photograph I saw in 1985 by the world-famous photographer Jake Rajs. My boss at the time said that I was crazy to try to paint it in watercolor and suggested gouache to make it a little easier. The challenge became more intense, and it took me more than 200 hours to finish it. *Manhattan Island* was not made public until the summer of 2000, the year I joined the Toledo Artists Club. When the disaster of September 11, 2001, happened, many of my friends who had seen the art-work on display at the club gallery suggested that I flood the market with prints of the painting. At first, I got excited about the possibility, but after watching the repeated TV coverage of that fateful day—the heroism of the rescuers and the suffering of the victims' families—I could not see myself benefitting from it. Because of September 11, the painting went from one exhibit to another, and the viewers looking at the World Trade Center spoke about where they had been when the towers collapsed. For me the

painting has become a reminder of the brave men and women of New York City who came together and united in a time of great tribulation. I have not seen Americans draw together as closely as we did in those days.

As far as the technique is concerned, the larger buildings received washes of solid colors first, and then I applied masking fluid with a rolling pen to outline the windows. I painted in reflections and rubbed off the masking to reveal the solid parts of the buildings. I used tiny lines of tinted Chinese White for the mullions of the World Trade Center. I chose to give the finished painting a cooler feel than the original photograph.

Earlier in my career, my technique was on the rough side, similar to that of John Singer Sargent and Winslow Homer. I switched to my new direction because I wanted my paintings to look like photographs and my photographs to look like paintings.

Places We Go

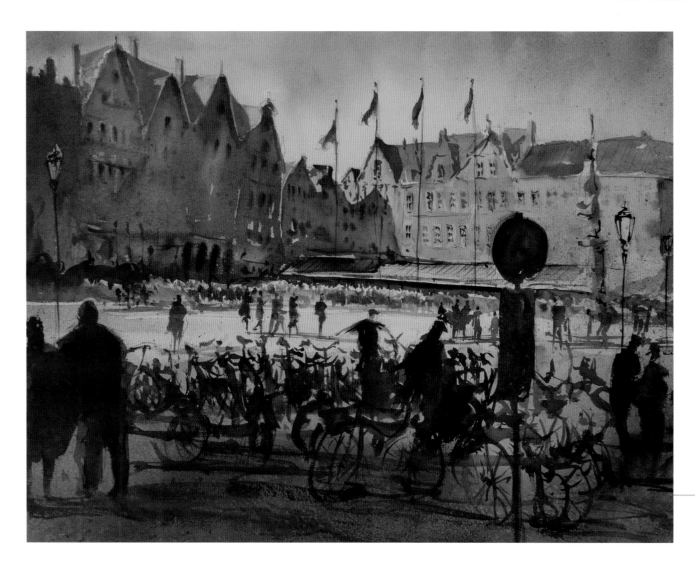

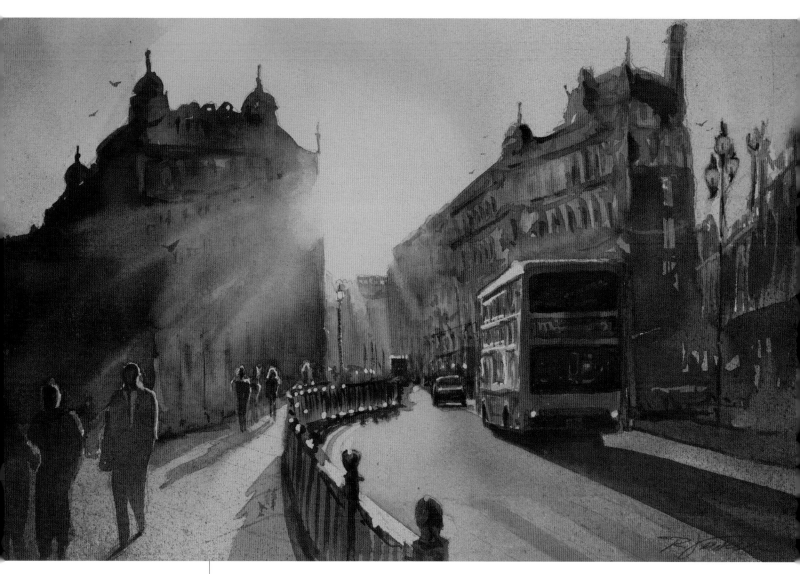

DOUBLE-DECKER | Russell Jewell
Transparent watercolor on 140-lb. (300gsm) rough Arches | 11" × 17" (28cm × 43cm)

Double-Decker was painted in the studio from a travel photo of London. Technically it is a painting with a strong one-point perspective. The directional of the painting is created by the dominant light source and its prevailing shadows. The guardrail also formulates a lead-in that wraps the viewer's eye around the double-decker bus. "Into the sun" summarizes my new direction in this painting. So often we have been taught the "proper" way to create photos, and one of the cardinal rules is never point a camera toward the sun. However, this is the exact direction that best captures the mood of a city.

In *Bikes and Brugge* the background and foreground came from two different photos. My new direction is a middle-ground spotlight effect. It plays on the fact that the eye cannot focus on two things at once. I have allowed both the foreground and the background to diffuse. Creating higher contrasts and sharper edges in the middle ground sets a visual stage upon which to place my main emphasis. Interestingly enough, this emphasis doesn't have to be a particular object, but it can be the essence of light itself. Remember: lights, camera, action!

BIKES AND BRUGGE | Russell Jewell
Transparent watercolor on 140-lb. (300gsm) rough Arches | 19" × 25" (48cm × 64cm)

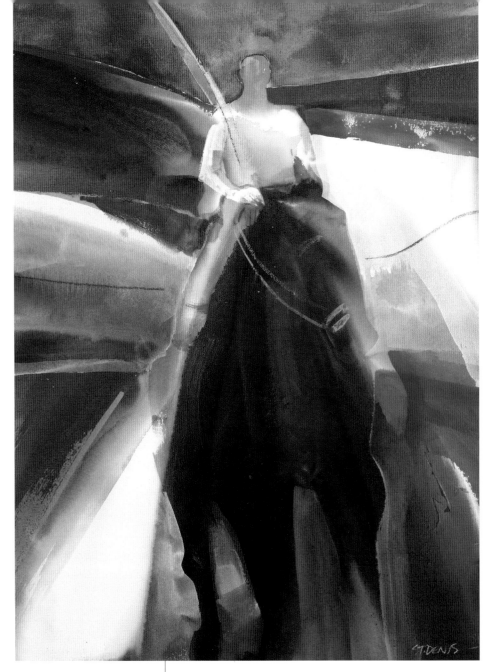

Be spontaneous.
Go out on a limb
and improvise.

—PAUL ST. DENIS

GHOST RIDER | Paul St. Denis
Concentrated transparent watercolor on 140-lb. (300gsm) cold-pressed Arches | 28¾" × 20¾" (73cm × 53cm)

For many years I have used fluid acrylics to achieve beautiful, flowing poured-color abstractions. A fellow painter introduced me to a new kind of concentrated liquid watercolor made by Robert Doak & Associates. I purchased an assortment of these colors and was amazed at how bright, permanent and lightfast they were. Using these paints in my studio, I created a brilliant poured-color abstraction more intense than those created with my acrylic paints. I then selected their super-opaque white and with a brush was able to pull out the horse and rider from the colored shapes. I added a few details and my *Ghost Rider* was complete.

TUSCAN WINDOW | Kathie George
Watercolor-batik on rice paper | 16" × 12" (41cm × 30cm)

On a trip to Italy, I did a quick sketch at this location, took a photo, then painted the piece when I returned home. Solving a problem helped me evolve as an artist. Years ago I dabbled in the traditional batik-on-fabric method using dyes. However, when my daughter was born, I found it much too messy, dangerous and time-consuming. Contemplating my dilemma, I changed from fabric to rice paper (still using wax to save areas), and used water-color and a brush to apply paint instead of dyes. It changed the look entirely, and it is so much fun!

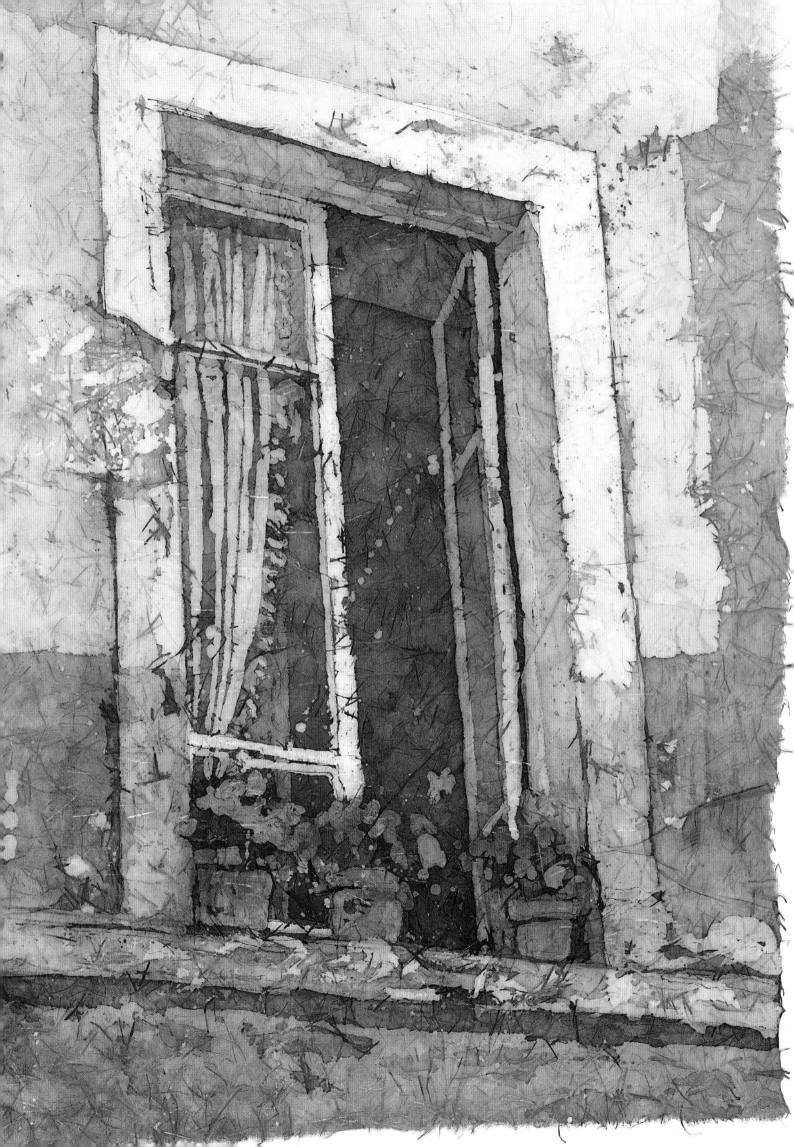

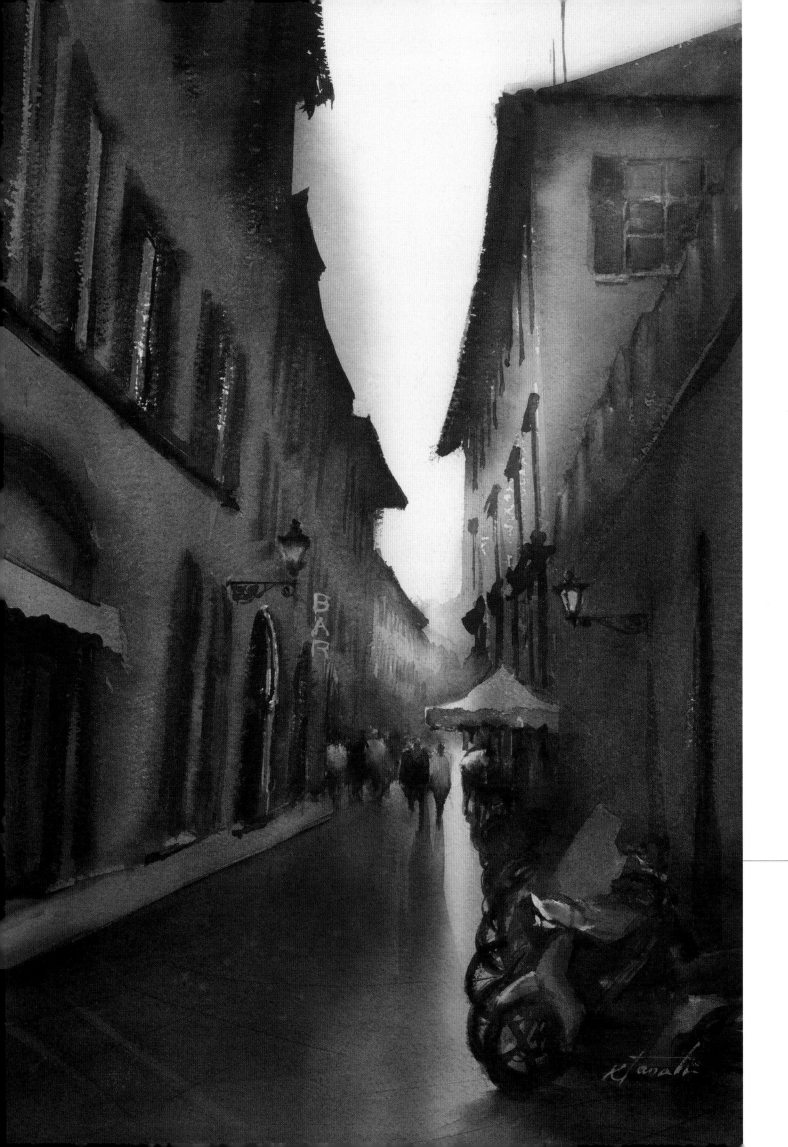

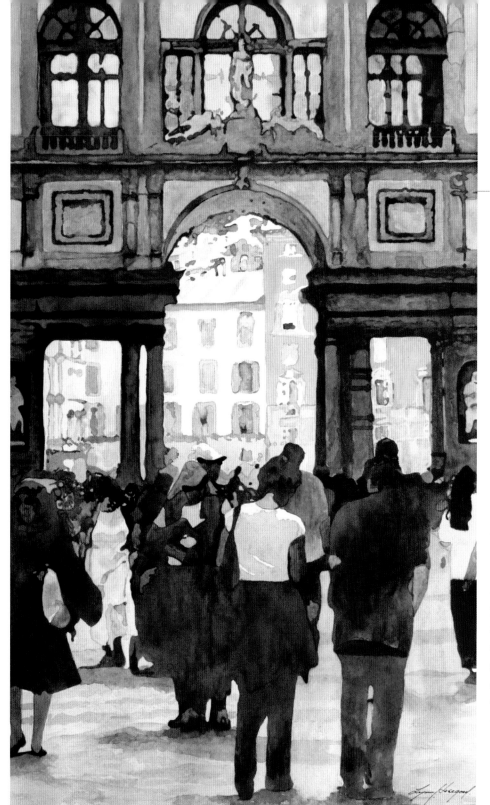

PIAZZA DEGLI UFFIZI
Lynn Hosegood
Watercolor on paper
17" × 29" (43cm × 74cm)

I've turned to taking a very analytical approach. My compositions start with my camera. Using Photoshop, I work on images from my digital files. This nearly always involves pasting elements from different photographs, cropping, resizing, changing proportions and exposure, and simplifying or combining shapes. I then concentrate on adjusting value contrasts and color. My design process ends with making sure that there are variations in shapes, features and colors and a predominance of either geometric or organic shapes. Turning to my watercolors, I select my palette and choose either a cool or warm, intense or dull predominance and use its complement for spot colors. Then I create a drawing on the watercolor paper and paint, starting with the darks and mixing colors on the paper. I've already worked out everything, so I concentrate on painting shapes, not things.

FIRENZE, ITALY VIII | Keiko Tanabe
Watercolor on paper | 21" × 14" (53cm × 36cm)

When my eyes are drawn to the stimulus of light pouring into a dark alley, like this one in Florence, I know I see a painting. My emotional response to the light reflects the intrigue my mind sees in the shadows. Compared to the bright highlighted areas, there is mystery in the colors, texture and mood in shadowy areas. Lately I have been challenging myself to interpret the mystery of darkness. Sometimes it feels inviting; sometimes it looks untouchable. Does it want me to put in more details? Or is it content with just a suggestion? I usually let my intuition guide me.

Do something surprising—something unusual, unexpected or **out of the ordinary**.

— DONNA JILL WITTY

LADY IN WAITING | Donna Jill Witty
Transparent watercolor on 100 percent rag paper | 22" × 30" (56cm × 76cm)

My painting process utilizes a method of precise drawing, masking and paint layering that requires working in the studio. These days, I seem to have an obsession with texture, pattern, shapes within shapes and layering as design. I love to use granulation of pigment for texture, and I am constantly experimenting with new color combinations that will show this type of pigment separation to its best advantage. I also am looking at different ways of breaking up the painting space for interest and for excitement. I still love bold color and strong patterns of light, but I am searching for new ideas and new challenges to keep things fresh and exciting.

NYC STREET CAFE 2 | Henry W. Dixon
Transparent watercolor on 300-lb. (640gsm) hot-pressed Winsor & Newton | 23" × 15½" (58cm × 39cm)

While observing how light streamed through the windows at different eateries, how it seemed to drench tables and chairs with natural light, I suddenly understood the old saying that darkness is the absence of light. I'm intrigued by the way sunlight and shadow set up a dynamic composition. My intention in *NYC Street Cafe 2* was to shed a whole new light on dining outside. I used masking tape diagonally to preserve the bright color of the sunlit cherry wood on the columns. To preserve the white of the sconce in the upper-right corner, I used masking fluid before applying a very dark wash.

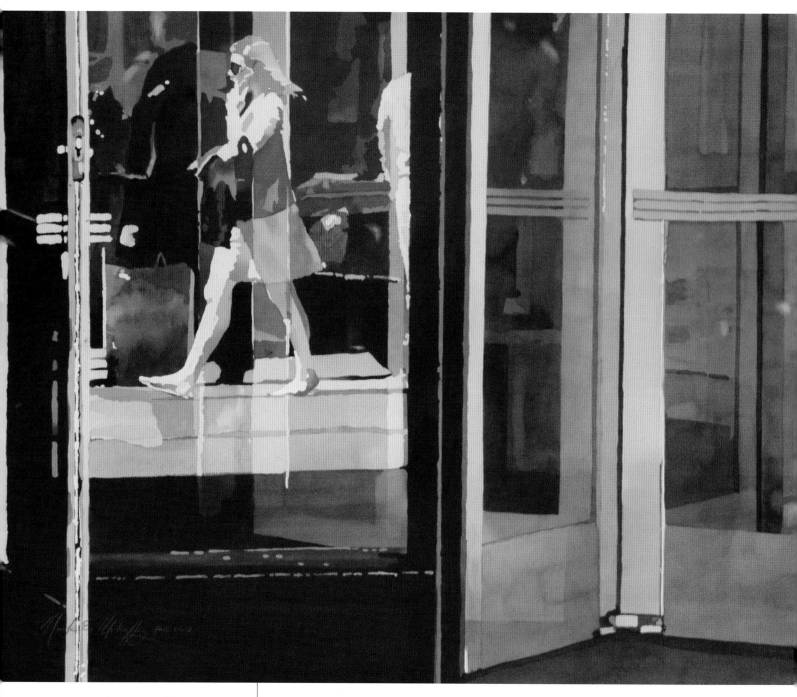

Always be
willing to ruin a
good painting.
Your goal is
to **produce
a great one**.

——MARK E. MEHAFFEY

NYC REFLECTIONS | Mark E. Mehaffey
Transparent watercolor on 140-lb. (300gsm) cold-pressed Arches | 23½" × 30½" (60cm × 77cm)

This was my first trip to New York City and was it fun! So many people, so much noise, so many great places
to eat. After I got over the visual overload, I started people watching. Prior to this painting most of my work
was nonobjective, allegorical or landscape based. We artists tend to work toward our strengths, but this
time I felt it necessary to move toward my weakness. I am just beginning to feel comfortable with the figure,
so this is an entirely new direction for me. Now I often feature the figure, sometimes even multiple figures.
Most of my paintings are executed the same way: I take many digital photographs of whatever catches my
interest (in this case, the woman's reflection and that reflected spot of red), select the best of those photo-
graphs, make compositional drawings in my sketchbook to simplify and arrange the shapes, assign value
to those shapes, then paint.

ALL THAT GLITTERS
Jewel Baldwin

Transparent watercolor on 140-lb.
(300gsm) cold-pressed paper
22" × 15" (56cm × 38cm)

I painted this scene in my studio
from a photograph taken on a
recent trip to Russia. I am a detail
person by nature and want my
work to be as accurate as possible,
so executing a good, strong sketch
is very important. I paint on dry
paper, which allows me to main-
tain control of the medium—lay-
ering for texture and lifting for
highlights. In this painting, my
new direction was making the
light source, the chandelier, the
focal point. Meanwhile, the hidden
treasures and gilded reflections
came to life. Using no masking
and leaving the white of the paper
for the chandelier was challenging,
but I believe the end result justifies
the trouble.

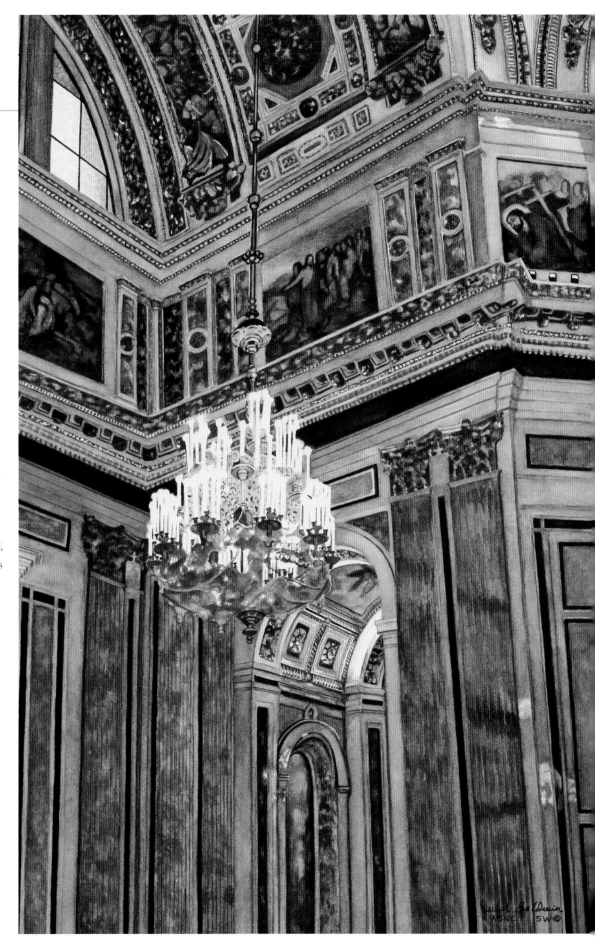

A band of paints
Kinship of colors
Feels good together

— NANCY FORTUNATO

HK CALLI | Nancy Fortunato
Transparent watercolor on 140-lb. (300gsm) cold-pressed Fabriano
9" × 13" (23cm × 33cm)

Hong Kong is exciting. There are signs everywhere, all done in Chinese calligraphy. Calligraphy occupies a distinguished place in China. It is a means of communication, but it also is an indispensable decorative element in the culture. In planning this painting, I wanted to include the neon signs but not let them take over the scene, so I had to leave many out. Texture and light give you something to sink your teeth into.

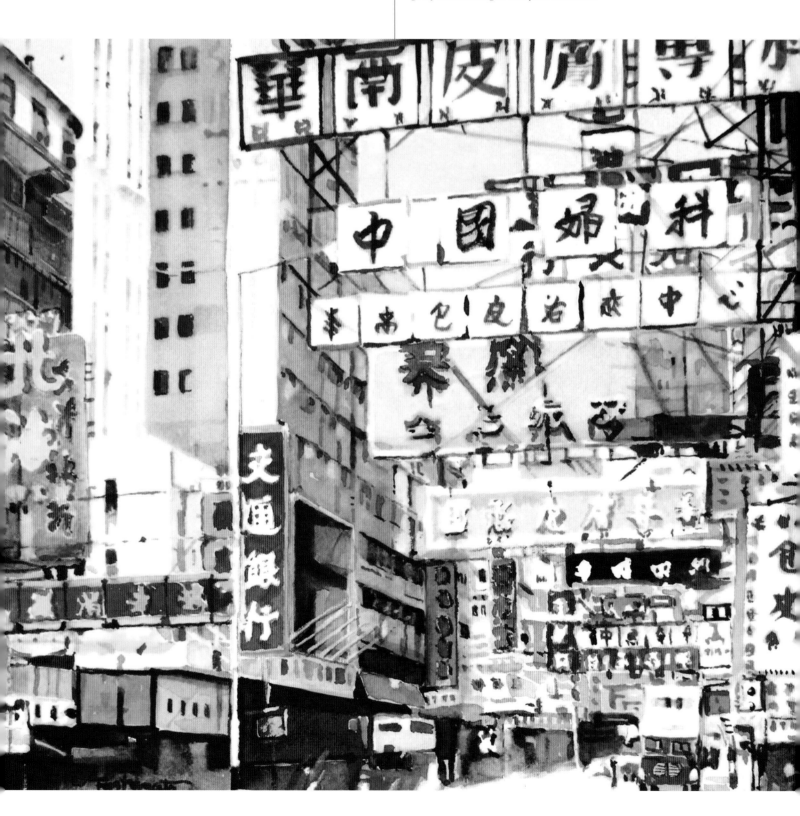

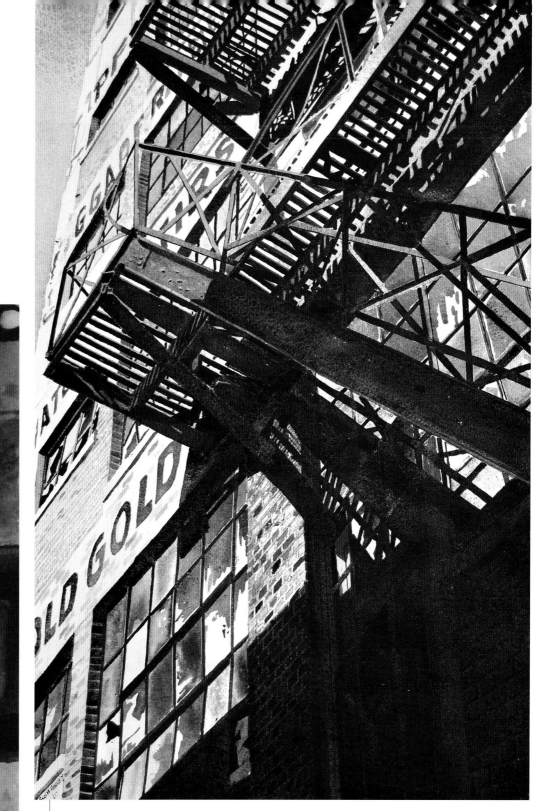

LADDER LANDING | Scott Hartley

Transparent watercolor on paper | 21" × 12" (53cm × 30cm)

I've been taking a new direction lately with composition. I learned early that I needed to master the fundamentals of design in order to create a satisfying painting. Recently it occurred to me that the sensitive relationships of two-dimensional shapes within a rectangle could be so well crafted as to reach a new level. This can include not only pleasing design, but emotional involvement on the part of the viewer. It is this power at the abstract level that I sought in *Ladder Landing*. After working on pre-studies, value and color, I turned my attention to the textures of brick and rusting iron. I made use of the granulating properties unique to watercolor paint on rough paper, mixing the sedimentary Mars Black acrylic with transparent staining red and yellow watercolor pigments.

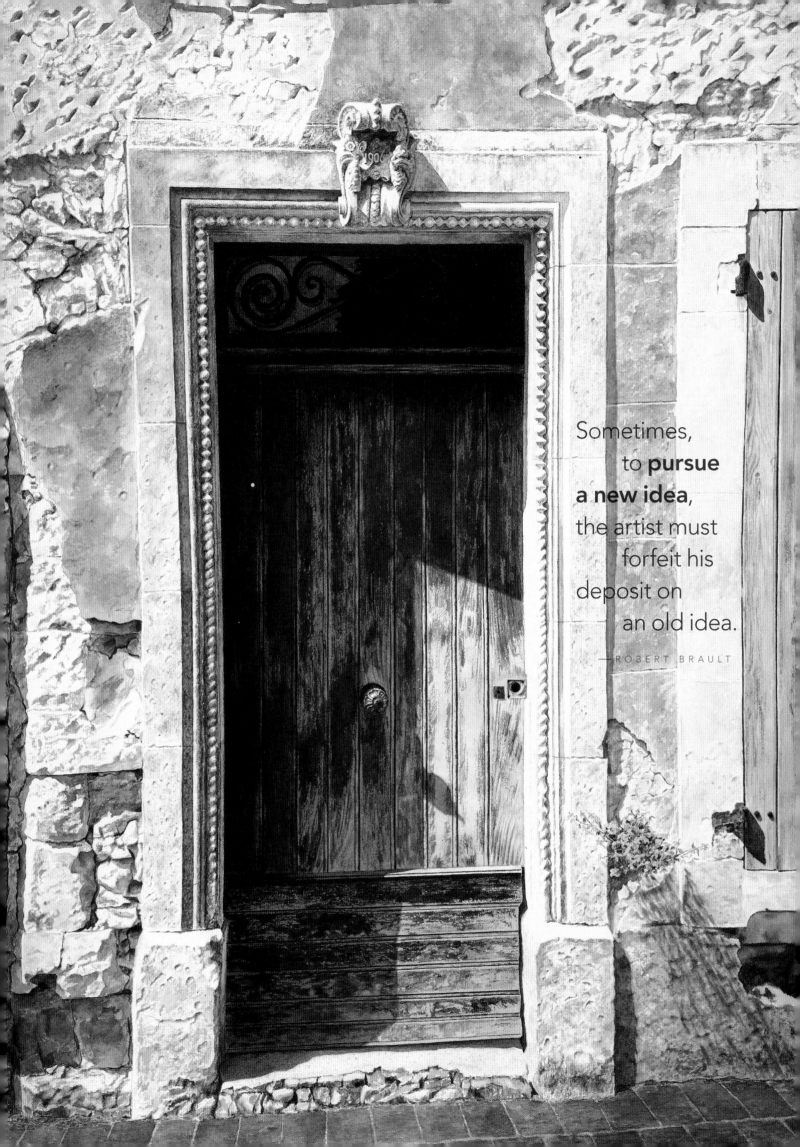

Sometimes,
to **pursue
a new idea**,
the artist must
forfeit his
deposit on
an old idea.

—ROBERT BRAULT

BRICK AND BLUE | Catherine P. O'Neill

Transparent watercolor on 300-lb. (640gsm) paper | 16" × 21" (41cm × 53cm)

The view depicted in *Brick and Blue* represents a change in my usual subject matter. I was attracted by the many textures in the crumbling building's façade and enjoyed experimenting with techniques to achieve its likeness. I also liked the composition with the repeating rectangular shapes interspersed with various linear and wavy contours. This painting was completed using a reference photograph given to me by my father. I used a limited palette of primarily blue and red, and tried a variety of effects, including applying salt, spattering, sponging and glazing.

RED DOOR | Kay Carnie

Transparent watercolor on 140-lb. (300gsm) Arches | 27" × 19" (69cm × 48cm)

I painted *Red Door* from several sketches and photographs taken in the town of Menerbes in France. I use three colors—Antwerp Blue, New Gamboge and Permanent Rose—to mix all colors for my paintings. *Red Door* was intended as the first painting in what was to be a series of white paintings in which a large part of each image would be white. As I got into this painting, I developed a creative block and seemed unable to move forward. I eventually finished *Red Door*, but as a result, the white series has come to a halt—at least for now. In the process I have learned to be more aware of the creative journey and place less importance on the destination.

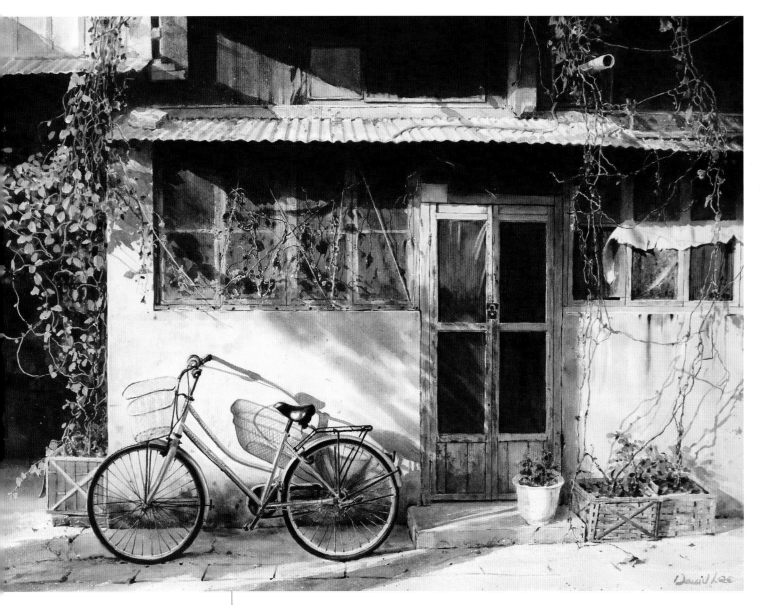

BEIJING HUTONG | David Lee

Transparent watercolor on 140-lb. (300gsm) cold-pressed watercolor paper | 21" × 29" (53cm × 74cm)

The new challenge I recently took on is to paint complex compositions with more interesting details but still keeping painterly, loose brushstrokes to avoid a tight look. This watercolor was painted from a photo I took in Beijing. The bicycle and the shadow cast on the old hutong building immediately caught my eye. In order to avoid tedious and meticulous brushwork around highlighted details, I applied masking fluid in a quick and painterly fashion to preserve the areas for later color application. The end result is a freshly painted watercolor with details for viewers to explore and discover.

ROMAN VIEW | Linda Kooluris Dobbs

Watercolor | 27¼" × 19¼" (69cm × 49cm)

When I was in Rome on a photo shoot of the Vatican gardens, I went out on the balcony of a friend's apartment and found this painterly view of St. Peter's Basilica and the spumoni- and Italian ice-colored buildings on his street. I wanted the painting to feel like a stage set. I began the painting with a very careful linear drawing in an H pencil. I typically do this so there isn't much smudge on the paper. If I choose later on to get rid of the line once the painting is complete, to make the image less graphic and more three-dimensional, no marks will show. I mostly work with Winsor & Newton A- and AA-rated watercolors in tubes to maintain saturation of hue.

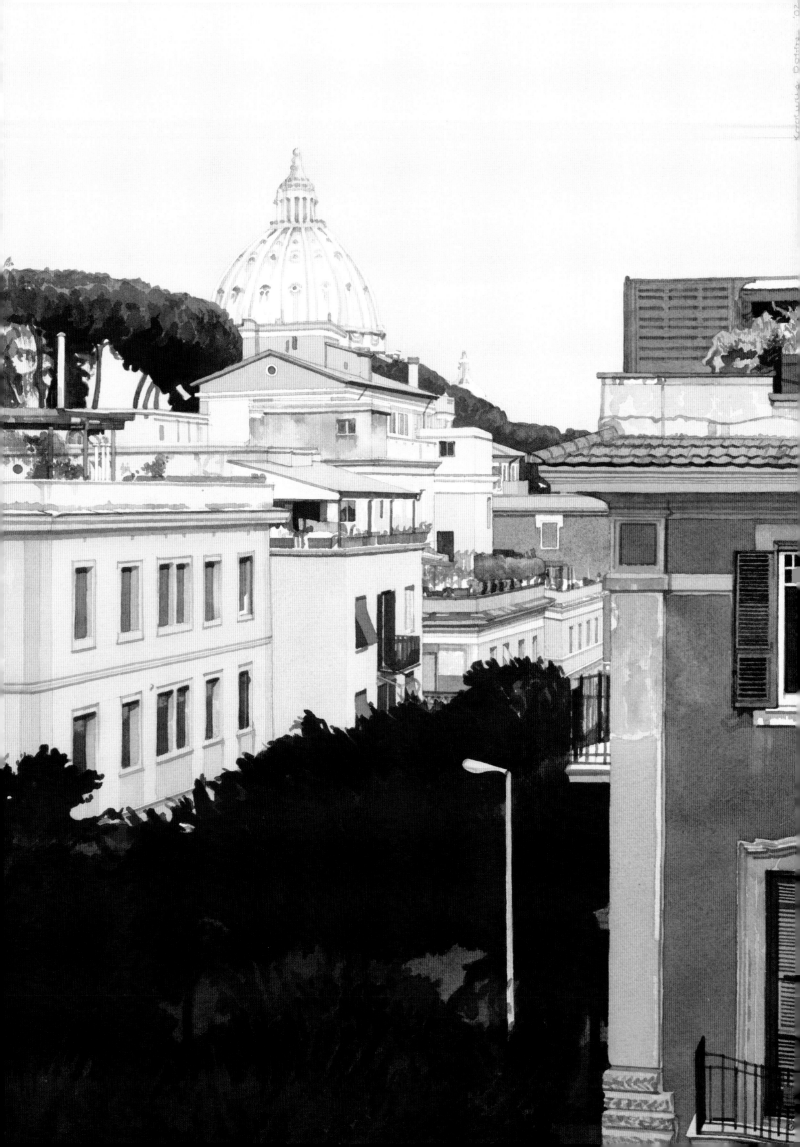

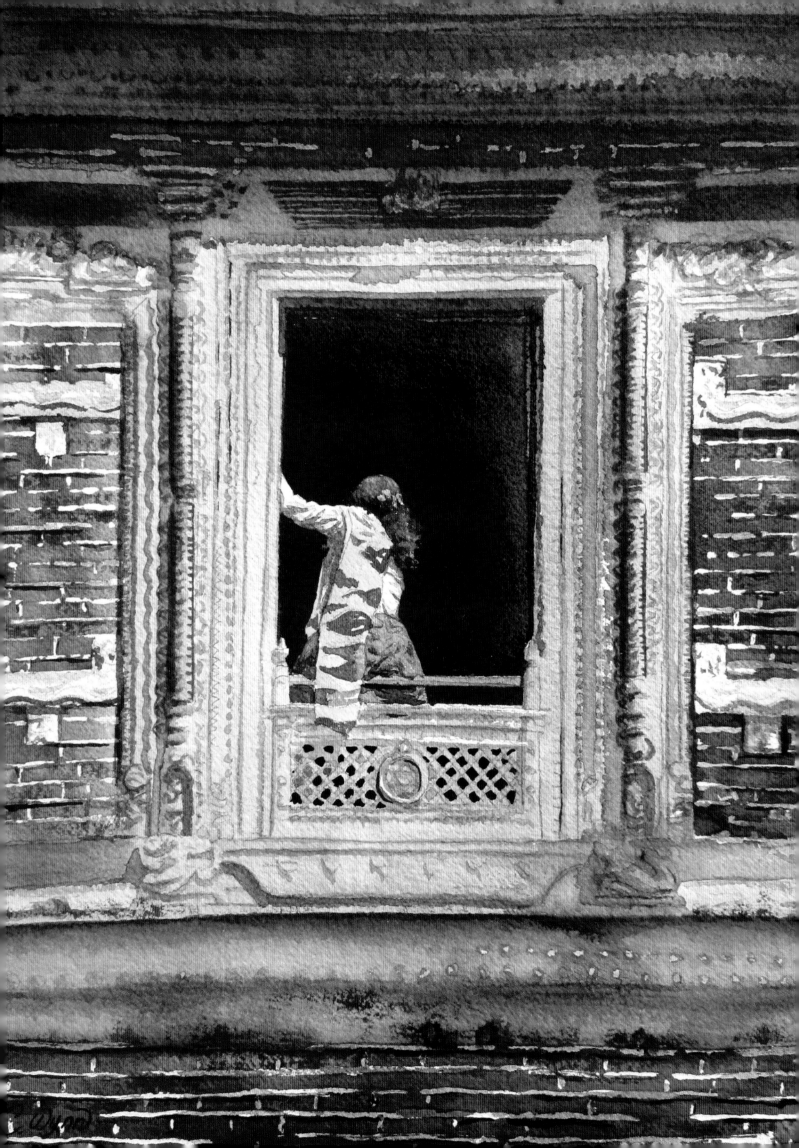

Transparent watercolor on 300-lb. (640gsm) Arches | 14¼" × 10½" (36cm × 27cm)

Before my trip around the world in 2005 and 2006, I lived along the coast of Northern California and enjoyed painting landscapes and seaside scenes. But in my travels, my palette and work took on a new direction upon my doing numerous small studies. The colors, people and architecture of India and Nepal, in particular, captivated me. *Katmandu Window,* completed after my return, reflects the intrigue of that part of the world. I painted masking fluid with very small twigs to suggest the grout in the brick wall, and then flooded and charged the brick with intense reds. While the red paint was still wet, I dropped Phthalo Blue shadows to allude to a tree out of the scene casting a shadow. I composed the woman last and draped her in a colorful shawl as a contrast to her surroundings.

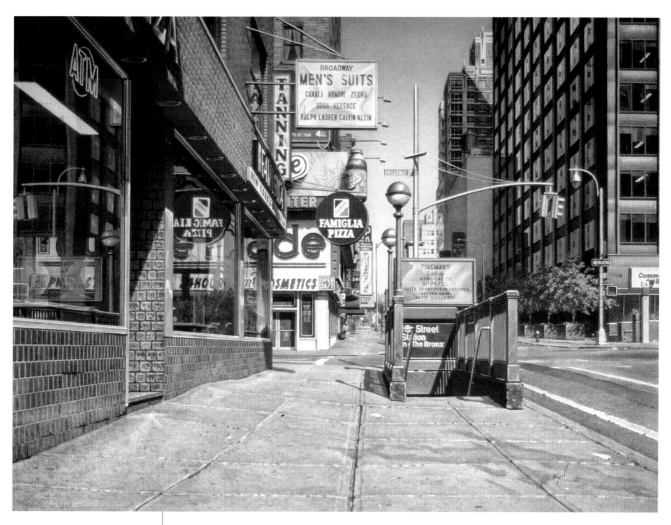

MIXED EMOTIONS | James Toogood
Watercolor on 300-lb. (640gsm) cold-pressed paper | 22" × 30" (56cm × 76cm)

The location, 50th and Broadway, is near a place where I stay when teaching in New York City. It was painted in my studio using many photographs, but more information was still needed. I wanted to change any number of things compositionally. Also, some things were obscured in the photos. So using foamcore, cardboard and Plexiglas, I made some models. I shined a light on the models so that the shadows lined up with the shadows in the photos. Once these areas of the painting were logical and believable, I could then make up other parts of the painting. For example, much of what's in the store window is made up, but it's believable because it's logical.

Let the painting speak for itself. It should not need a verbal explanation.

— ANDREW WYETH
PARAPHRASED

ON THE WEST SIDE | Anne C. Abgott
Transparent watercolor on paper | 30" × 22" (76cm × 56cm)

On a trip to New York City in 2003, I took hundreds of photographs of fire escapes. I have long been fascinated with city shadows and colors, but most architectural paintings I've done have been a disappointment. The introduction of hematite pigments gave me the courage to dig out the fire escape photos. The challenge to keep the color and add texture proved a real adventure. It has been rewarding, with some awards and even sales! My painting style involves virtually no glazing. I like to "get in and get out," mingling the transparent pigments as I paint.

30 SECONDS TO MARS | Jim Petty
Transparent watercolor on 300-lb. (640gsm) cold-pressed watercolor paper | 21" × 31" (53cm × 79cm)

I've recently taken my subject matter in a new direction: urban landscape. I shoot digital photos of people, signage, reflections from storefront windows, buildings, etc. Always looking for an idea that's unique or different, I combine many different photo references together to make a strong image. I make small sketches and then produce a color study that is 11" × 14" (28cm × 36cm). In the study I work out any color, composition or detail issues. The study acts as a guide for the larger finished painting. I always paint the main subject matter first, then move on to the larger areas to set the values. Working in layers, I build up the desired colors I want.

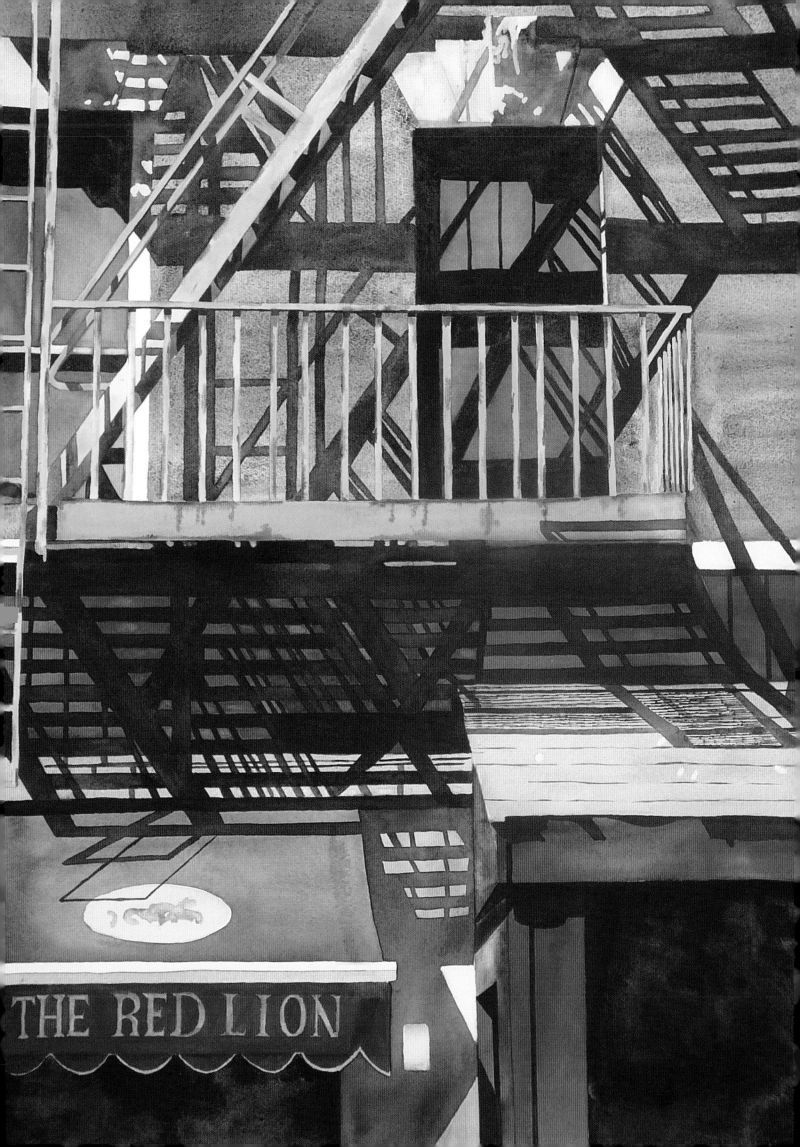

THE RED LION

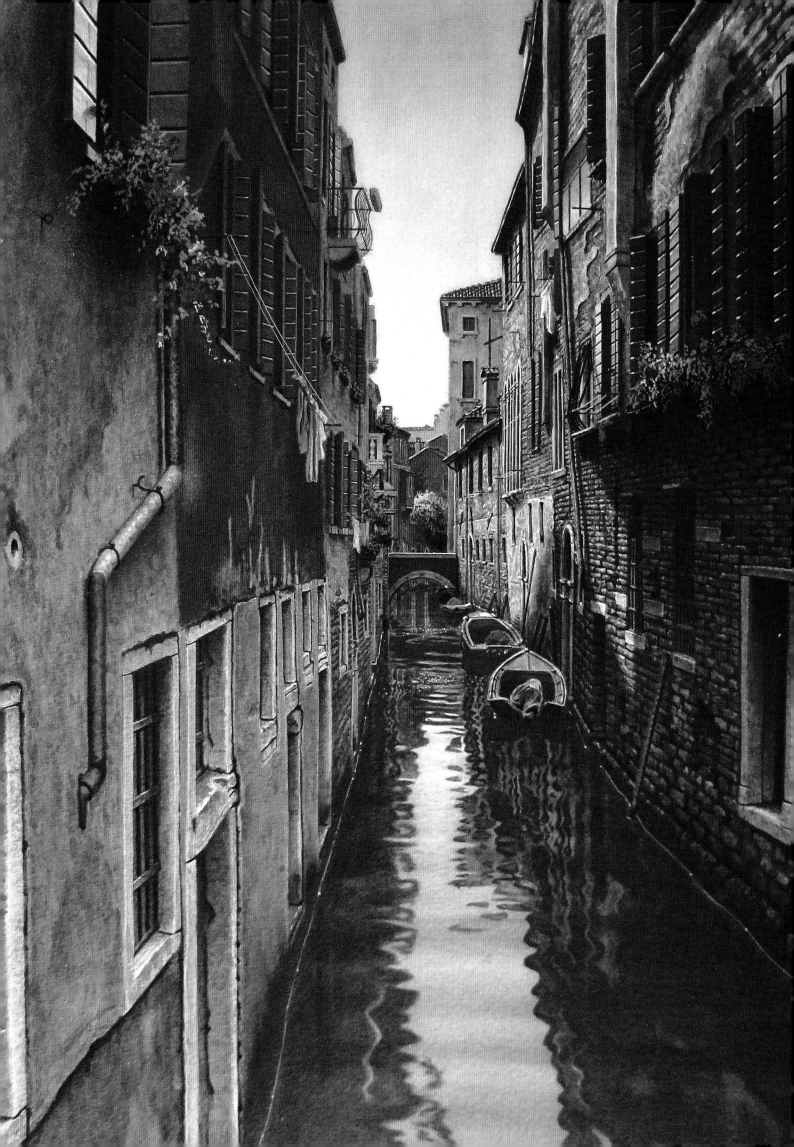

PONGGOL FLATS | Ong Kim Seng
Transparent watercolor on Arches | 52" × 67¾" (132cm × 172cm)

This painting was a breakthrough in many ways. Technically I found that even with such large-format works (unusual for watercolors), the traditional method of painting still could be maintained with well-controlled timing. This helped prevent visible, uneven drying marks, a common problem in huge works. Artistically it was the first time I fused the past with the present in this way. I pass this modern public housing estate in Singapore every day. The area historically housed pig farms. I depicted shadow forms of the sow with her piglets contrasted with areas of sunlight to suggest these links between the past and present. The work was exhibited in our national art museum in my solo exhibition, Heartlands, in 2008.

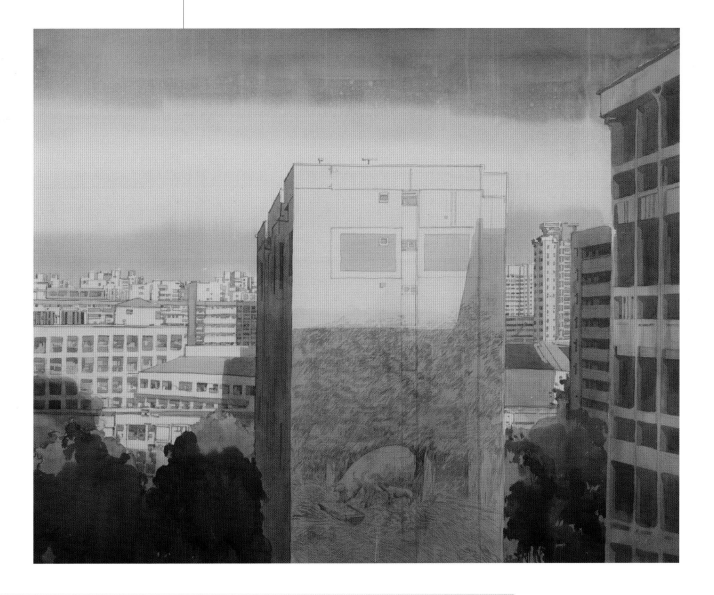

RIO DE LE BECARIE | James Toogood
Watercolor on 300-lb. (640gsm) cold-pressed paper | 30" × 22" (76cm × 56cm)

This painting, done from a series of sketches and photographs, is a view along a narrow canal in the San Polo section of Venice. I decided that a muted palette would best represent its quiet mood. The paints are predominantly quinacridones and phthalocyanines. I began with a wash of Raw Umber over the entire painting. Varieties of Phthalo Green were used to complement the warm tones of the buildings. I used blues mostly to modify other colors except in the case of the laundry on the left.

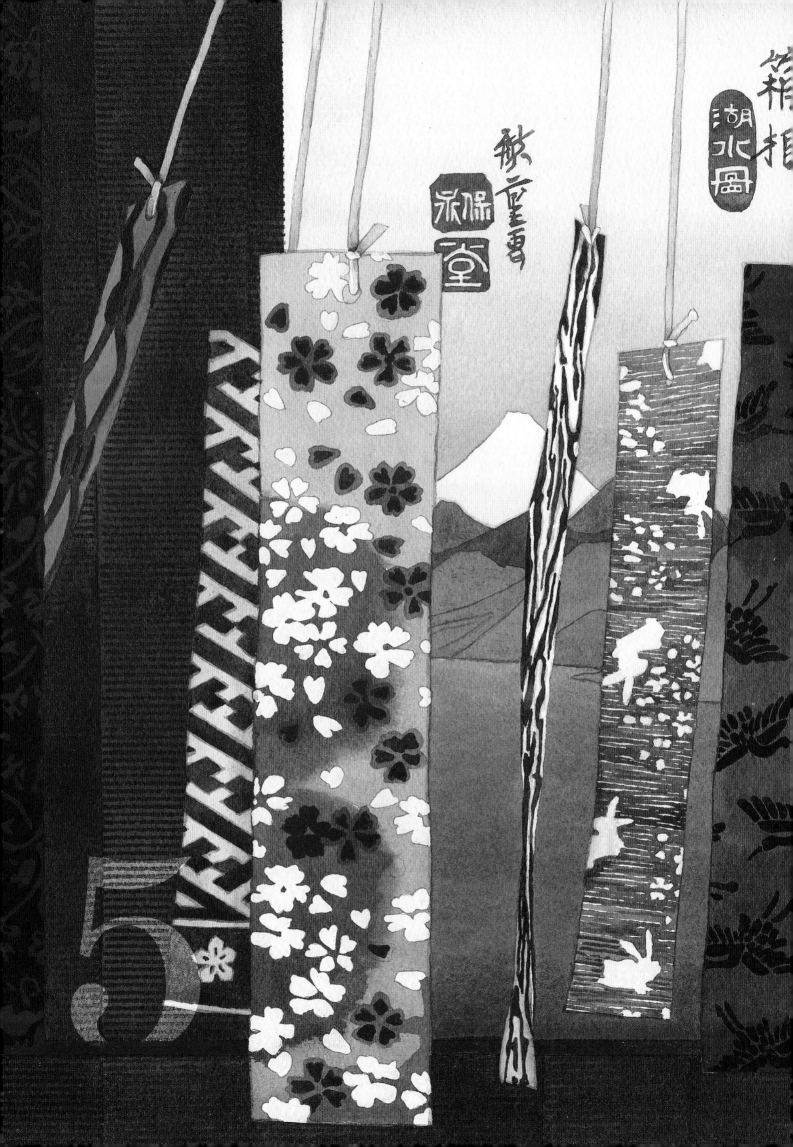

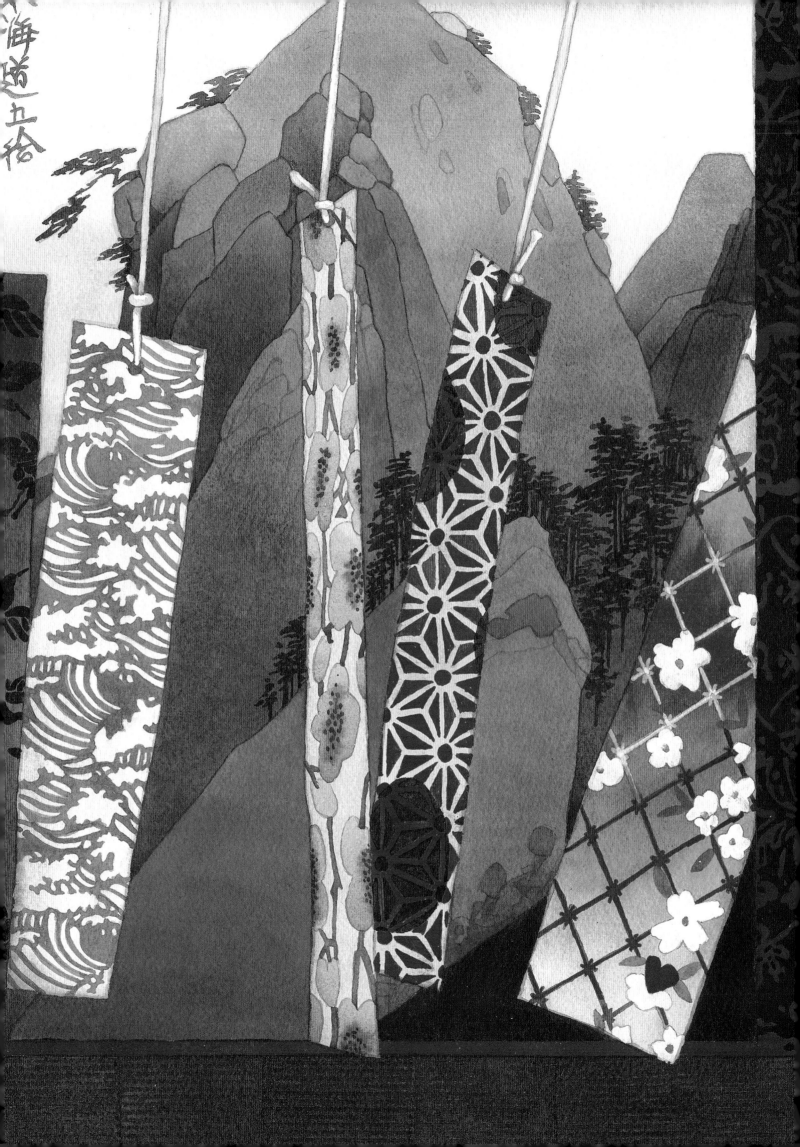

PRETTY PAPER | Judy Morris

Watercolor on 300-lb. (640gsm) cold-pressed Arches | 20½" × 28½" (52cm × 72cm)

My first trip to Japan in 2008 inspired a new direction for subject matter. I found myself intrigued by the horizontal and vertical borders found in many traditional Japanese artworks. I recorded a multitude of stylized patterns that decorated the surfaces of everything from kimonos to dishes. Patterns used as texture in a painting provide what I call "surface entertainment," which encourages extended viewing. I was a calligraphy teacher for thirty years. The Japanese kanji on everything from street signs to menus caught my attention, so I placed a few in my painting. All these elements and a special visit to Lake Hakone, which inspired the background, were combined for my studio painting, *Pretty Paper.*

World of Imagination

Life is either a **daring adventure**,
 or it is nothing at all. —HELEN KELLER

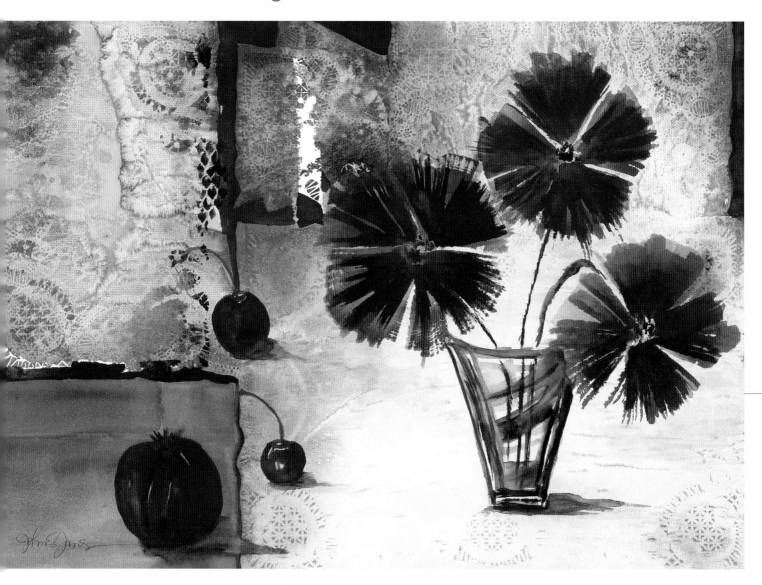

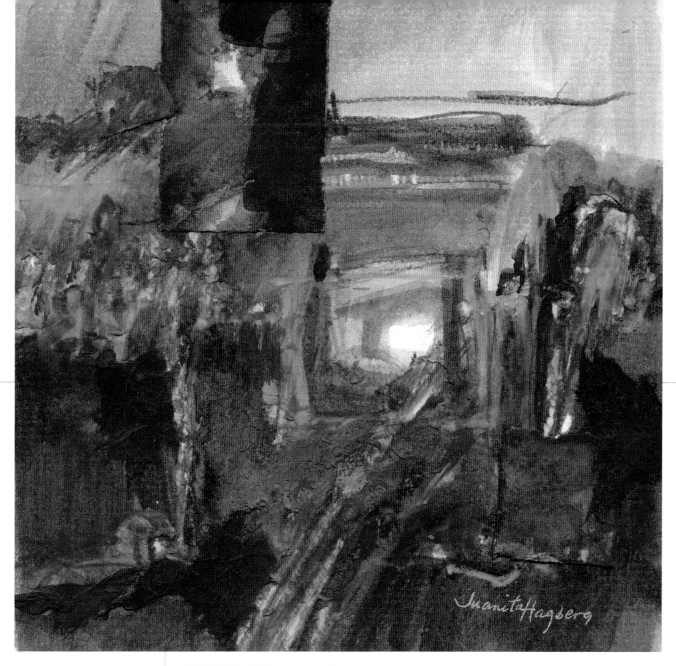

BREAKTHROUGH | Juanita Hagberg
Transparent watercolor, collage and watercolor crayon on archival mat board | 8" × 8" (20cm × 20cm)

I felt a need to go beyond my impressionistic landscapes and explore subjects more abstractly, pushing what could be done with transparent watercolor. I wanted to make art with less-obvious meaning and representation—thus inviting more thoughtful consideration when viewed. I added collage to enhance texture and depth, and watercolor crayon for calligraphic marks. Painting on archival mat board and using square and small formats took me further out of my comfort zone. My memories and experiences suggest forms, colors and design. These personal connections to content can make the art more meaningful.

O'CHERRY 2 | John E. James
Transparent watercolor on paper | 16" × 20" (41cm × 51cm)

I created a design out of paper place mats and then added color (Cerulean Blue, Burnt Sienna and Payne's Gray) while using the place mats as impressions. Once the paint had dried, I changed brushstrokes by using a large flat brush to create more of a jagged appearance to the flowers instead of trying to be precise. I worked quickly on the vase, cherries and pomegranate to keep them loose. With a little redefining of the background and adding shadows, the painting took shape. I like to create texture on an already-textured piece of cold-pressed paper.

SYNERGY 1 | Carol Jones McDonnell
Watercolor and mixed media on paper | 20" × 20" (51cm × 51cm)

Synergy 1 is part of a nonobjective series that explores new ways of using the lyrical flow and translucent qualities of watercolor. Working with watercolor and mixed media is filled with surprises in color and texture. Japanese paper is torn, twisted and folded. A layer of foil surrounds the paper and is crushed to create lines, depth and dense texture. Radiant watercolor flows from one piece to the next, producing a color wheel effect. My paintings express energy, emotion and inner reflection—a celebration of the transformative power of art.

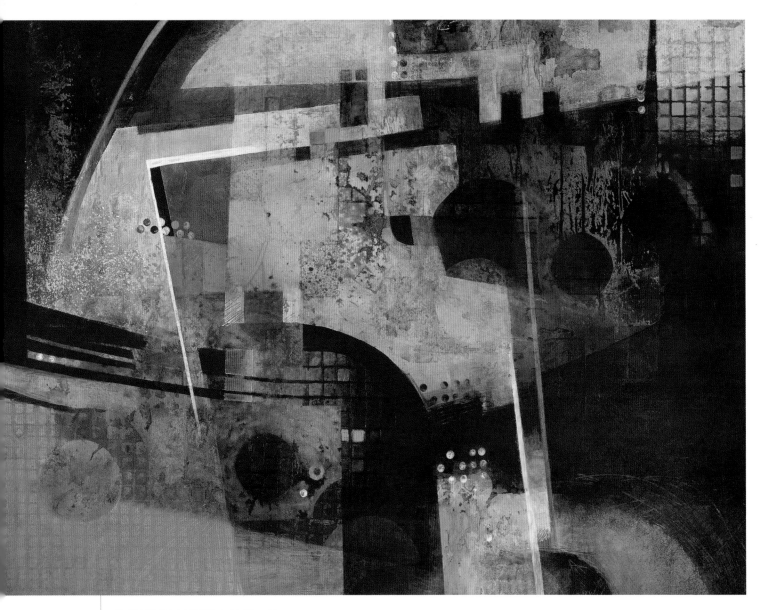

URBAN BALANCE | Kathleen Conover
Watercolor, gouache and acrylic on watercolor paper | 22" × 30" (56cm × 76cm)

Urban Balance is part of a series that melds two divergent painting styles of mine. I love the spontaneous expressiveness of gestural, intuitive mark making. I also love the cerebral design process. My work now encompasses both. I first try to capture an important spark of energy, which I find difficult to interject later in a painting; initially I want some chaos, motion, color disharmony and texture. The texture in *Urban Balance* was achieved with watercolor pours over the plastic grid from a fluorescent light fixture. I then developed and finished this painting according to a well thought out value, color and design plan. The resulting imagery meets my goal of the marriage of two styles, which has become one new beginning for me.

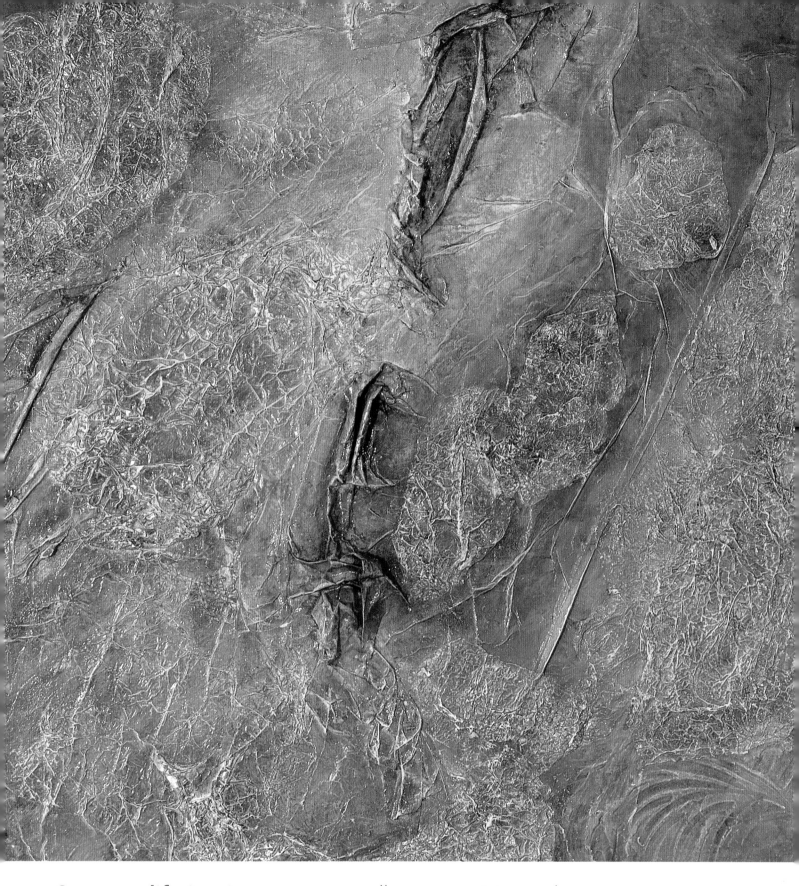

Suppose **life is a journey**, an endless, surprising odyssey
in which we may move from naiveté to wisdom,
from self-consciousness and awkwardness to grace,
and **from superficial knowledge to profound wonder**.

— PETER LONDON
NO MORE SECONDHAND ART

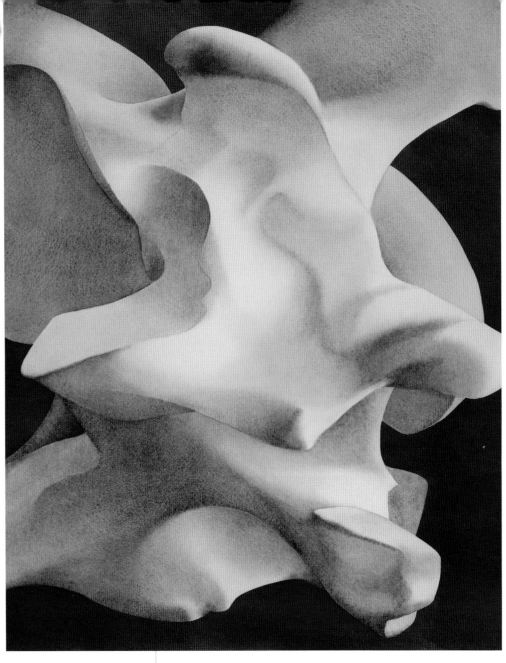

VERTEBRA IN GOLD AND BLUE | Rachel B. Collins
Transparent watercolor on 300-lb. (640gsm) paper | 28" × 21" (71cm × 53cm)

My work is bound by nature's form; nothing I can devise from my imagination can compete in beauty, variety
or drama. Bleached animal vertebrae provided beautiful structure as models, but their lack of obvious color
posed a challenge to me as someone who has concentrated on painting leaves and flowers up close. One day,
I observed a vertebra lit by both a warm incandescent lamp and the cool north light that streams into my studio.
Thus began an adventure that has taught me that the closest possible observation makes a great start but I must
trust the actual painting process, with its successes and its mistakes, to give me the color I need.

SHAPES AND SHADOWS | Anna C. Carlton
Watercolor on 140-lb. (300gsm) cold-pressed paper | 30" × 22" (76cm × 56cm)

Shapes and Shadows was conceived on our back terrace. Fascinated by the shadows, I took photos of this metal
chair for reference and painted from them in my studio. This subject was a new direction for me as I previously had
painted mostly regional plants. I'm captivated by the continuous development and interplay of both the deliberate
and random movements of watermedia, as well as the reciprocal action between color and light. For me painting
is a method of meditation and unconscious play—a dance between my inner being and the paintbrush.

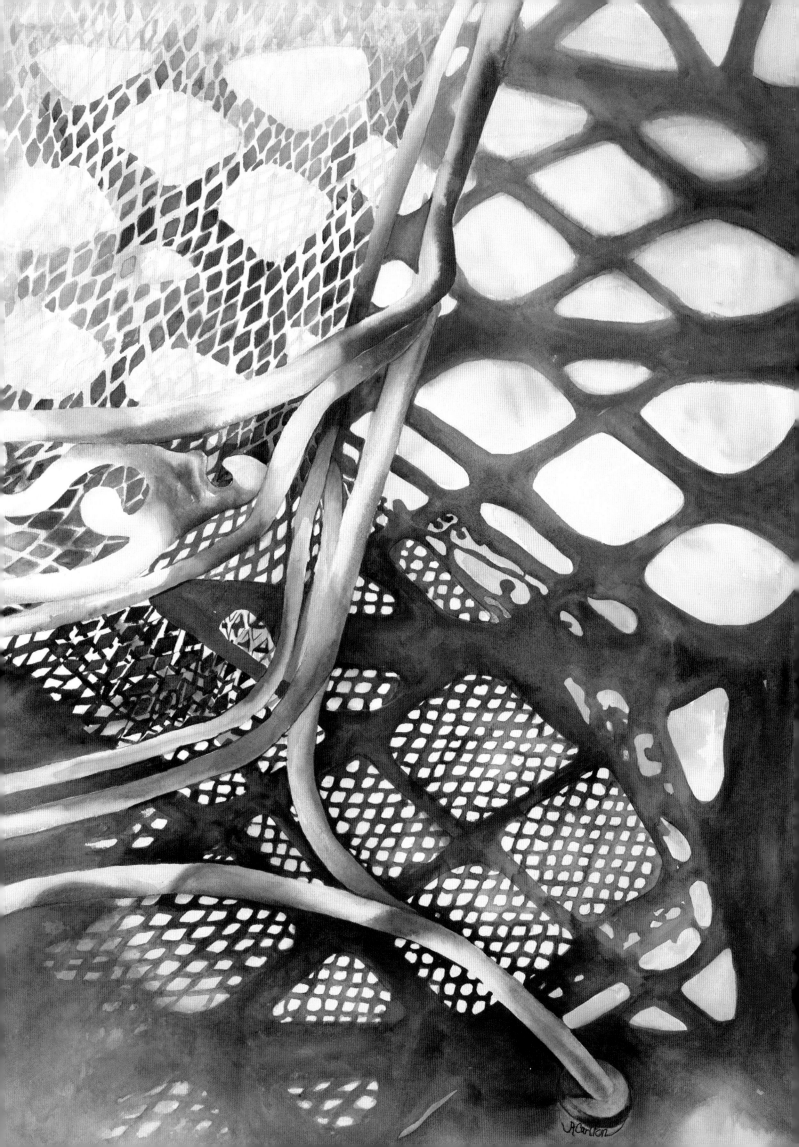

Define a moment in pain and let grace
help you through a transformation. —JUDY LEWLOOSE

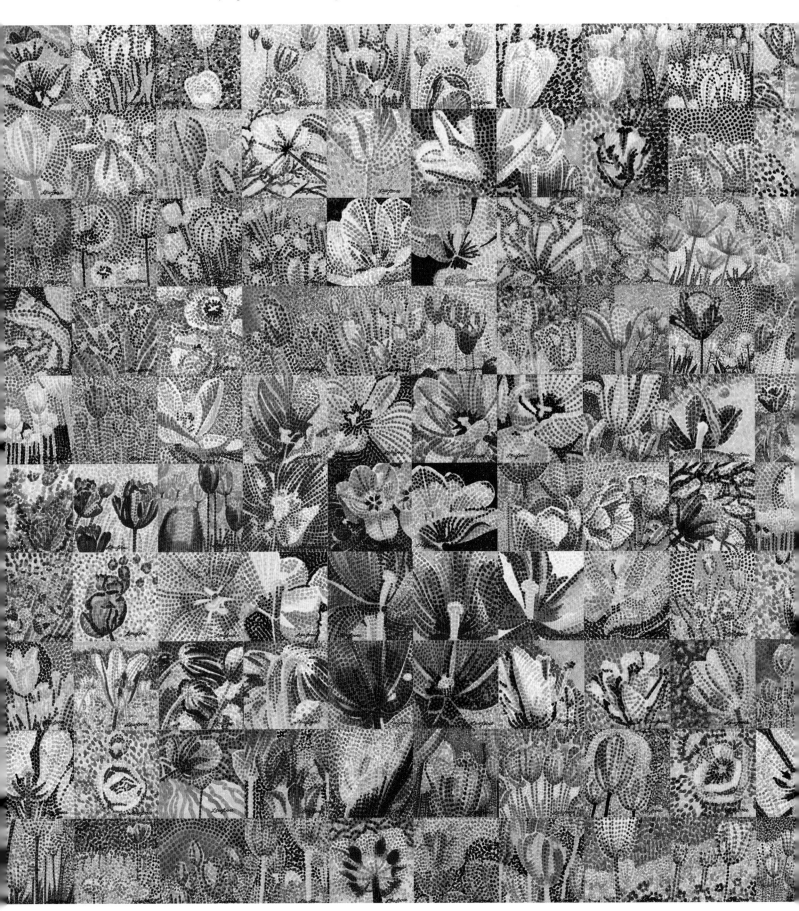

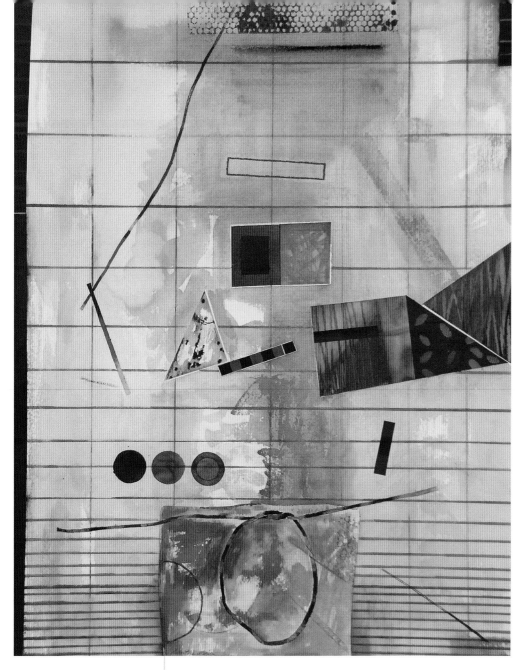

WINDOWSCAPE: REVISITED | Robert Lee Mejer

Transparent watercolor on 300-lb. (640gsm) cold-pressed Saunders Waterford | 30" × 22½" (76cm × 57cm)

Windowscape: Revisited reflects my interest in window vistas and the interplay of inside and outside space. It is, like life, a study of contrasts. The impetus for this watercolor was a review of my early explorations of paper collages and water-based monotypes. I revisited a small 1985 monotype image that was printed from painted assembled elements. The challenge was twofold: to push the boundary of watercolor into the realm of illusion without resorting to the physical use of collage, and to reverse the traditional procedure of working in layers from light to dark, by applying lighter, saturated colors over darker areas. I wanted the light to be internal.

100 TULIP BULBS ON THE WALL | Judy LewLoose

Watercolor on Ampersand Aquabord | 60" × 60" (152cm × 152cm)

My breakthrough came when I developed a watercolor Pointillism technique on Ampersand Aquabord. I had painted 100 single 6" × 6" (15cm × 15cm) tulips and wanted to create a large fleeting tulip image. I laid them out on the floor like a big jigsaw puzzle and organized the squares by color. The Pointillism creates layers of vibrant colors and makes the painting come alive. This new direction is a powerful way for me to connect with my viewers. My goal is to have watercolors gain the same respect as oils and acrylics, with a prominent place in museums.

Every line is a gesture, **like a dance**.

— CAROL Z. BRODY

PARTY PAPERS AND RIBBONS IV | Carol Z. Brody
Transparent watercolor on cold-pressed Lanaquarelle | 22" × 30" (56cm × 76cm)

I am primarily a watercolorist although my work changed direction when I began working in collage. I felt the need to return to painting and to bring some of the feeling of collage into my watercolors. A friend suggested that I start a piece by wetting only portions of the paper and floating in color, the process I used here. That inspired a new beginning. After the paint dried, I worked by "finding" pieces of "collage" (my party papers), glazing negatively around them to complete the painting's structure, and painting pieces with fun patterns and textures. I then added the ribbons for their contrasting and gestural effect, directing the viewer's eye around the painting and tying it together.

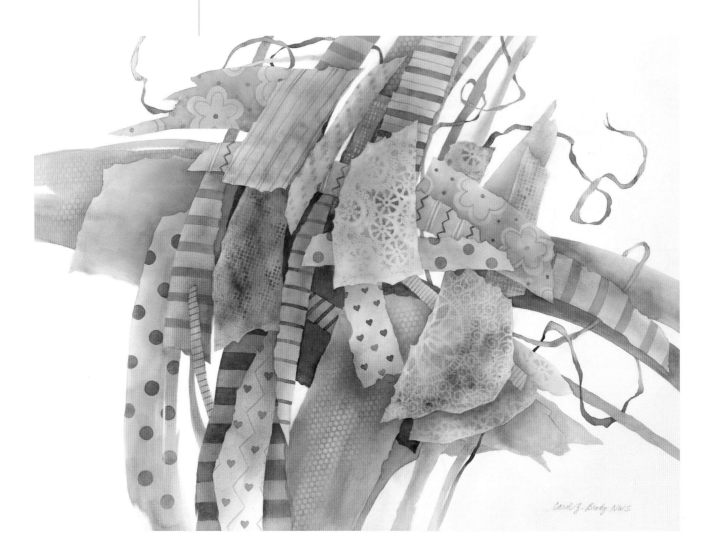

SISTERS | Elisa A. Khachian
Watercolor and gouache on Yupo paper | 11½" × 8½" (29cm × 22cm)

Much of my work has recorded family history in mostly black and white, using watercolor in a very particular way. Rather than using realism (figures and faces) to tell my stories, I started to use my personal, invented symbols. A house shape means home; red checks, warm and cozy; and here I am using the sunflower as my symbol for girlfriend. This story is about my two oldest granddaughters, who are best friends, leaving home and going off to college. I set a miniature still life in the top sunflower, which represents the sister who is at art school. This new way of storytelling has unlimited possibilities.

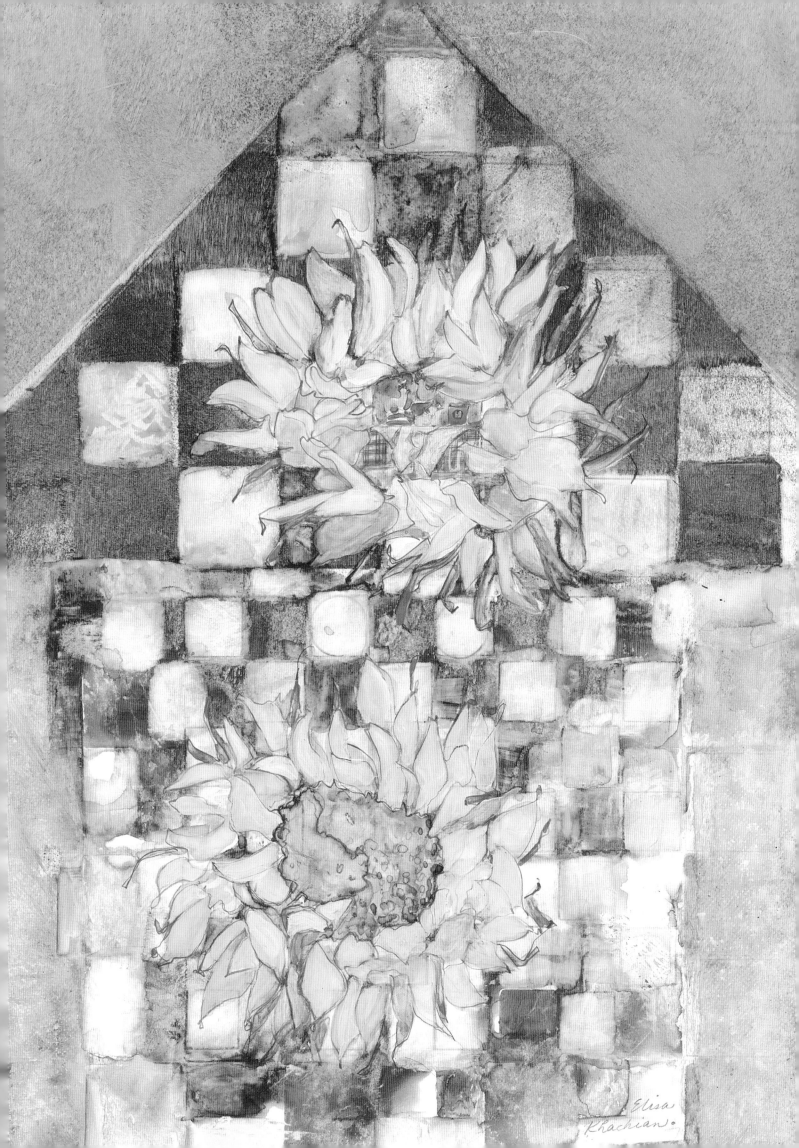

Elisa
Khachian.

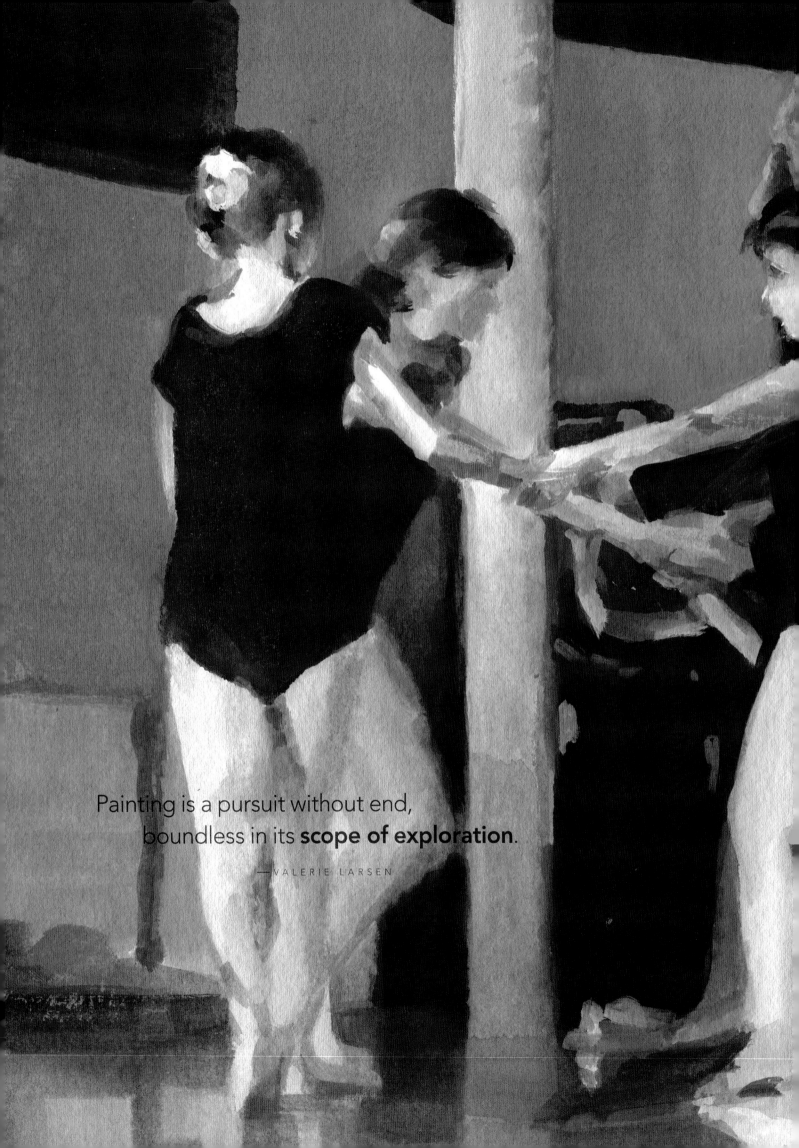

Painting is a pursuit without end,
boundless in its **scope of exploration**.

—VALERIE LARSEN

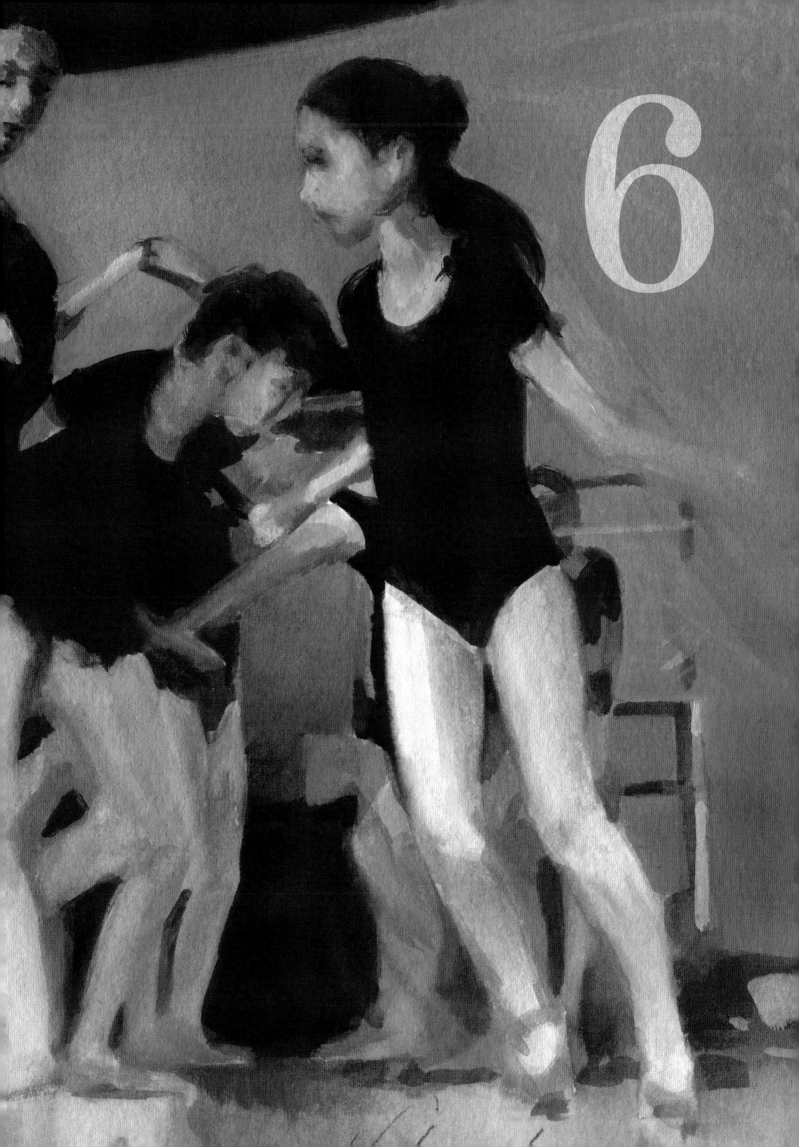

6

FLOURISH | Valerie Larsen
Gouache on paper | 7" × 9½" (18cm × 24cm)

6

Expanding a transparent watercolor palette with opaque pigments broadens the range of expression, allowing for exploration of surface texture, density and finish. *Flourish* is a gouache study created in the studio from fragments of photos taken on location. These were reassembled to capture the movements of the young ballet dancers weaving in and out of their routine. The dense powdery application of paint sets the mood for the interior scene and creates soft edges that suggest movement.

People and Pastimes

A painting is much more than a fixed reproduction of reality; it is the **result of a cascade of decisions** that will make it unique.

— S A N D R I N E P E L I S S I E R

MY SISTER, LISA | Susan L. Harper
Watercolor and gouache on 300-lb. (640gsm) hot-pressed Arches | 12" × 14" (30cm × 36cm)

I love portraits and wanted to paint a family member for some time. One weekend when my sister was visiting, I asked her to pose for some photos. She had just woken up and was not happy that I wouldn't let her put on any makeup, but I wanted her to be natural. I placed her in a north-facing window, where I knew the light would reflect beautifully off her creamy-white skin and copper-red hair. I worked traditionally from light to dark, glazing the figure in layers. I don't typically use masking fluid, but did for the wisps of hair. That was a good decision because my first attempt at the background was dreadful, and I had to scrub it all out, which was very nerve-racking! I did the final touches on the figure with watercolor mixed with white gouache.

ONE OF A KIND: LOUISE | Sandrine Pelissier
Watercolor, acrylic, watercolor pencil and pastel accents on watercolor paper | 21" × 28" (53cm × 71cm)

Despite my daughter Louise's dashing into my studio from time to time, it was only feasible to do this portrait of her (and the one on page 7) from a photograph. I recently started experimenting with some mixed-media elements within my watercolor paintings. I still like my portraits to be realistic, but I'm finding it interesting to add design elements that lead to more contouring of the subject and more abstraction in the background. I have also drawn directly on top of the painting, especially on the face, as a way to reveal the movement and energy of my subject. The juxtaposition of realism and abstraction strengthens the impact of the faces in my paintings.

HANNAH | Bev Jozwiak

Transparent watercolor with graphite on 140-lb. (300gsm) hot-pressed paper | 14" × 22" (36cm × 56cm)

More than two decades of painting has seen my work take some significant turns. Recent influence by oil artists such as David Leffel, Richard Schmid and Charles Mundy was making my work dark and heavy. I began to paint on canvas in acrylic, but as a diehard watercolorist, I just couldn't put down my watercolor brush. The solution was to develop a style that could encompass both my new influences and my affection for watercolor's unpredictable drips and puddles. I now feel that I live in the best of both worlds. As in *Hannah*, I can go from thick, dark and dramatic to light, loose and washy, all in one piece. Who says you can't have it all?

JOHN COMMAND | Robin Berry

Transparent watercolor on 300-lb. (640gsm) cold-pressed Arches | 15" × 22" (38cm × 56cm)

My new direction is portrait and figure painting. For many years it lingered in the background of my interests while I painted everything but. Then I remembered that a *National Geographic* photographer once said that after you've taken all your shots in the obvious direction, turn around; you may find your best view. During a period of deep grief over the illness and loss of my sister, I turned around to discover blessed support and love from countless friends and relatives. And I found the need to speak to these people through my painting. Having matured as an artist, I realized I could paint anything, even people. With timely guidance from artists Ted Nuttall and Carla O'Connor, I began to use portraits to talk directly to individuals. *John Command* was painted from a photograph. John is a dear friend as well as the director and choreographer of a theater I've been involved with for many years. I felt it important to fill the painting of him with all the light and color with which he fills his musical productions.

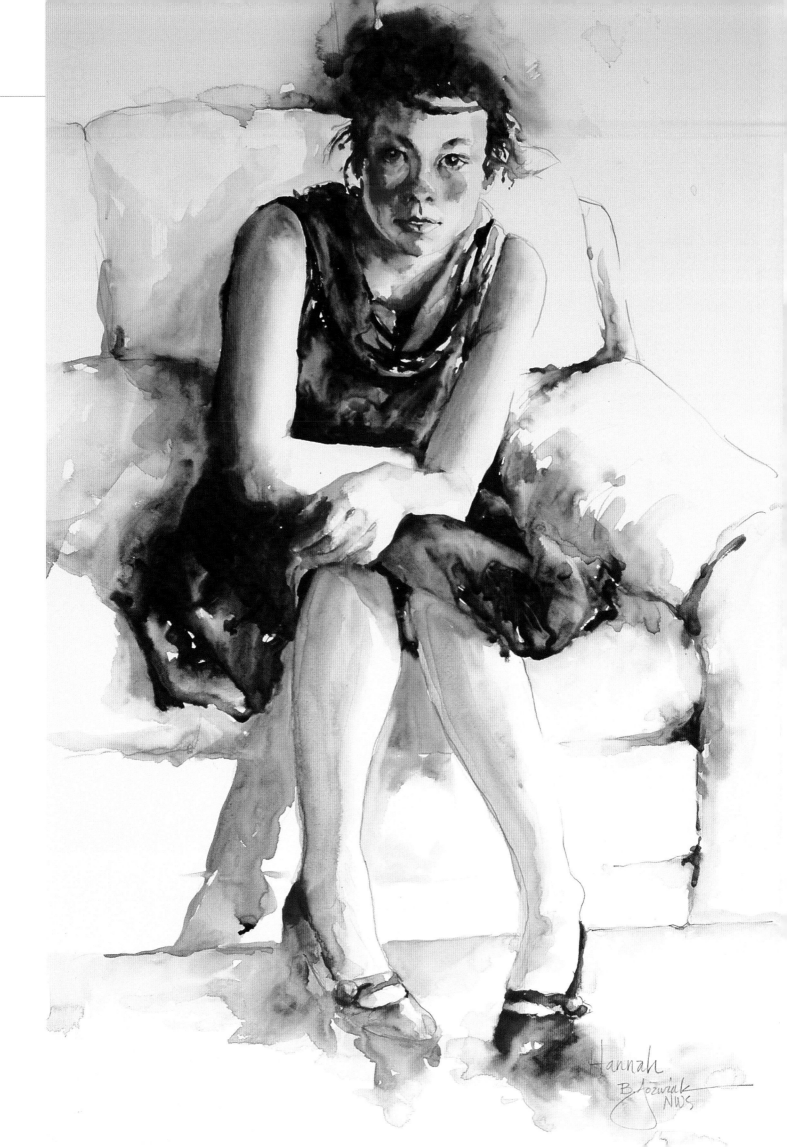

Hannah
B. Jozwiak
NWS

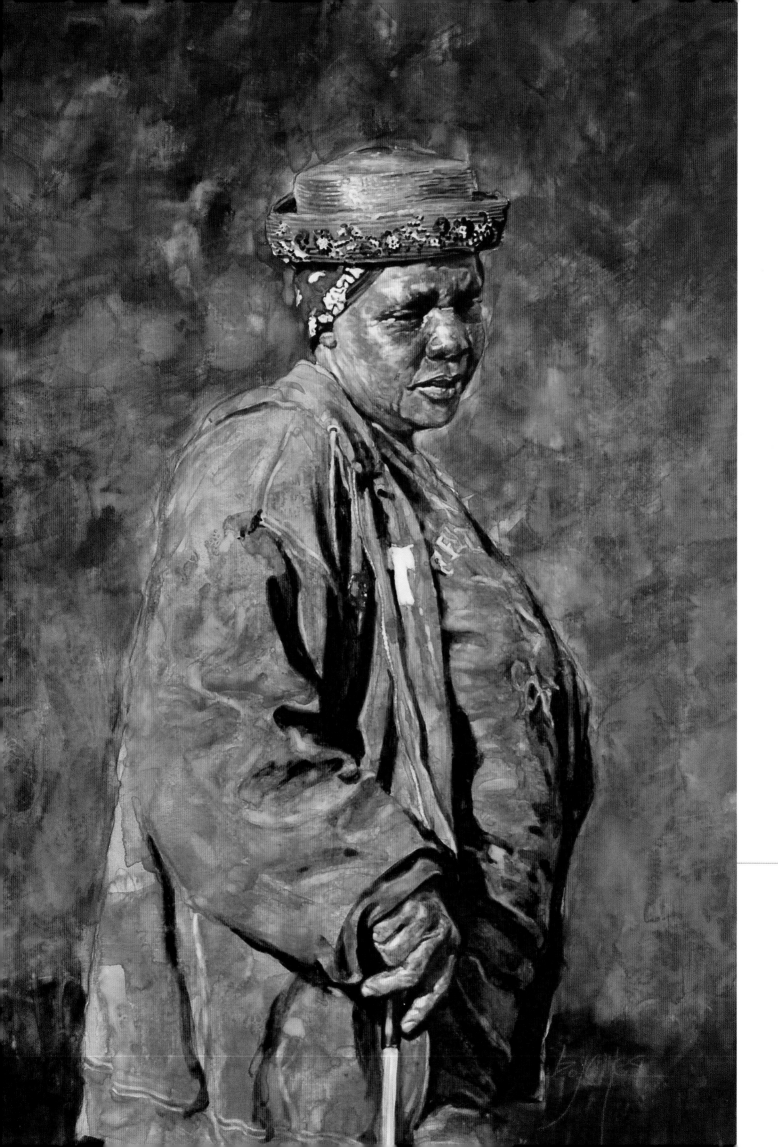

ST. TEMPLE | Zhou Tianya
Transparent watercolor on paper | 28 ⅓" × 41" (72cm × 104cm)

This image is redesigned from photographs I took in Tibet. I wanted to explore the relationship between people and their religious beliefs, and this is one of a series on this subject. With transparent watercolor, I tried to create a style similar to French neoclassical oil painting of the nineteenth century. I looked for a lifelike image, thick and solid in modeling with harmonized color, delicate lighting and good composition. Technically I applied a thick coating and then gently washed off the paint on the surface until the texture of the paper was revealed. Then I worked on every detail several times.

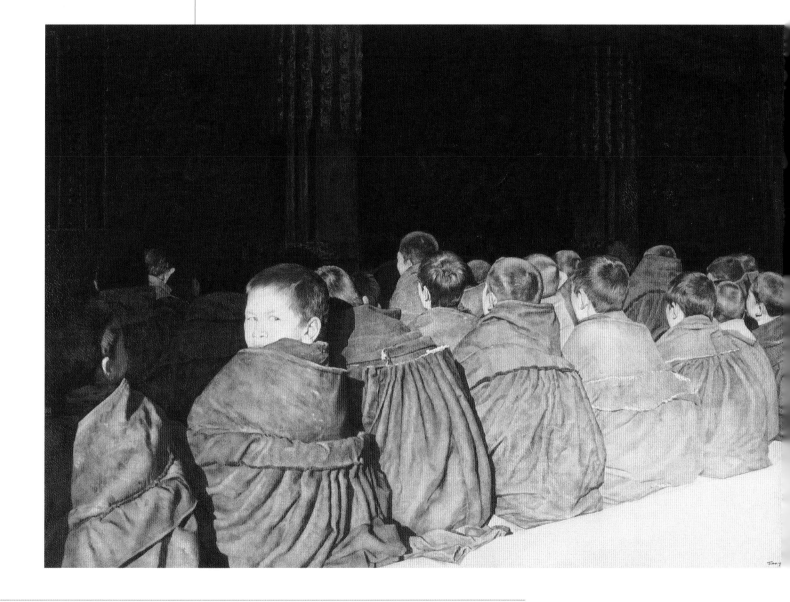

BACK IN THE DAY | Bill James
Transparent gouache on gesso-coated illustration board | 30" × 19" (76cm × 48cm)

I look for unique-looking people—for something that makes them stand out. In this case I first noticed the woman's hat, which was the same beautiful blue color as her dress. I took several photos and selected the best one before I started painting in my studio. With this painting, I wanted to make the background seem more as if it were painted using oils. To complement the blue color of the woman's clothes, I used both umber and sienna browns. After applying the dark colors, I washed over them with lighter colors until they all blended together, a technique called *scumbling*.

THE HAITIAN | Ted Head

Transparent watercolor on 300-lb. (640gsm) cold-pressed paper | 18" × 24" (46cm × 61cm)

Halfway through painting *The Haitian* I had an epiphany. Having painted for only eight years, I found myself painting every subject matter imaginable. I was told to find my niche, but I resisted. I did not want to limit myself; every new painting was a fresh adventure. Then, when I least expected it, my niche found me. I began *The Haitian* by painting the background and the straw hat, saving the detail for the face. As I looked into this stranger's face, I wondered what had brought him to this moment in the Haitian marketplace where the photo was taken. I thought about the other portraits I had done and how they had brought me the greatest pleasure in my watercolor journey. As I glazed the skin tones with layers of New Gamboge, Burnt Sienna, Raw Umber and Ultramarine Blue, I realized that everything I'd learned was coming into play in this painting. As I finished the last brushstroke, I knew what my new direction was going to be—not just portraits, but characters whose faces hold a story, a dream, a mystery. I can't wait to see what the next eight years will bring.

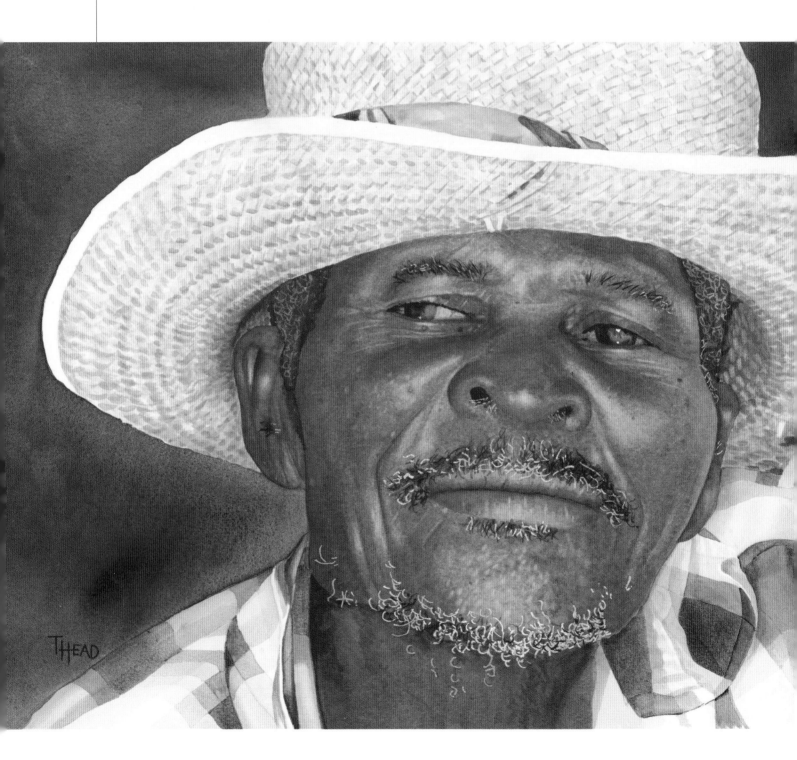

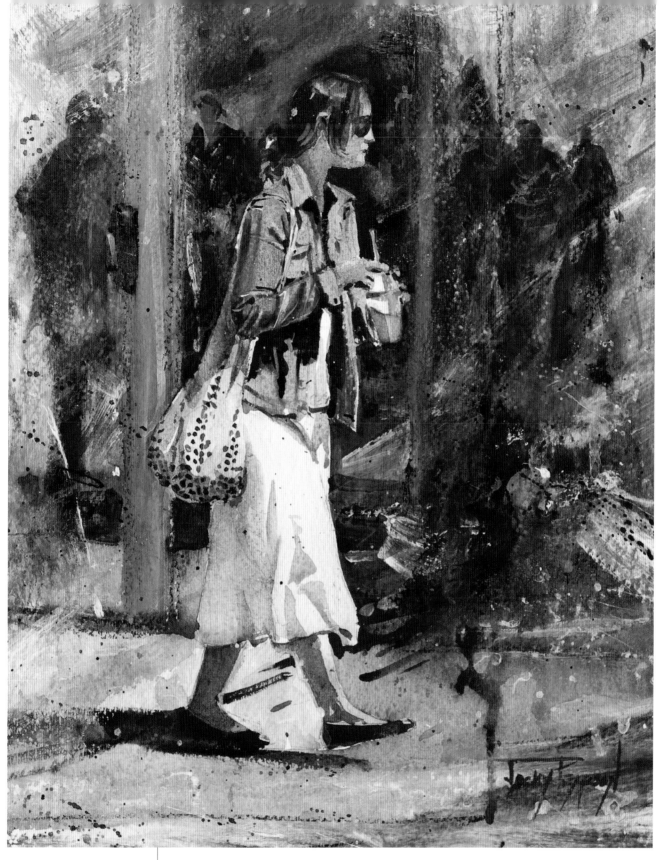

SUMMERTIME | Jacky Pearson

Transparent watercolor with gesso on cotton rag paper | 12" × 9" (30cm × 23cm)

A big change to my painting style occurred when I was introduced to the pointed squirrel mop brush. It is made from such fine, dense hair that large quantities of paint and water can be picked up and smoothly spread over the paper to create wonderful, even passages of glowing colors. The brush also is a one-stop shop. Its lovely pointed tip can be dipped into thicker pigment to create detail, so there's no need to change brushes. For a quick, Impressionistic style, these brushes are ideal. In *Summertime*, while the background was still wet, I flicked a few brush marks with gesso, which produced some interesting effects when mingled with watercolor.

TEXAS ASSETS | Cheryl Sutter Wooten
Transparent watercolor on 140-lb. (300gsm) cold-pressed Arches | 10½" × 15" (27cm × 38cm)

A new life direction—being suddenly single—led to a new direction in painting. I moved to a tiny farm in the Texas countryside. Fodder for a painter, I thought. However, the many farm projects were a distraction from painting, and the humidity, wind and fire ants sent me looking for a suitable studio/gallery. A local artist introduced me to the beauty of Western art. My challenge was to use watercolor and humor to lighten up the serious look of traditional Western art. For this painting I modified a photo to tell my story and used a traditional dry-brush multiple-glaze method. Careful observation of values, color and details was critical.

THE BLACKSMITH | Dennis Albetski
Transparent watercolor on paper | 20" × 14" (51cm × 36cm)

In the past I did formal portrait work. The person or group sat before me straight on as I captured a likeness in a serene setting. Though it was lucrative, it became very mundane, not at all challenging. Now I strive to create a portrait of the whole person, with a sense of what she is known for or enjoys doing. This brings the viewer into the life of the subject, creating a kind of relationship. Going from the generic stiff portrait to a relaxed living portrait has challenged me and helped me grow as an artist. *The Blacksmith* was created from quick sketches and color studies done on location, along with photographs of the subject and work tools at different angles.

An artist should be **intoxicated with the idea** of the thing he wants to express. —ROBERT HENRI

7TH INNING STRETCH | Tom Francesconi
Watercolor on cold-pressed watercolor paper | 14" × 21" (36cm × 53cm)

7th Inning Stretch is a directly painted vignette that incorporates the white of the paper as an important part of the design. My new favorite subject is the figure. I have been primarily a landscape painter, but I have had growing interest in the figure as subject matter. My early attempts with this new direction were disappointing, but never defeating. I began painting head studies and eventually the full form. Observing and painting the figure have given me a heightened awareness of my world as well as increased fulfillment as a painter.

Don't be afraid to go out on a limb.
That's where the fruit is. —H. JACKSON BROWN JR.

REVERIE | Dannica Walker
Transparent watercolor on 300-lb. (640gsm) cold-pressed Arches | 20½" × 20" (52cm × 51cm)

After observing a young woman sitting alone, obviously deeply troubled by something, I started thinking about our inner lives and thoughts. I had already been kicking around the idea of incorporating some abstract elements into my mainly realistic painting style. So I started thinking what I could do to help convey what I wanted to say. I wanted to suggest an inner private moment, and I eventually hit on the idea of swirling leaves to suggest her swirling thoughts. I pushed this painting toward a dominant cool, which makes her skin and lips especially warm. I also chose to keep all the values subdued except on her face and her glorious head of hair.

Transparent watercolor on hot-pressed watercolor paper | 22" × 18" (56cm × 46cm)

I began *Pop* as a demo in my drawing and painting class. The students had asked me to do a watercolor painting. I hadn't painted with watercolors in more than ten years, but another faculty member told me about using gesso as an undercoat on hot-pressed watercolor paper—a new approach for me. I prefer to paint from life, but my dad would not sit still, so I decided to use a photograph for this demo. Using watercolor paper to which I had previously applied gesso allowed me to pick out the highlights in the painting. I used simple shapes because I was not interested in details for this painting. I wiped and rubbed the painting until I got something that I liked. This was an interesting approach, which I continue to employ.

THE OTHER SIDE OF THE MOUNTAIN | Leslie Wilson

Watercolor on paper | 22" × 30" (56cm × 76cm)

This painting was from a photograph. I enjoy finding opportunities to weave light and color throughout my paintings, incorporate lost and found edges, and exaggerate color. I begin with a contour drawing and apply paint with control, striving for a spontaneous effect, whether working from a photograph or en plein air. Although I'd been painting with watercolors for more than twenty years, in 2007 I took a new direction and left my corporate position to follow my passion for watercolor painting full time. Since then, I have worked to develop my knowledge and technique, and painted en plein air at every opportunity. Our Northern California location provides unlimited inspirational material and great weather to pursue watercolor painting to its fullest.

Draw what you see,
and see what you draw.
—ALEXANDER BOSTIC

I really got excited about painting this scene of my brother. I love strong value contrasts, and I especially wanted to portray the reach of the dim lamplight in the otherwise shadowy room. I also loved the mood created by Paul's relaxed pose in this familiar camp setting. In this painting I applied my dark values in a new way. Rather than glazing with layers, I painted the darks section by section, using a variety of muted colors in a narrow range of values. I hoped this would allow me to introduce more color into the shadows while retaining the overall feeling of darkness on this quiet evening.

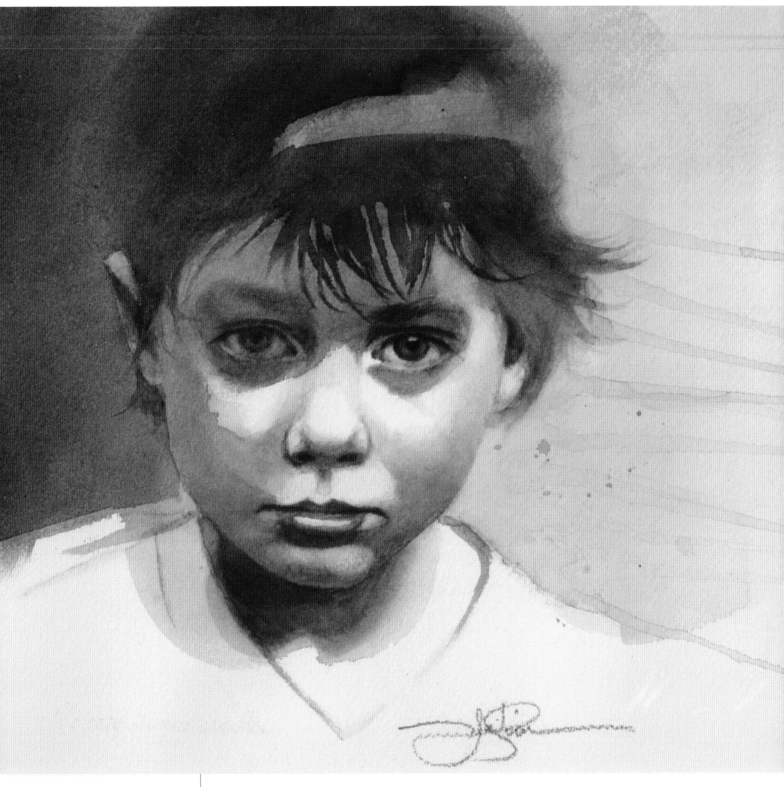

MY BOY KANE | Tom Heflin

Transparent watercolor on Fabriano | 8½" × 9½" (22cm × 24cm)

My Boy Kane was painted from a photo I took in our backyard. Returning home one day last summer, I found Kane in the backyard. His face was dirty with traces of tears running down his cheeks. I had my camera, so I took a quick shot before lifting him into my arms. His distraught expression immediately changed into a big smile complete with dimples. This is pure watercolor with no masking fluid. It was tempting to refine, but I decided I liked the freshness of the sketch just the way it was. I used a limited palette of Burnt Sienna, Ultramarine Blue, Medium Cadmium Yellow and Cadmium Red—my first attempt at doing a portrait in watercolor.

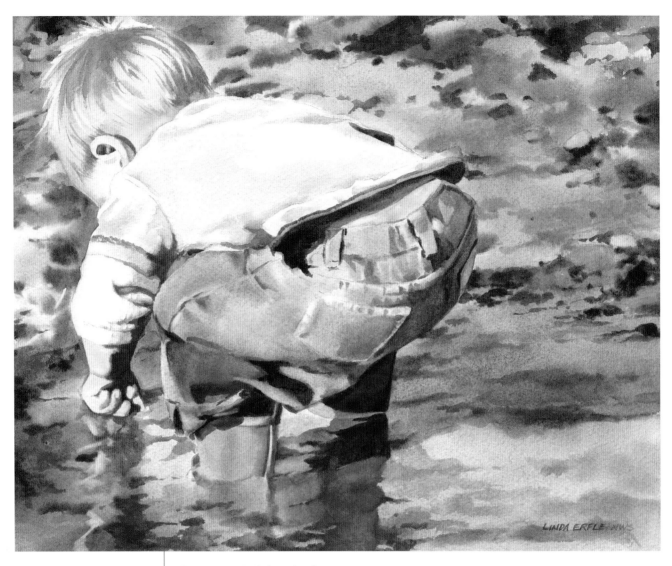

GREEN BOOTS | Linda Erfle
Transparent watercolor on 300-lb. (640gsm) cold-pressed Arches | 12" × 15" (30cm × 38cm)

Plan carefully, **paint quickly**.

— L I N D A E R F L E

Rather than painting people staring back at the viewer, I have begun to create intrigue by not revealing facial features. I involve the audience through my subject's body language and also through depictions of what my subjects find captivating. The camera allows me to capture my subjects spontaneously and without disturbing them. I often shoot dozens of photos for a painting. Each painting begins with an accurate sketch and is painted using a damp-into-damp technique, which means the front of my paper is damp, the back is wet, and the brush is damp, but loaded with plenty of pigment so I must paint quickly.

CEREMONY | Fealing Lin
Transparent watercolor on watercolor paper | 16" × 12" (41cm × 30cm)

Using a photo as a reference, I started *Ceremony* as a demonstration for my class and finished the final touches in my studio later on. Since this native woman was overexposed by sunlight, I kept the values of layers quite light in order to show off the transparent quality of the watercolor. Toward the completion, I added darker values to achieve the contrast and depth. In this painting I tried to use very limited details with more abstract shapes in groups and layers. I've found myself working more and more toward abstraction within my representational subject matters. This is becoming my goal for future artworks.

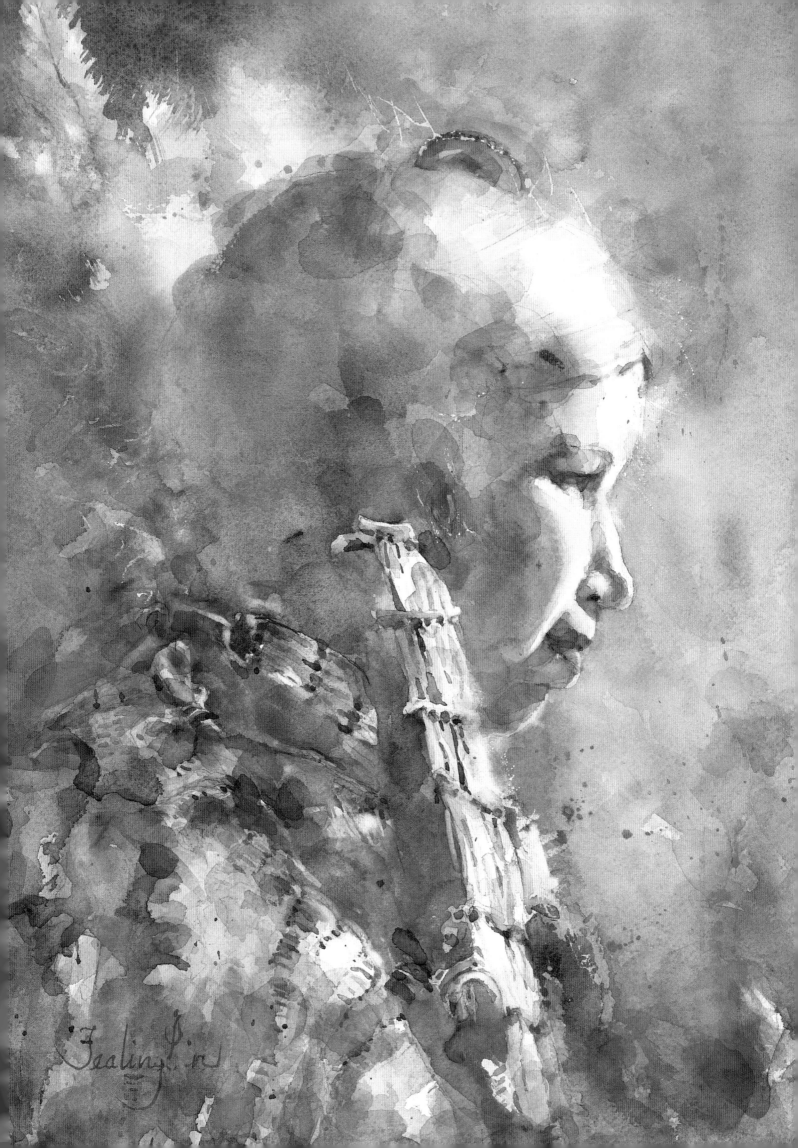

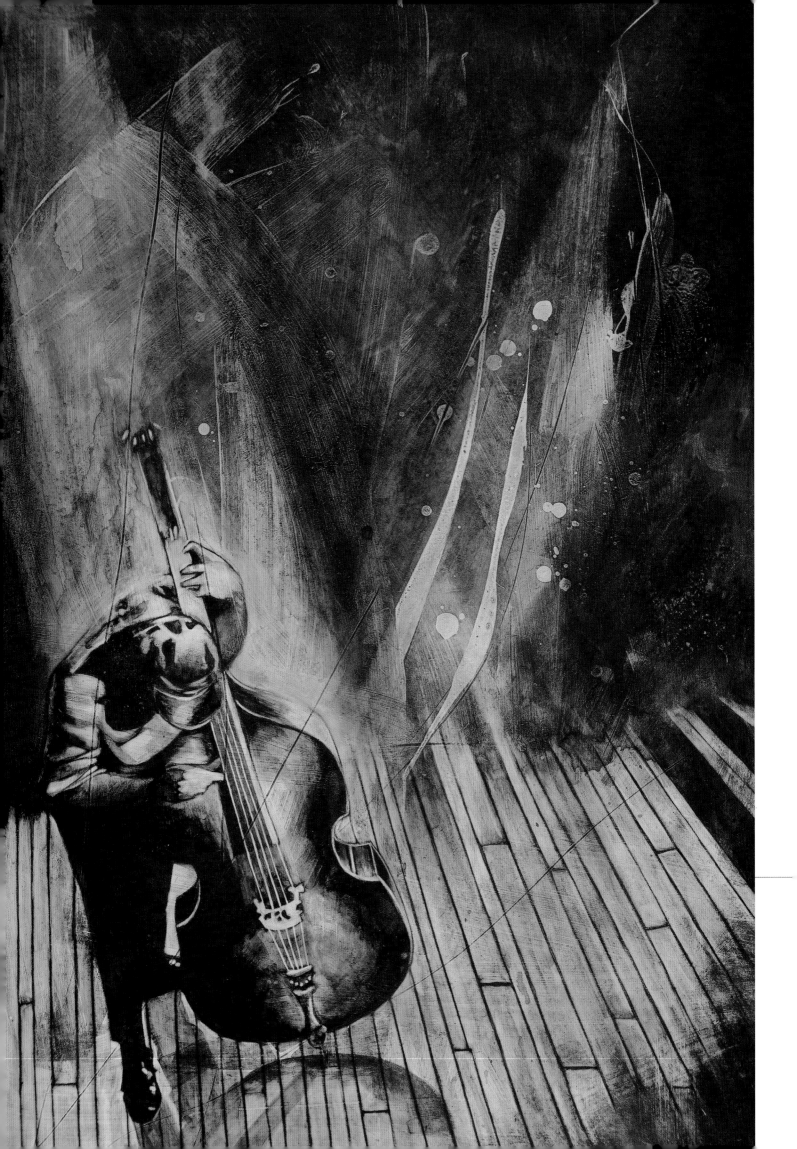

BLUEGRASS FOREVER | Al Zerries
Transparent watercolor on paper | 28" × 36" (71cm × 91cm)

My husband Al never painted without water, paint or music. Most of his final year's paintings depict musicians. *Bluegrass Forever* was inspired by a duet at a folk music festival. *Soul* (page 5) turns the emotive lead singer of an a cappella quartet on Prince Street in Soho into a one-man quartet. Music is art that floats on the air; I believe that these two paintings capture that idea on paper.

IN MEMORIAM. AL ZERRIES PASSED AWAY DURING THE BOOK'S PRODUCTION. HIS WIDOW WROTE THIS CAPTION.

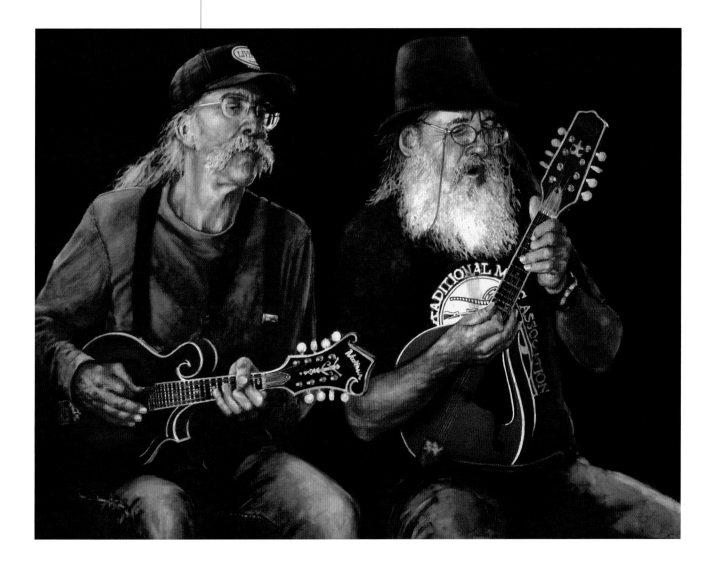

MAN WITH STAND-UP BASS | Jaya King
Gouache on textured Masonite | 33¾" × 23" (86cm × 58cm)

One day I came across some old barn wood and said, "I can't just throw this out! This is awesome!" When I prime old wood with gesso, I love how the texture of the knots and cracks shows through. After applying a layer of four to five colors of gouache in a fairly muddy fashion, I use white transfer paper and a white water-soluble pencil to draw the image. Using stiff nylon brushes, I begin to lift off the gouache, exposing the white gesso underneath. The rough, time-weathered texture changes the mood of the piece dramatically.

7

The past often **inspires us** and
reveals itself in the present.

—STEVEN A. WILDA

THIS SIDE OF TOWN | Steven A. Wilda

Transparent watercolor on 300-lb. (640gsm) Arches | 11¾" × 16" (30cm × 41cm)

I work primarily in graphite, so this is a rare color approach to the deteriorating, weathered subjects that I'm always drawn to. For me there is a fine line between commercial and fine art; for years I hand-lettered signs. After masking off the subject, I applied numerous background washes to achieve its deep value. Details in the contrasting white and rust were layered in washes and stippling techniques. I purposely created this artwork in my usual precise, controlled manner.

Birds and Other Friends

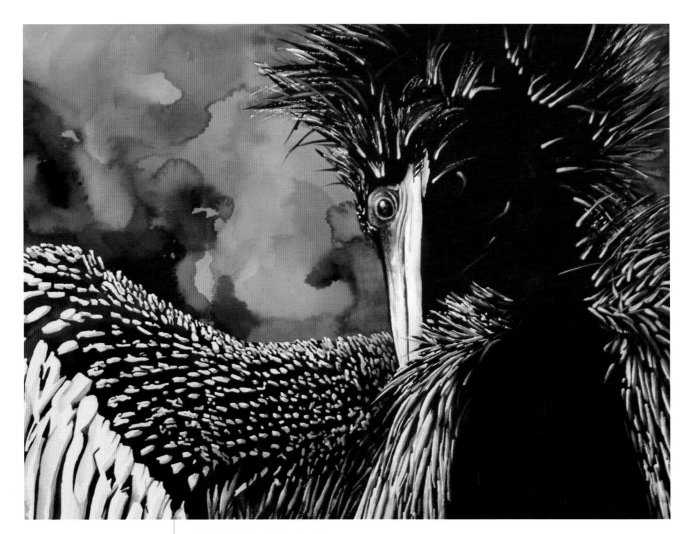

ULINGUS | Jody Henderer Burns

Watercolor on 300-lb. (640gsm) paper | 22" × 30" (56cm × 76cm)

I have come to understand that the things we grow up with affect our lives more than we realize. I watched my grandfather feed the birds and heard his words about their habits and songs. I sat in awe of my mother as she carved feathers into her wooden bird sculptures and painstakingly painted every detail of each songbird. My father would then put the feet on and mount the birds for her. My daughter took me to my first bird show—I took photos of the birds with the camera my son gave me. I was amazed by the personalities of each. My family's love of birds has moved me in a new direction of painting; I think I now paint birds to pay tribute to the people I love.

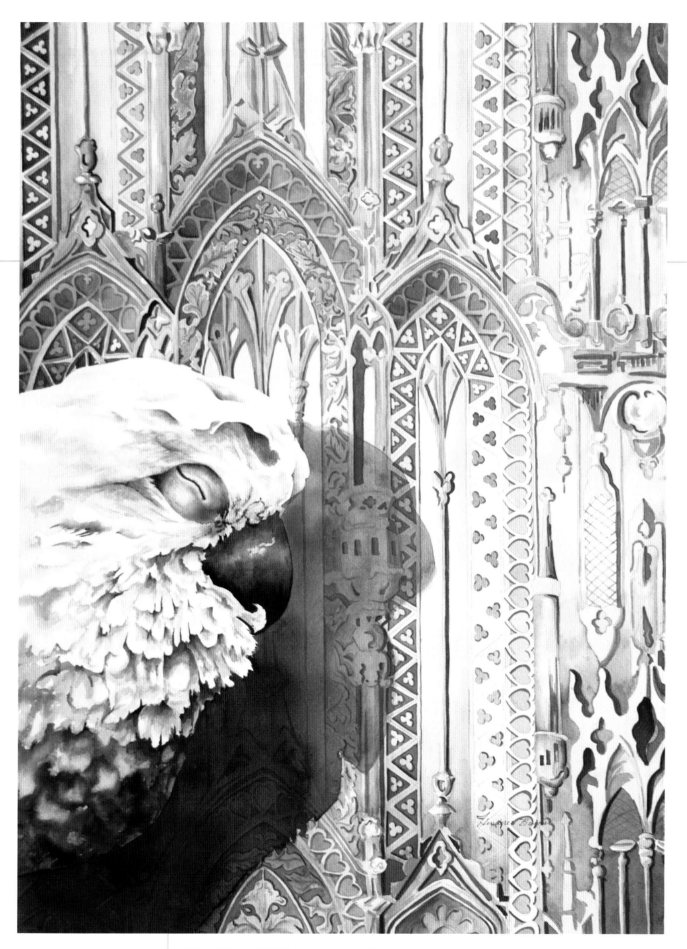

IT'S STILL A CAGE | Jody Henderer Burns
Watercolor on 300-lb. (640gsm) paper | 30" × 22" (76cm × 56cm)

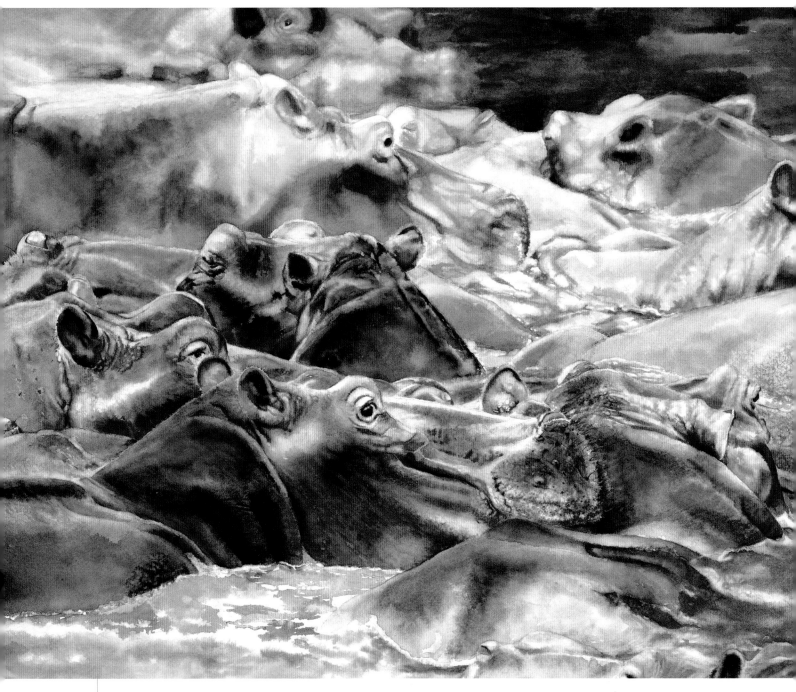

FOURTEEN HIPPOS | Linda DuPuis-Rosen

Transparent watercolor on 300-lb. (640gsm) paper | 20" × 30" (51cm × 76cm)

This painting became a turning point for my style. This was not merely an animal portrait but a composition of form and light with interaction and movement. I ventured beyond the photograph and painted my personal impression of the hippos at that moment. I established a painstakingly slow underpainting for clear direction, which allowed me to keep the forms loose in the background and avoid becoming lost and frustrated in endless details.

HEADS OR TAILS | Kathleen Maling

Watercolor on 300-lb. (640gsm) cold-pressed Arches | 22" × 30" (56cm × 76cm)

There is something about a prehistoric and dangerous predator that ignites our curiosity and imagination. My fascination with these beautiful reptiles has led to a series of alligator paintings. I love the way their scales fit together like puzzle pieces and how the sun illuminates them. I've taken numerous photographs of them in various settings. I print them out and experiment with different colors on the printouts using watercolor pencils to get an idea of how they will work before applying paint to paper. I enjoy working in series and can't think of anything more wonderfully consuming than exploring the different angles and lighting of new subjects.

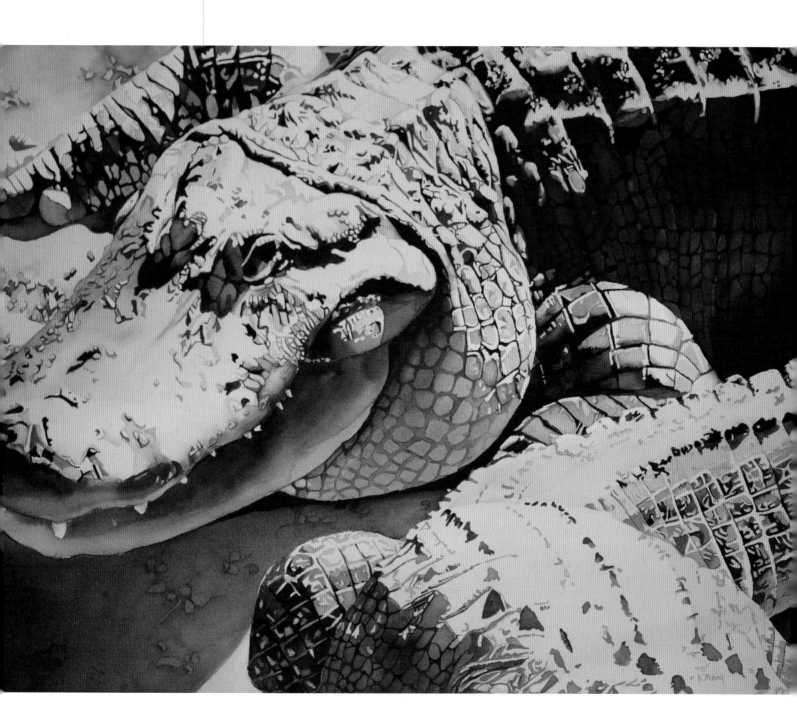

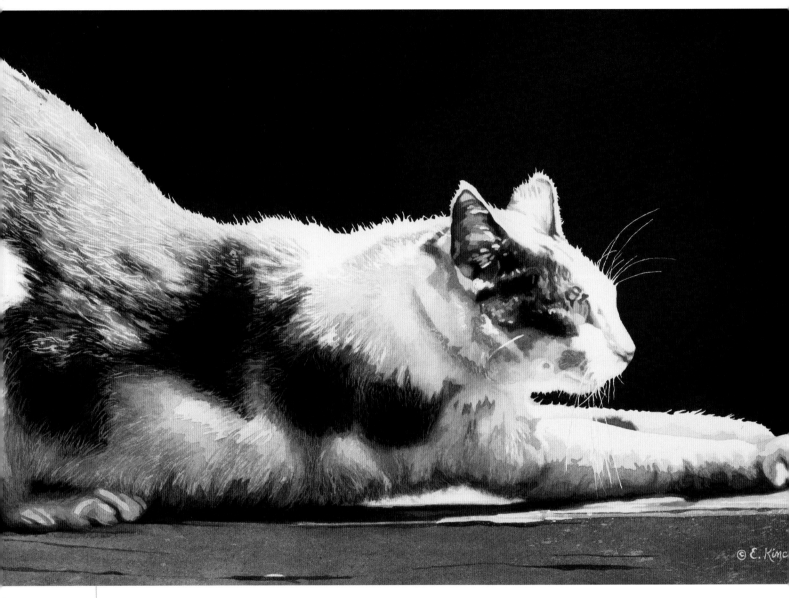

SPOT STRETCH | Elizabeth D. Kincaid
Transparent watercolor on 300-lb. (640gsm) cold-pressed Arches | 13½" × 21" (34cm × 53cm)

I painted *Spot Stretch* from a 35mm slide. I masked the cat with frisket film and liquid mask, and applied masking with a ruling pen for the fine lines of Spot's hair and whiskers. I glazed the background with layers of Indian Yellow, Quinacridone Violet and then Winsor Violet for the deepest dark. I have been exploring how to follow a Mario Cooper quote I heard decades ago: "Tell one story." I boldly sacrificed the entire beautiful line of Spot's back and tail, and focused on the one section that was most exciting to me—the steep "ski jump" line of her back. I then searched for a gradation of color for the background that focused attention on the punch line of this story—her backlit face.

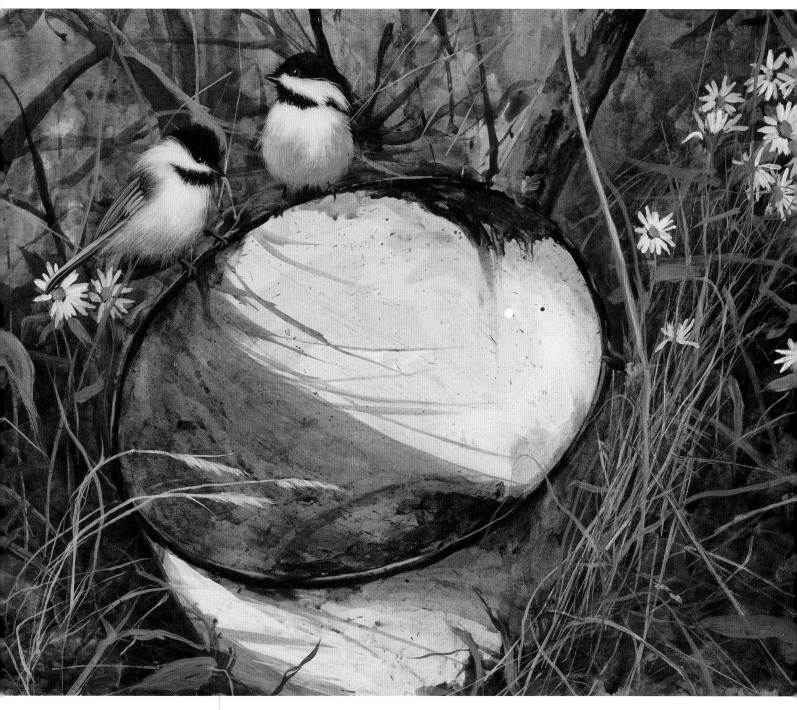

LATE FOR DINNER | Neil H. Adamson
Acrylic watercolor on Strathmore illustration board | 15" × 17" (38cm × 43cm)

While painting on location, I came across an old enameled white pan with a blue handle amongst the grass and the wildflowers. The pan was chipped and rusted, and the morning sun cast its shadows, creating a striking contrast. I first made a drawing of the pan and laid in a very loose wash of Phthalo Blue. I also laid washes of Raw Umber and Raw Sienna for the grass and background, and carefully saved the white of the paper for the pan's highlights. I worked quickly to capture the light. I refined the grass and flowers and also the shadow sand textures in the pan. Several years later I added the two chickadees for interest, hence the name *Late for Dinner*.

Tell **one** story.

—— M A R I O C O O P E R

Transparent watercolor on paper | 14" × 20" (36cm × 51cm)

A get-together with artist friends provided an opportunity to learn a resist technique using masking tape. Inspired by reference photos of seagulls, I developed a sketch and value pattern for my painting and then transferred the sketch to watercolor paper. I applied torn strips of masking tape to the areas of lightest value. The direction of strips and torn edges was important. I applied a first layer of paint over both paper and tape. The process was rather simple: Tape, paint, allow to dry—repeat until done. As paint seeped between the layers of tape, it left interesting and unpredictable markings. It was fun to finally peel away the tape and unveil those surprises.

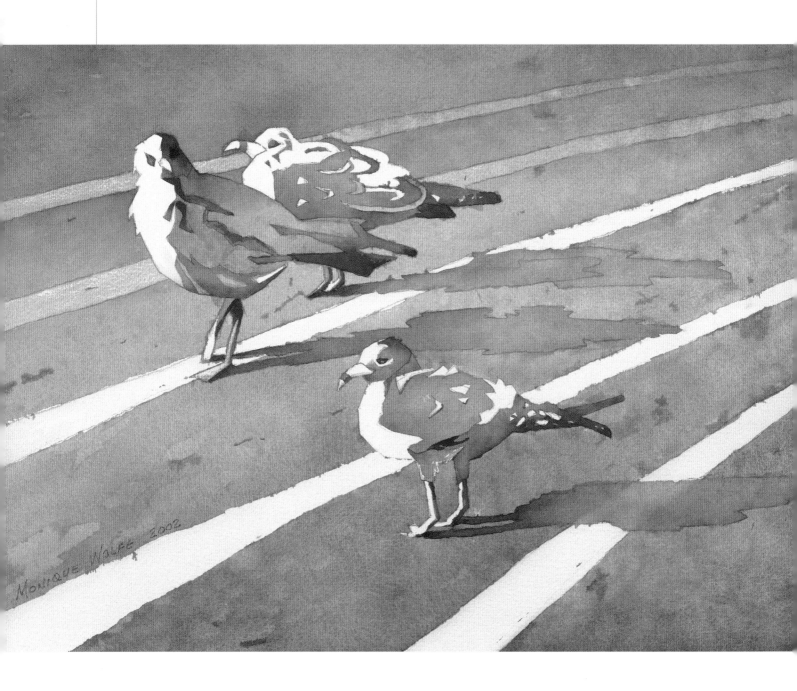

BIRDS OF A FEATHER | Monique Wolfe
Transparent watercolor on paper | 14" × 20" (36cm × 51cm)

Our senses, thoughts and emotions are our most
potent creative tools to **bring our artwork to life**.

— KRISTINE FRETHEIM

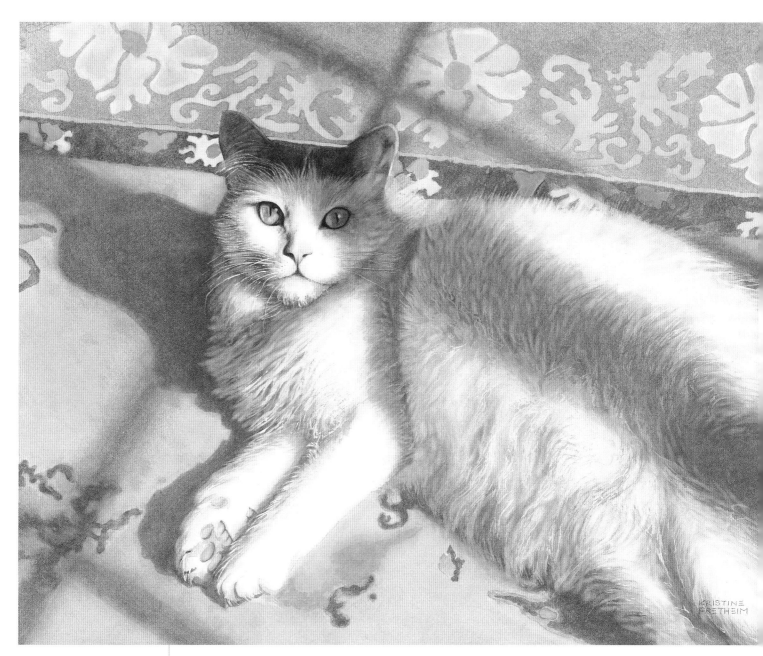

SAY A WORD OF TRUTH | Kristine Fretheim
Transparent watercolor on 140-lb. (300gsm) cold-pressed Arches | 16" × 20" (41cm × 51cm)

My feline friend was reluctant to pose, so I painted from photographs and referred to the live cat for detail. I was
impatient to finish, and it showed in the artwork. Time for a new direction! I abandoned the painting to a bucket
of water and a sponge, washing most of it away. Suddenly it came to life. Was he purring? After the paper
dried, I used small brushes to bring detail to the cat's face, contrasting the overall softness of the image. The
eyes are an important focal point, conveying a sense of feline mystery. Breathing, eating, sleeping and playing—
we use our senses, thoughts and emotions as paint and brushes to create our life. What happens when we
suspend judgment and simply experience each moment with wide-eyed curiosity?

COOPER'S HAWK | Floy Zittin

Transparent watercolor on canvas | 16" × 30" (41cm × 76cm)

I love to throw paint around. With sumi-e line work, splashes and dribbles become branches and foliage; with the proper surface, birds can be added in as well. My challenge has been to find a surface where I can lift out a bird shape after allowing a design of textures and lines to evolve. I had found paper coated with gesso to be the best solution. Recently, though, it occurred to me that canvas coated with gesso would give me a similar surface with which to work. *Cooper's Hawk* is one of my first attempts to paint a large water-color work on canvas. I stretched medium-weave canvas, primed it with three coats of gesso and sealed the finished work with an archival aerosol varnish.

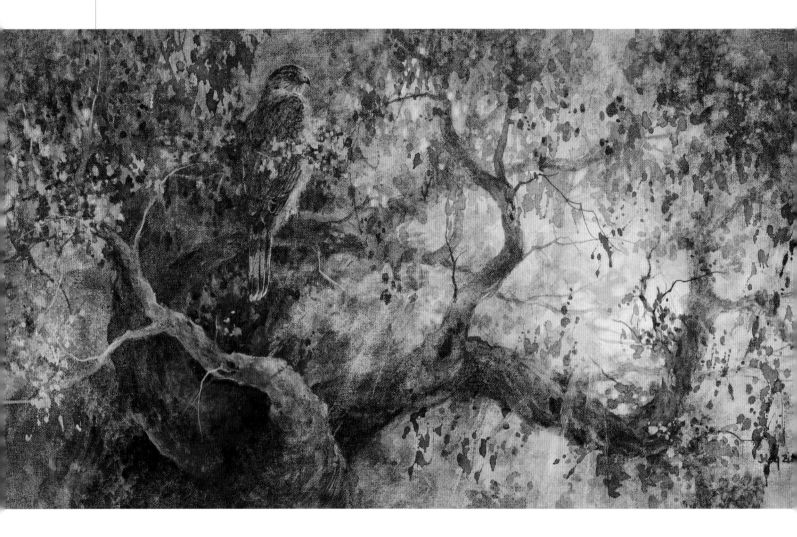

Life gets in the way of art.

— BEV JOZWIAK

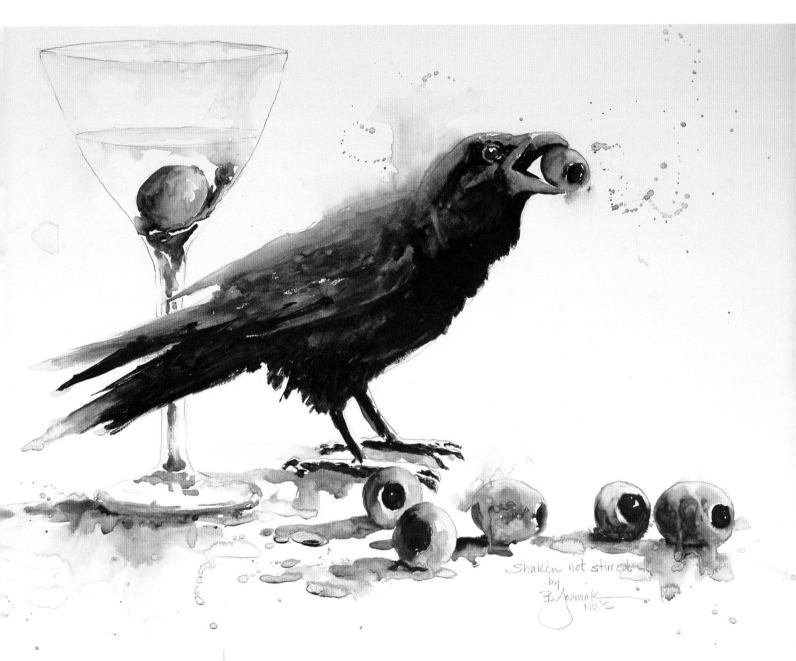

SHAKEN NOT STIRRED | Bev Jozwiak
Transparent watercolor with graphite on 140-lb. (300gsm) hot-pressed paper | 16" × 21" (41cm × 53cm)

This new series of crows and ravens that I have been working on is splashy, wet and wild. It started with one piece that sold instantly, so I painted another. Fifty or so paintings later the series has morphed into whimsical watercolors, which bring a joy to the serious side of art. Part of the fun is in the titles. My gallery owners tell me that clients actually laugh out loud. I am still painting on hot-pressed paper but with much more water and a looseness unparalleled in my previous work. The varied color, painterly style and compromising positions these birds find themselves in have made for one of my most enjoyable series yet.

After I created dozens of floral paintings for my book *Vibrant Flowers in Watercolor*, koi and bicycles captured my imagination as I sought a greater variety of subjects. I painted *Feeding Time* after seeing koi at the botanical garden.

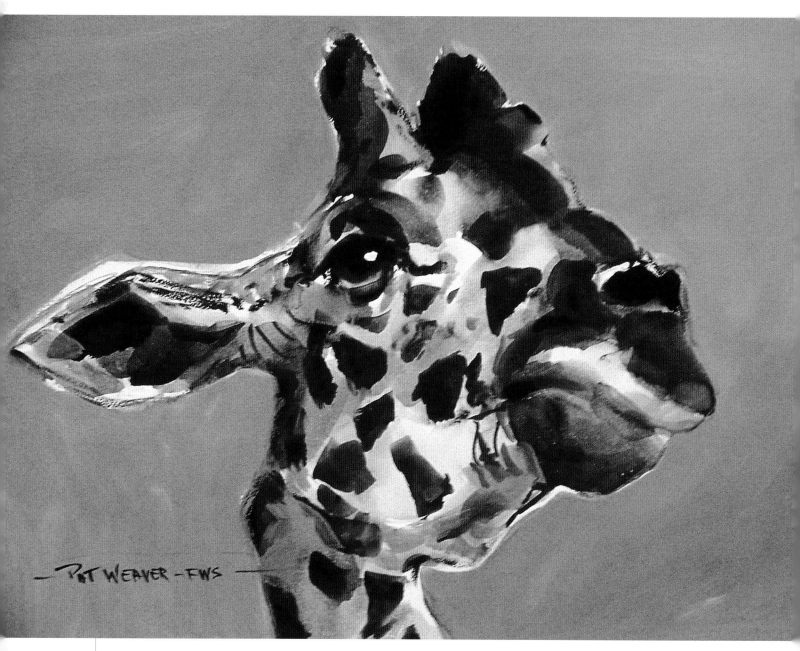

GIRAFFE ON AQUABORD | Pat Weaver
Transparent watercolor on Ampersand Aquabord | 12" × 16" (30cm × 41cm)

My board was tinted with transparent watercolor. The giraffe was drawn on the board with a brush using Burnt Umber watercolor. I used a combination of white casein mixed with transparent watercolor to complete the painting. The use of casein and transparent watercolor is a new direction for me. I also do rubouts on Aquabord combining both mediums.

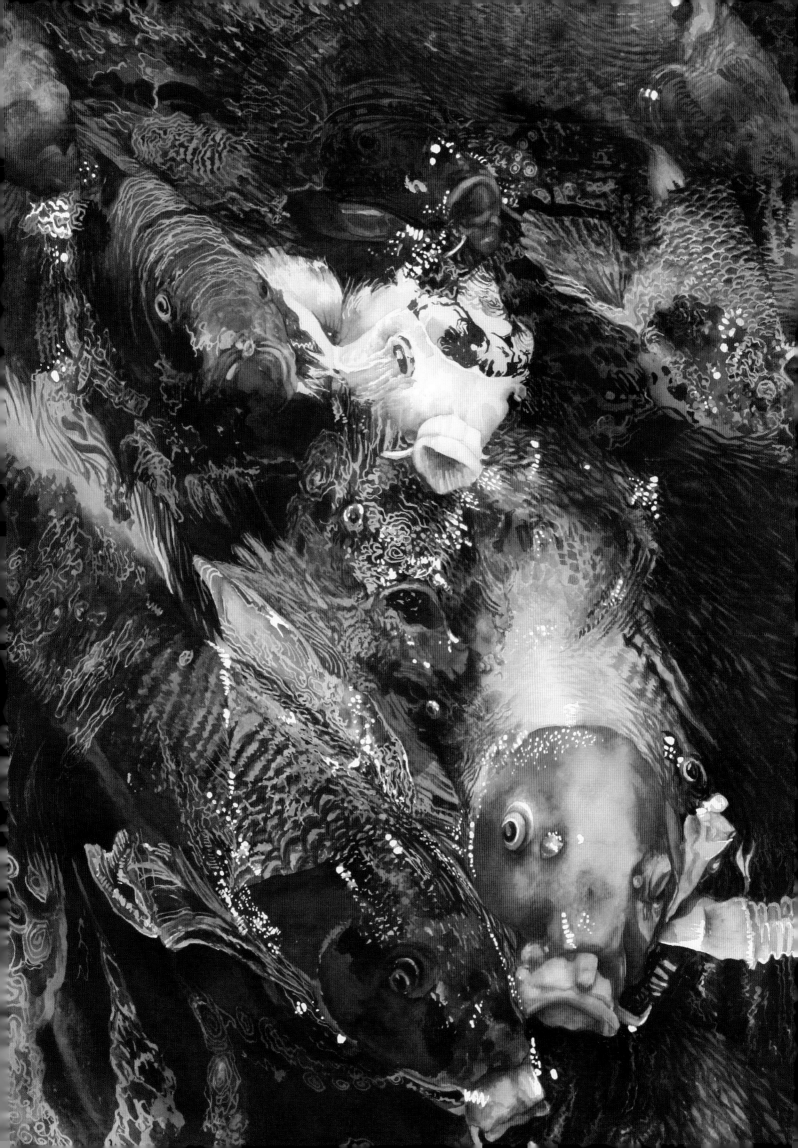

It is at the **very moment** when the artist experiences
the despair of failure and reaches out in desperation
to save the painting, **that creativity begins**. —MARILYNN DERWENSKUS

SHIFTING PLACES: FROM BLACK TIE PARTIES TO BUFFALO FIELDS | Marilynn Derwenskus
Transparent watercolor, gouache, watercolor pencils and collage on 140-lb. (300gsm) rough Fabriano | 22" × 22" (56cm × 56cm)

I am interested in creating visual imagery to communicate ideas within a flat, lyrical yet abstract space. This painting was inspired by two distinctly different experiences I had one evening—attending a theater benefit and visiting a field of buffaloes. I began the painting with no expectations, translating both experiences from memory as well as photographs and on-site sketches. To develop the dual notion of the composition—party and buffalo— I "read the painting," seeking out image and shape possibilities to intentionally create.

contributors

Anne Abgott
3840 Mariners Way
Cortez, FL 34210
h: (941) 795-5181
c: (941) 713-1146
anneabgott@aol.com
www.anneabgott.com

Neil H. Adamson, AWS,
NWS, FWS, PAA
5529 First Ave. N.
St. Petersburg, FL 33710
(727) 347-3555

Dennis Albetski
P.O. Box 166
Rochdale, MA 01542
(508) 892-8029
dalbetskiart@yahoo.com
www.dennisalbetski.com

Frances Ashley
4806 Roundup Trail
Austin, TX 78745
(512) 444-4527
francesashley@hotmail.com

Jewel Baldwin
11928 James Richard Dr.
Charlotte, NC 28277
(704) 814-8734
frednjewelb@yahoo.com
jewel@jewelbaldwin.com
http://jewelbaldwin.com

Karen E. Benco, PWCS
Allentown, PA
paint101@ptd.net
www.karenbenco.com

Robin Berry
5429 Park Ave. S.
Minneapolis, MN 55417
(612) 824-5488
tabetberrystudio@comcast.net
www.natureartists.com/
 robin_berry.asp

Susan Biros-Dawes
York, PA

Alexander Bostic
9629 Dove Hollow Lane
Glen Allen, VA 23060
h: (804) 755-7455
c: (804) 502-3151
alex@alexbostic.com
www.alexbostic.com

Carol Z. Brody
801 Caraway Ct.
Wellington, FL 33414
(561) 792-0806
czbrody@carolzbrody.com
www.carolzbrody.com

Jody Henderer Burns
1401 S. Cross St.
Robinson, IL 62454
(618) 554-3259
jodyhburns@hotmail.com
http://jhendererburns.com

Anna C. Carlton
6769 Lower Meigs Rd.
Moultrie, GA 31768
h: (229) 985-8328
c: (229) 873-0822
anna_carlton@hotmail.com
www.annacarltonart.com

Kay Carnie
10439 Heney Creek Pl.
Cupertino, CA 95014
(650) 962-0218
kccarnie@aol.com

Cheryl Chalmers
5074 Rice Rd.
Trumansburg, NY 14886
(607) 387-4133
cherchalmers@yahoo.com
www.cherylchalmers.com

Rachel B. Collins
Torpedo Factory Art Center #342
105 N. Union St.
Alexandria, VA 22314
(703) 838-9695
rbcollinsart@yahoo.com
www.rachelcollinsart.com

Kathleen Conover
Studio Gallery
2905 Lakeshore Blvd.
Marquette, MI 49855
(906) 228-2466
michstudio@gmail.com
www.kathleenconover.com

Jaimie Cordero
7125 SW 95th St.
Pinecrest, FL 33156
c: (786) 303-5293
h: (305) 661-8842
wdjaimiec@aol.com
aquarellestudiosandgalleries.com

Marilynn Derwenskus
1902 N. Halsted St., Unit 1
Chicago, IL 60614
(773) 327-3749
marilynderwenskus@yahoo.com
www.derwenskusart.com

Missie Dickens
2-C Fountain Manor Dr.
Greensboro, NC 27405
(336) 574-2351
theartistmd@201.com

Henry W. Dixon
8000 E. 118th Terr.
Kansas City, MO 64134
(816) 966-1830
wdix5@hotmail.com
www.henrywdixon.com

Linda Kooluris Dobbs
484 Avenue Rd., Suite 609
Toronto, ON M4V 2J4
Canada
(416) 960-8984
www.kooilurisdobbs.com

Linda DuPuis-Rosen
28870 Bay Heights Rd.
Hayward, CA 94542
fourteenhippos@linda
 dupuis-rosen.com
ldupuisrosen@msn.com
www.lindarosenart.net

Janet Mach Dutton
1417 El Dorado Pkwy. W.
Cape Coral, FL 33914
(239) 410-9654
www.jmachdutton.com

You never know until you try,
so **never give up**—and keep your brushes wet.

— A N N E C . A B G O T T

Linda Erfle, NWS
2723 Ivy Knoll Dr.
Placerville, CA 95667
(530) 622-2210
linda@lindaerfle.com
www.lindaerfle.com

Paula Fiebich
56323 Chesapeake Trail
Shelby Township, MI 48316
(586) 747-7928
cafeulait222000@yahoo.com
http://paulafiebich.blogspot.com

Pat Fiorello
341 W. Wieuca Rd.
Atlanta, GA 30342
(404) 531-4160
patfiorello@aol.com
www.patfiorello.com

Mary "Mariska" Folks, ISAP
2638 Foreman Ave.
Long Beach, CA 90815
(562) 429-1122

Nancy Fortunato, TWSA/M
249 N. Marion St.
Palatine, IL 60074
(847) 359-5033
nancyfortunato@yahoo.com
www.watercolorart.net

Ellen A. Fountain, NWS
Fountain Studio
4425 W. Tombolo Trail
Tucson, AZ 85745
elf@fountainstudio.com

Barbara Fox
7590 Maples Rd.
Little Valley, NY 14755
(716) 699-4145
bfoxart@yahoo.com
www.barbarafoxwatercolors.com

Tom Francesconi
2925 Birch Rd.
Homewood, IL 60430
info@tomfrancesconi.com
www.tomfrancesconi.com

Kristine Fretheim
8766 Zinnia Way N.
Maple Grove, MN 55369
(763) 494-4564
www.kristinefretheim.com

Kathy Gagnon
1407 Kensington Ct. A6
Hendersonville, NC 28791
kthygagnon@bellsouth.net
www.ohioonlinearts.org
www.southernwatercolorsociety.
 org/kathygagnon.html

Kathie George
126 Blue Gate Cir.
Kettering, OH 45429
www.kathiegeorge.com

Marjorie Glick
10 High Rock Way
Allston, MA 02134
marjorieglick@mac.com
www.marjorieglick.com

Nancy M. Grigsby
7981 Sawgrass Way
Blaine, WA 98230
(360) 371-9042
itneverrains@comcast.net

Juanita Hagberg
4219 Maple Ave.
Oakland, CA 94602
(510) 531-1190
881 Lawson Rd.
Camano Island, WA 98282
(360) 387-3128
hagberg1@pacbell.net

Susan L. Harper
56 Saint Francis Way
Holtwood, PA 17532
sue@susanlharper.com

Scott Hartley
5334 Nollar Rd.
Ann Arbor, MI 48105
(734) 355-2992
scotthartley@copper.net
www.scotthartleywatercolors.com

Ted Head
5425 N. Autumnbrook Trail
Jacksonville, FL 32258
(904) 504-7711
ted@tedheadwatercolors.com
www.tedheadwatercolors.com

Tom Heflin
1162 S. Weldon Rd.
Rockford, IL 61102
(815) 962-1835
tomheflin1@comcast.net
http://tomheflin.com

Suzanne S. Hetzel, PWS
71 Long Grove Rd.
Yorkville, IL 60560
(847) 372-5622
dragonflys71@sbcglobal.net
www.dragonflywatercolors.com

Robert Highsmith
2920 Suncrest Arc
Las Cruces, NM 88011
(575) 650-1556
ra_highsmith@hotmail.com
www.rhighsmith.com

Terri Hill
terrihill@designerhill.com
www.designerhill.com

Lynn Hosegood
Williamsburg, VA
lynn@lynnhosegoodstudio.com
www.lynnhosegoodstudio.com

Anne Hudec, AFCA
Victoria, BC Canada
ah@annehudec.com
www.annehudec.com

Peggie Hunnicutt
P.O. Box 91475
Anchorage, AK 99509
(907) 349-4168
phnyct@gmail.com
http://peggiesartstudio.com

Bill James, AWS/DF,
 NWS, PSA/M, KA
509 NW Thirty-fifth St.
Ocala, FL 34475
(352) 694-8080
artistbilljames@earthlink.net
http://artistbilljames.com

John E. James
(817) 652-1340
john-drew@prodigy.net

Russell Jewell
116 Deer Creek Ct.
Easley, SC 29642
jewellart@charter.net
http://russelljewell.com

Bev Jozwiak
315 W. Thirty-fourth St.
Vancouver, WA 98660
paintingjo@hotmail.com
http://bevjozwiak.com

Elisa A. Khachian
artistelisa@optonline.net

Elizabeth D. Kincaid
9515 NE 137th St.
Kirkland, WA 98034
(425) 823-9420
e@elizabethkincaid.com
www.elizabethkincaid.com

Jaya King
(650) 283-5292
jayascool@earthlink.net
www.jayasart.com

Painting is just another way of **keeping a diary**.

— PABLO PICASSO

The role of the artist is not to duplicate our world but to **interpret it through our own eyes**, filtered by the uniqueness of personal experience.

Andrew M. Kish III
5490 Ashley Dr.
Laurys Station, PA 18059
(484) 225-7958
art@andrewmkish.com
www.andrewmkish.com

Nellie Kieke Kress
22418 Vobe Ct.
Katy, TX 77449
(281) 347-0248
nkkress@msn.com
www.artbynelliekress.com

Valerie Larsen, NWS
www.valerielarsen.com

David Lee
186 Hickory St.
Washington Township, NJ 07676

Roland L. Lee
Roland Lee Art Gallery
P.O. Box 2768
Saint George, UT 84771
www.rolandlee.com
www.travelsketchbook.blogspot.com

Judy LewLoose
2795 E. Bidwell St. 100-193
Folsom, CA 95630
(916) 984-4936
lewloosewatercolors@yahoo.com
www.lewloosewatercolors.com

Fealing Lin
1720 Ramiro Rd.
San Marino, CA 91108
(626) 799-7022
fealinglin@hotmail.com
www.fealingwatercolor.com

Tom Linden
Rockford, IL
sales@tomlindenart.com
www.tomlindenart.com

Kathleen Maling
7175 A1A S. #D123
St. Augustine, FL 32080
(904) 312-2157
katmalin@bellsouth.net
http://katscolors.com

Renate Martin
k.r.martin@alaska.net

Antonio Masi
121 Brompton Rd.
Garden City, NY 11530
(516) 455-6601
amasi@optonline.net
www.antoniomasi.com

Laurin McCracken
1005 Picasso Dr.
Fort Worth, TX 76107
(817) 773-2163
laurinmc@aol.com
www.lauringallery.com

Carol Jones McDonnell
30 Brittania Cir.
Salem, MA 01970
(978) 594-0686
cjm@caroljonesmcdonnell.com
www.caroljonesmcdonnell.com

Mark E. Mehaffey, AWS, NWS
5440 Zimmer Rd.
Williamston, MI 48845
(517) 655-2342
mark@mehaffeygallery.com
www.mehaffeygallery.com

Robert Lee Mejer
Art Department/Quincy University
1800 College Ave.
Quincy, IL 62301
(217) 228-5371
mejerbob@quincy.edu

Judy Metcalfe, AWS
1 Jerdens Lane
Rockport, MA 01966
jdy@gis.net
www.judymetcalfe.com

David Milton
31682 Fairview Rd.
Laguna Beach, CA 92651
(949) 415-0155
dmiltonart@cox.net
www.davidmiltonstudio.com

Judy Morris, AWS, NWS
2404 E. Main St.
Medford, OR 97504
(541) 779-5306
judy@judymorris-art.com
www.judymorris-art.com

Vickie Nelson
722 SE 200th Pl.
Camas, WA 98607
(360) 817-5836
vickienelsonstudios@comcast.net
www.vickienelson.com

Robert J. O'Brien
2811 Weathersfield Ctr. Rd.
Perkinsville, VT 05151
robert@robertjobrien.com
www.robertjobrien.com

Frances Briscoe O'Callaghan, WW, SWS, MWS
5615 Willow Crest Dr.
Shreveport, LA 71119
(318) 635-6956
franboc@bellsouth.net

Sandy O'Connor
P.O. Box 63
Cotuit, MA 02635
(508) 420-3223
sandy@redhillstudio.com
www.redhillstudio.com

Edmond S. Oliveros, AIA, SI
2112 Bishopsgate Dr.
Toledo, OH 43614
edolive@aol.com
www.edmondoliveros.com

Catherine P. O'Neill
34 Marengo Ave.
Hamburg, NY 14075
(716) 648-4852
kconeill@roadrunner.com

Heidi Lang Parrinello
25 Madison St.
Glen Ridge, NJ 07028
hlang25@comcast.net

Pamela K. Patton
221 Bellevue Blvd. N.
Bellevue, NE 68005
(402) 293-1730
pampatton@cox.net
www.pamelapatton.com

Jacky Pearson
230 Muritai Rd.
Eastbourne, New Zealand
+64 4-562-8664
jacky@jackypearsonwatercolours.
co.nz
www.jackypearson.com

Sandrine Pelissier
North Vancouver, BC Canada
sandrine@sandrinepelissier.com
www.sandrinepelissier.com

Jim Petty
735 Wisp Creek Dr.
Bailey, CO 80421
(719) 838-1102
jimpettyartist@aol.com
DGallery
3558 Navajo Street
Denver, Colorado 80211
(720) 242-8354

Robin Purcell
409 Triomphe Ct.
Danville, CA 94506
(925) 648-0971
robin.purcell@gmail.com
robinpurcellpaints.blogspot.com



Robert Reynolds
www.robertreynoldsart.com

Irena Roman
575 Washington St.
Caton, MA 02021
(781) 830-9490
irena@irenaroman.com
www.irenaroman.blogspot.com

Ong Kim Seng
Block 522 Hougang Ave. 6, #10-27
Singapore 530522
65-978585287
kseng@pacific.net.sg
www.ongkimseng.com

F. Charles Sharpe
4617 Reigalwood Rd.
Durham, NC 27712
csharpetts@aol.com

Charles Sluga
P.O. Box 128
Yackandandah
Victoria 3749
Australia
+61 4-1812-9740
+61 2-6027-0993
sluga@hotkey.net.au
www.sluga.com.au

Paul St. Denis, AWS/DF, NWS
28007 Sites Rd.
Bay Village, OH 44140
wcstdenis1@aol.com

Pam Stanley
215 Aberdeen Ave.
Corpus Christi, TX 78411
(361) 854-3695
pamsarts@hotmail.com

David L. Stickel
www.davidstickel.com

Susan M. Stuller, NWS
2930 Barrow Pl.
Midlothian, VA 23113
(804) 379-1477
susan.stuller@comcast.net
www.susanstuller.com

Brenda Swenson
514 El Centro St.
South Pasadena, CA 91030
(626) 441-6562
brenda@swensonsart.net
www.swensonsart.net

Keiko Tanabe
12662 Sandy Crest Ct.
San Diego, CA 92130
(858) 793-8277
ktanabe@san.rr.com
www.ktanabefineart.com

Vivian Thierfelder
P.O. Box 3568
Spruce Grove, AB T7X 3A8
Canada
vivian22@tetus.net
www.vivianthierfelder.com

Zhou Tianya
DongHu ZhongXue
1 Xin An Rord
Shenzhen City, Gangdong 518020
China
p: +86 136-8244-2735
f: +86 755-2578-2344
ztianya@126.com
www.watercolor.com.cn
Hong Kong HanXiangYuan Gallery
Room 19, F/Hollywood Centre
233 Hollywood Rd.
Sheung, Wan.
p: 00852-6136-3389

James Toogood, AWS, NWS
920 Park Dr.
Cherry Hill, NJ 08002
(856) 429-5461
jtoogood@verizon.net

Dani Tupper
960 Willowwood Lane
Delta, CO 81416
(970) 874-3088
kdtup@msn.com
www.danitupper.com

Dannica Walker
6384 Sterling Rd.
Newport, MI 48166
(734) 731-3803
djwoldgoat@yahoo.com
http://dannicawalker.com

Soon Y. Warren
4062 Hildring Dr. W.
Fort Worth, TX 76109
(817) 923-1586
soon-warren@charter.net
www.soonwarren.com

Pat Weaver
P.O. Box 1246
Dade City, FL 33526
(352) 567-6392
ivel2@aol.com
www.patweaver.net

Gayle Weisfield
P.O. Box 572
Hood River, OR 97032/97031
(509) 365-3709
info@gayleweisfield.com
www.gayleweisfield.com

Steven A. Wilda
53 Rockyhill Rd.
Hadley, MA 01035
(413) 584-8482
swilda@acadiumass.edu
www.stevewilda.com

Leslie Wilson
Walnut Creek, CA
(925) 935-7529
leslie_wilson@pacbell.net
www.lesliewilson.net

Donna Jill Witty, AWS,
 NWS, TWSA/M
444 N. Hill St.
Woodstock, IL 60098
(815) 338-0849
jilwitty@owc.net
www.donnajillwitty.com

Monique Wolfe
214 Broughton Dr.
Greenville, SC 29609
(864) 242-3551

Cheryl Sutter Wooten
P.O. Box 56
Somerville, TX 77879
(979) 596-2782
cheryls_art@yahoo.com
www.cheryls-art.com

Christopher Wynn
10110 Hearthrock Ct.
Richmond, VA 23233
(804) 747-3446
christopherwynnart@yahoo.com
www.wynncreative.com

Al Zerries
http://alzerriesart.com

Diane Williams Ziemski
11 Pontalba Dr.
Little Rock, AR 72211
(501) 219-1938
diwizi@gmail.com
diwizi@comcast.net
www.dianeziemski.com

Floy Zittin
10210 Lebanon Dr.
Cupertino, CA 95014
(408) 253-3258
floy@floyzittin.com
www.floyzittin.com

Transparent **watercolor is not inferior**
to the performance of oil media.

— ZHOU TIANYA

index

ideas. instruction. inspiration.

These and other fine North Light books are available at your
local art & craft retailer, bookstore or online supplier.

This brilliant collection of over 140 works is
dedicated to discovering how today's artists
create great watercolors, and what motivates
them to be creative, work in this amazing
medium, and portray the subjects they love.

Z0757 | 144 PAGES | HARDCOVER
978-1-58180-971-8

This inspiring second collection in North
Light's *Best of Drawing* series celebrates the
beauty, diversity and expression of drawing
with 140 examples from 100 artists of today's
finest drawing.

Z2507 | 144 PAGES | HARDCOVER
978-1-60061-158-2

For artists working in watermedia, *Watercolor
Artist* magazine is the definitive source for
creative inspiration and technical information.
Find the latest issue on newsstands, or order
online at **www.artistsnetwork.com/magazines**.

Recieve a FREE GIFT when you sign up for our free newsletter
at **www.artistsnetwork.com/newsletter_thanks**.

Splash: The Best of Watercolor

The *Splash* series showcases the finest watercolor
paintings being created today. A new book in the series is
published every other year by North Light Books (an
imprint of F+W Media) and features nearly 140 paintings
by a wide variety of artists from around the world, each
with instructive information about how it was achieved —
including inspiration, tips and techniques.

Gallery

Passionate Brushstrokes
Rachel Rubin Wolf

Splash 10 explores "passion" through the work and
words of 100 contemporary painters. With each
vividly reproduced modern-day masterpiece,
insightful firsthand commentary taps into the
psyche of the artist to explore where their passion
comes ...

Watercolor Discoveries
Rachel Rubin Wolf

Splash 9 holds its own as a visual showcase,
representing some of the best work being done in
watercolor today. But of course, that's only the
half of it. *Splash* is much more than a pretty face.
In the same open, giving spirit that ha...

Want to see your art in print?

Visit **www.splashwatercolor.com** for up-to-date
information on future North Light competitions
or email us at *bestofnorthlight@fwmedia.com* and
ask to be put on our mailing list!

Carole Barnes
29625 Gimpl Hill Rd.
Eugene, OR 97402